Promise

Witness

April 7 - June 13, 2021

Remembrance

Speed Art Museum
Louisville, Kentucky

SPEED ART MUSEUM

Stephen Reily Allison Glenn Toya Northington

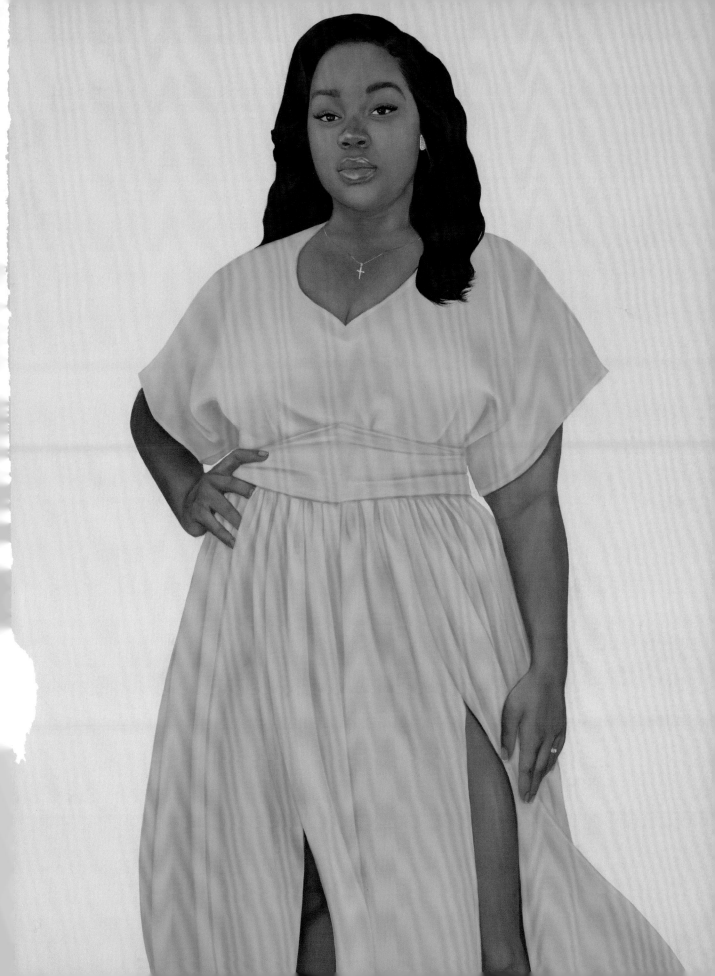

Published to document the exhibition *Promise, Witness, Remembrance*, organized by
the Speed Art Museum in Louisville, Kentucky, on view from April 7 to June 13, 2021.
Copyright © 2022 Speed Art Museum

Printed in Canada
First edition: July 2022
ISBN: 978-1-7342485-1-7
Library of Congress Control Number: 2022937266

Published by the Speed Art Museum, 2035 S. Third Street, Louisville KY 40208
Primary contributions by Stephen Reily, Allison Glenn, Toya Northington
Compiled and produced by Evan McMahon
Edited by Tyra A. Seals at Typology
Designed by Annie Langan at Kertis Creative
Printed and bound by The Prolific Group
With special thanks to Phillip March Jones

Cover illustrations:
Front: Amy Sherald, *Breonna Taylor*, 2020. Photo by Joseph Hyde
Back: Photo by Bill Roughen

Credits and permissions are located on pages 262-265.
Every effort has been made to contact all copyright holders.
If any copyright holders have been unintentionally omitted,
please contact the Speed Art Museum at:
2035 South Third Street
Louisville, Kentucky 40208
502.634.2700
info@speedmuseum.org

The exhibition *Promise, Witness, Remembrance* was made possible
by a grant from the Ford Foundation.

Support for this publication provided by:
Owsley Brown III & Victoire Reynal Brown
Christina Lee Brown
Augusta Brown Holland & Gill Holland, Jr.
Brooke Brown Barzun & Matthew Barzun
Stephen Reily

Contents

Introduction
by
Stephen Reily

—

This book documents an exhibition that we wish there had been no reason to present.

On March 13, 2020, the Speed Museum joined institutions around the country in closing our doors to prevent the spread of COVID-19. At the time, we did not know that something else happened on March 13 that we would never forget.

In the first hours of that day, the Louisville Metro Police Department executed a "no-knock" warrant on the apartment of a 26-year-old medical worker named Breonna Taylor. When her boyfriend, Kenneth Walker, shot a gun against what he assumed were intruders, the police began shooting back. Six of their thirty-two bullets hit Breonna Taylor, who died in her hallway. The systemic failures that led to this warrant, the botched police raid, and Breonna Taylor's death are too numerous to describe here.

It took several months before the facts of this case became generally known, and in late May protests began in downtown Louisville seeking justice for Breonna Taylor. The protests would continue for the rest of 2020, as would other killings, of David McAtee (shot by the National Guard after they were called in to quell protests), of photographer Tyler Gerth (while documenting protests in downtown Louisville), and of protest leader Travis Nagdy (in an apparently unrelated attack), along with a record-breaking number of killings and gun violence all across our city.

At the Speed, we struggled along with our city and country during those months. As we worked to adapt our work and mission to COVID-19, we also worked to examine our own history and commitment to racial equity. In August we issued the Museum's first annual Racial Equity Report, which presented the Speed's standing in seven critical areas of our work—from employment to art acquisitions—together with a commitment to regularly report where the Museum stands against specified goals.

But we still had not answered the question: what could an art museum do to serve our city at a time like this?

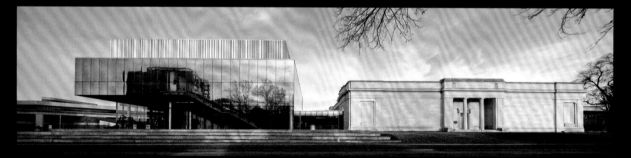

How we asked ourselves that question—and even why we were asking that question—requires a little background. The Speed Art Museum, founded in 1925 by Hattie Bishop Speed, reopened in 2016 following a four-year closure and renovation beautifully designed by Kulapat Yantrasast of WHY Architecture. I became the Museum's Director exactly one year after that reopening and had the honor of working with over 100 talented colleagues and two wonderful boards to bring this incredible new building to life by reinventing the relationship of our great art museum to its city and state. Together, we developed and then lived by a mission to "invite everyone to celebrate art forever."

Early in my tenure I learned that we could be fearless in addressing real-world issues, as long as we did it through art. Museums should not tell people what to think, because great art doesn't tell people what to think. The power of great art—and, as a result, the power of a museum—comes from allowing people to find their own thoughts and feelings in it. I learned that there was no topic we could not address, as long as we did it through the open-ended, generous, and generative view of artists. The Speed's curators were bold in letting artists from all eras show us new ways to consider real life issues. Some examples:

In *Southern Accent: Seeking the American South in Contemporary Art*, co-curated in 2017 by the Speed's Curator of Contemporary Art, Miranda Lash, and Trevor Schoonmaker from the Nasher Museum of Art at Duke University, the artist Sonya Clark presented her work, *Unraveling*, in which she invited members of the public to join her in slowly unraveling a Confederate flag. This action turns the most incendiary symbol in the American South into a shared process of contemplation and reconciliation.

In *Women Artists in the Age of Impressionism*, Erika Holmquist-Wall, the Speed's Mary and Barry Bingham, Sr. Curator of European and American Painting and Sculpture, realized that the #MeToo movement created an opportunity to recast this display of beautiful 19th century paintings as stories of 37 women working to overcome professional, social, and personal obstacles on their path to becoming great artists. Rather than being limited by controversy, this approach allowed our guests to find more relevance, beauty, and meaning in art.

With *Loose Nuts: Bert Hurley's West End Story*, Kim Spence, the Speed's Curator of Works on Paper (and later, Director of Collections & Exhibitions), presented an illustrated novel from the 1930s by a self-taught and unrecognized Black artist who depicted the glamour and beauty in Louisville's segregated neighborhoods, while also connecting it to our contemporary understanding of the long-term impact of redlining and urban renewal on the Speed's hometown.

As I approached my fourth year as Director, the "new" Speed gained confidence and determination toward—even a sense of obligation about—addressing issues that matter, always through the work of great artists and art.

In August 2020, as Louisville remained in national and international news for Taylor's killing, we began to find a way to address this new reality when *Vanity Fair* published a portrait of Taylor by the artist Amy Sherald on its cover. A colleague, Adrienne Miller, suggested that the Speed ask to borrow and exhibit this painting. One sign of a good idea is how easy it is to embrace, and I immediately realized that this portrait offered the Speed a chance to serve Louisville at a time of need, and to do it in a way that fit our mission. An art museum can't end a global pandemic, bring people back to life, reform policing, or end a surge in gun violence. But it can offer art.

We immediately began the process that led to *Promise, Witness Remembrance*—although at the time I had no idea that it would produce an exhibition, gather and elevate so many great talents, or generate so much attention to their work and to the Speed. I did know that, for us, staying focused on a great painter and her painting would show us the way.

This book tells the story of how that happened. We brought many experts together to organize it, but none of them had organized anything quite like it before. Rather than congratulating ourselves on the exhibition's outcome after the fact, we want to convey the uncertainty and tension that we embraced in the process of assembling it. For that reason, we have chosen to tell this story using words and images almost entirely created during the preparation and run of the exhibition itself. It was a fast process; it invited many players to the table; it used conflict to generate better results, and it kept us all focused, not just on a deadline but on a goal: using great art to help people process one of the hardest years of our lives, and possibly finding a way forward together.

The first section describes the four people without whom the exhibit would not have happened, and I want to thank these four Black women for their trust, their talent, their commitment, and for everything I have learned from them: Amy Sherald, Tamika Palmer, Allison Glenn, and Toya Northington.

In addition, I need to single out a few others with deep gratitude: Darren Walker and the Ford Foundation for encouraging our ambitions and making everything about this project possible; the Speed's Department of Collections & Exhibitions (Kim Spence, Hannah McAulay, Adrienne Miller, Ron Davey, Mike Stauss, Ryan Daly, and others) for their incredibly hard work and adaptability in presenting this beautiful and complicated exhibition in record time; Toni Carver Smith, Deputy Director for Finance and Operations, whose connections and wise counsel kept me and our work on track; Roger Cude, my mentor and Chair of a Board of Trustees that supported this exhibition at every step; Lonita Baker, Tamika Palmer's attorney and friend; Irene Karp, a great patron and connector; and Evan McMahon, our Chief of Staff, who worked tirelessly to keep this ship (and me) afloat on sometimes rough and rushing waters.

As for this written record, I want to thank Owsley Brown III, who encouraged me to publish this book and then, together with his mother and sisters, gave it their financial support; Annie Langan, who designed this book and everything in it; Phillip March Jones, who (among other things) knows how to make a book and generously shared that knowledge with us; Tyra Seals, who edited it; and my successor, Raphaela Platow, who graciously allowed me to remain involved enough to tell and share this story with others.

— Stephen Reily, Director, Speed Art Museum (2017-2021)

The Time is Now
Allison Glenn

—

Promise

The past few years have been tumultuous, filled with many shifts, changes, and growth. Like many others, I spent a majority of the past two years bearing witness to intersecting pandemics: COVID-19 becoming the largest and most deadly virus in over 100 years, and a world watching the United States become embroiled in the largest racial reckoning of a lifetime. Like many others, I was striving to make meaning of a world that had changed so drastically. Like many others, I was searching for a purpose and impact.

During this global pandemic, years, months, weeks, days, and hours have come to be defined in new ways. Early on, the end of a workday was marked by the closing of a computer and clearing of a kitchen island that doubled as a desk during work hours. The act of taking a long walk or run replaced a short commute to work, and Zoom gatherings replaced in person get togethers. Days also came to be defined by the percentage increase or decrease of people infected by new Coronavirus variants; the number of cases in my region, this country, and world; the number of months between vaccinations; the amount of vaccinated people in certain age groups and the necessary distance needed between my body and another to avoid a potentially exposure.

One of the major impacts of the early pandemic was that people were unable to turn away from the brutality and injustice in police killings of Black and Brown people and an increasing rate. In 2020, death by firearms was increasing across the United States contrary to the fact that life for many Americans had slowed down. Numbers of people killed by gun violence in the United States are staggering. From 2018 to 2019, we saw a decline in numbers from 54,139 in 2018 to 39,561 in 2019. In 2020, during the height of the pandemic, when logic would have it that there were less interactions between people because of social distancing, the United States saw a 28% increase in gun violence, with 43,643 total deaths by firearm.[1]

Witness

On the evening of March 13, 2020, I was making peanut stew in my kitchen, talking on the phone with an artist about the cultural climate and rumors of shutdowns. That day, word of Breonna Taylor's killing did not reach me in Arkansas. I did not know that her boyfriend was taken to jail amidst ludicrous claims of assault and attempted murder of a police officer. It wasn't until the nationwide protests started in June that I learned about Breonna, after the world watched the most tragic, gut-wrenching 9 minute 29 second video of George Floyd begging for his life that was bravely captured on camera by then 17-year-old Darnella Frazier. But what if Frazier had not had the courage to record that incident on her phone and share it?

I'll never forget where I was when I received an email from Stephen Reily, then Director of the Speed Art Museum. I was sitting at my desk in a tiny apartment in Bentonville, AR, reading his invitation for me to consider a project that would ultimately come to define the future of my personal and professional endeavors. In his email, Stephen shared that the Speed had plans to exhibit the portrait of Breonna Taylor that was painted by Amy Sherald and invited me to serve as guest curator. This is the same portrait that had graced the cover of *Vanity Fair,* the same portrait that had controversially[2] circulated widely on social media platforms since September 2020. *This opportunity was not one that I took lightly.*

I began working on this exhibition on December 7, 2020, and for four months, it became my life. It was clear from the onset that this moment was so much bigger than me, and that the stakes were incredibly high. I knew early on that I was going to have to embrace drastically different

—

1 / "Past summary legers," Gun Violence Archive, Accessed January 20, 2022 https://www.gunviolencearchive.org/past-tolls

2 / Wortham, Jenna. "Breonna Taylor, b. 1993." *New York Times Magazine*, December 23, 2020.

curatorial methodologies. To balance the expectations and anchor myself in the most important voice in the room, I turned to Tamika Palmer, and asked her what this exhibition meant to her and what could it do for her daughter's legacy. The visioning process was a swift one, and I developed the three sections—promise, witness, remembrance—from her mother's statement.[3] Even after her beautifully articulated sentence, I still struggled with how to prioritize the input that I was receiving from the thought partners. I knew there was so much that the exhibition could not do. I was unsure if it would have the ambition and impact to represent a person's life.

To be prepared to present my ideas to the Louisville Steering Committees, I decided to build an advisory board to collectively guide decisions and provide the necessary feedback. The National Advisory Panel came together effortlessly, and with great intention. Selecting the team meant turning toward my network of colleagues, peers, and friends; with each of these people I had shared many meals and ambitions over the years. Selecting advisors from outside of Louisville provided a lens through which to understand the heartbreaking truth of the incident for which this exhibition was developed; Breonna's death at the hands of police was a truly devastating event, but not an isolated incident. We have seen many of these incidents happen across the United States, for decades. With this in mind, the National Panel represented friends, family, and communities of Keith Briscoe, Trayvon Martin, Reverend Clementa C. Pinckney and the Mother Emanuel Nine, Tamir Rice, Alton Sterling, Jason Thompas, and those lost to gun violence, but not police brutality, including Songha Thomas. I am so indebted to the Panelists' brilliance, acumen, and care.

The National Panel also provided an opportunity to articulate connections between the local, contemporary protest movement and national, historic movements for justice that were happening at other moments within the exhibition. As a response to the Louisville Steering Committee's request for more Louisville-based artists represented in the exhibition, five photographers were chosen to represent key moments in the city's protest movement. Each of those seven photographs, now in the Speed's permanent collection, were horizontally hung wrapping the corner of a wall, very close together. The horizontality of the photographs was intersected by the verticality of the eight stacked drums in Terry Adkins' *Muffled Drums* (from Darkwater) (2003). Adkins created this sculpture in homage to W.E.B. DuBois, whom he would often honor in performances he called recitals. DuBois was instrumental in organizing the NAACP led Silent Protest Parade down 5th Avenue in New York on July 28, 1917, a march to raise awareness about lynchings in East St. Louis just over 100 years before the nationwide protests for Black lives erupted across the globe in response to similar forms of state-sanctioned voilence. The title of Adkins' work was taken from DuBois's autobiographical *Darkwater: Voices from Within the Veil*, penned in 1920.

At all points of the exhibition, sight lines were strongly considered.

Although not located in the same gallery, two artworks framed the portrait of Breonna: *Open Up the Cells*, September 24, 2020 (printed 2021) by Jon P. Cherry in Gallery 2; and *Unarmed* (2020) by Nick Cave in Gallery 4. *Open Up the Cells* depicts a smiling Travis Nagdy screaming into a megaphone, hung on a wall by itself. Standing in the center of the Witness section, you could see both this portrait and the one of Breonna. This placement was extremely intentional. Travis was one of the leaders of the protest movement that emerged in Louisville that year, finding his voice through organizing for justice for Breonna's behalf. He was lost to gun violence in 2020. *Unarmed* is a sculpture of Cave's raised hand, index finger pointing upwards and thumb protruding from the side, cast as if raising a gun. Both a call to action and a memorial for victims of gun violence, Cave made this work after hearing of the killing of Michael Brown by Ferguson police in 2014. The raised hand evocative of the rallying cry, "Hands up, don't shoot!" that echoed around the country, reverberating from crowds of protestors, emboldened by the burgeoning Black Lives Matter movement.

There were moments that I was anxious about the sparse presentation of the portrait, afraid that we owed it to Breonna and her family to include it amongst other significant paintings in the Speed's collection. I shared this concern with Tamika, and, through a series of options for how we could include other artworks in the same room, proposed how the portrait of her daughter could be placed in dialogue with the Kentucky portraits. Tamika reminded me that the portrait was enough. Seeing this moment through her eyes reinforced the impact and importance of calling people into the space of the Museum, of the galleries, and how this calling in essentially had the capacity to simultaneously disarm and dismantle systemic hierarchies embedded within museological systems. It was this same kind of knowledge and unlearning that led to Tamika's voice, in the form of her authored timeline of Breonna's life, occupying the galleries with incredible intention. The story of a daughter's ambition, life goals, personality, and love humanized her beyond the short sighted media portrayals.

3/ Please see page 46 for statement

There were many conversations in the National Panel meeting about where the portrait should be placed. We ultimately decided that, when you walked into the 1927 building, all that you saw on your sightline was the portrait of Breonna. When the painting was uncrated the day before the family private viewing, Stephen Reily and I stood in the doorway to the original Speed building, in awe of how the surface of Sherald's portrait glowed, reflected in the terrazzo floors below.

Other crucial conversations were had with artists, including National Panelist and the invisible architect Amy Sherald, who would pop up on a planning Zoom in a heartbeat to offer guidance or provide support. I'll never forget long phone conversations I had with other artists in the exhibition. Noel W Anderson and I discussed representations of violence in some of his work, and how I made a distinct choice to not include traumatic images in the exhibition. On another day, over coffee, I chatted on the phone with Rashid Johnson about the exhibition and ideas for including a new work from his Anxious Men series; eventually choosing *November 3, 2020* (2020) to complement with Glenn Ligon's *Aftermath* (2020)—both Johnson and Ligon made works to mark the timing of the 2020 Presidential election. A phone call to Sam Gilliam's studio confirmed the possibility of displaying *Carousel Form II* in the round, which, to my knowledge, was the first time it was exhibited this way at the Speed. The drape of the canvas suspended from the ceiling created immense, parabolic forms that echoed the braids in the hairstyles depicted in Lorna Simpson's *Same* (1991).

Gilliam's draped painting was a visual and conceptual anchor. Not unlike Ligon or Johnson's usage of dates as artwork titles in this exhibition, Gilliam's early drape paintings were also titled with dates to commemorate significant moments. *April 4* (1969), for example, was titled for the day Rev. Dr. Martin Luther King, Jr. was assassinated. The archive was just sitting there waiting for me to unearth the fact that Gilliam's painting appeared on the cover of *Art in America* in September 1970, exactly fifty years before Sherald's painting appeared on the cover of *Vanity Fair*, its inclusion accompanying the feature "Black Art in America." Including *Carousel Form II* was not only a dream to consider, but the intentional placement of the painting offered opportunities to frame the text in Alisha Wormsley's *There Are Black People in the Future* (2011-present). Wormsley's protest statement was boldly installed where the wall meets the ceiling, just below the frieze molding in the second gallery; calling to mind iconic text-based works like Jenny Holzer's text-based light projections or Felix Gonzalez-Torres' *Untitled* (1991), a self-portrait in the form of words and dates.[4] Depending on where one stood, the drape of Gilliam's highly colorful painting reframed Wormley's text, creating statements like "There are Black People" and "Are Black People in the Future." In conversations with the Louisville Steering Committee, one woman shared a story of visiting the Speed as a child and leaving with the impression that artwork by Black people was not valued there. She is now a visual artist. While installing *Carousel Form II*, I thought of her story, and imagined how the experience of being enveloped by colorful, painted canvas while sitting on the ground underneath the painting—either experiencing Tricia Hersey's *Guided Meditation for Breonna*, or reading Wormsley's words—could be wildly impactful to a young person's perception of the future:

Your body is sacred.
Our bodies are a site of liberation. Wherever our bodies are, we can find rest. Breathe. Breathe deeper.
Inhale. Hold for four seconds. And slowly exhale. Keep breathing.
Thank you for living.
Thank you for resisting.
Thank you for thriving.
Thank you for resting.[5]

Remembrance

For me, 2021 will forever be remembered as a year marked by the privilege to co-develop a radical approach to collaborative exhibition making. This year showed me that the practice of centering artists and publics in authentic ways is possible and can provide the freedom to build curatorial methodologies and exhibitions strategies that departed from traditional museological approaches. The immense impact of *Promise, Witness, Remembrance* is a testament to what institutions can achieve for artists, publics, and museum staff. There are so many people that made this exhibition possible, and I'd like to give special thanks to Tamika Palmer, Lonita Baker, Stephen Reily, Toya Northington, Evan McMahon, Adrienne Miller and Hannah McAuley, for being the boots on the ground, and the core team that supported and developed this exhibition.

——

4 / "Untitled" The Collection, The Art Institute of Chicago. Accessed January 25, 2022.
5 / Tricia Hersey, "A Guided Meditation" *Promise, Witness, Remembrance*

And to Amy Sherald, and all the artists who trusted and believed in this project. Immense gratitude goes to Mecca Brooks, Theaster Gates, Jon-Sesrie Goff, Raymond Green, LaKeisha Leek, Hank Willis Thomas, and Dr. Allison K. Young for being the dream team advisory panel.

Our impact was only as great as it was because we consistently, insistently came together time and again to discuss, debate, disagree, and decide on a way forward that was best suited to the mission of the Museum and the scope of the project. And the project is about a portrait of Breonna Taylor painted by Amy Sherald, commissioned by Ta-Nehisi Coates, to be on the cover of *Vanity Fair*. But is also about a person whose life was ended tragically and unfairly, whose family is still awaiting the justice they seek and rightfully deserve.

Although our project was unique, the space of exhibition-making can accurately reflect the times that we are living in. It's been an honor to work jointly with a city and her communities and a museum and its publics, to give visibility to a family and their daughter, sister, girlfriend, cousin, niece, granddaughter, and friend. I've also never felt as challenged, inspired, and committed to an exhibition, project, idea, community, story, and family. It changed the way that I want to work in this field. I hope that the unfurling of the process in the enclosed pages serves as a toolkit for how museums can make radical shifts to connect, and respond, to contemporary issues and ideas that reflect the time we are living in. I hope this exhibition is a reminder, a call to action, a catalyst. While just one approach, the reverberations of this project will hopefully be felt for years to come.

— Allison Glenn, Guest Curator, Speed Art Museum

Learning to Let Go
Toya Northington
—

When I talked with Ms. Palmer, Breonna's mother, or Bianca Austin, Breonna's aunt, they often talked about times when Breonna would say, "Apply Pressure." In sports, this is used by coaches to tell their teams to stop the opposition or to force change in the game. In Breonna's chosen profession of nursing, applying pressure to a wound is done to stop the bleeding. It is an immediate, life-saving action; the first step in the healing process, and it is often painful. It's a way to shift momentum from a bleak or dire circumstance to force a positive outcome in your team or patient's favor. Wise beyond her years, Breonna gave us the blueprint for how to effect change and how to heal and nurture your community while doing it. When historians look back at this time and see our progress toward equity, liberation, and justice, they will know that we started with the life and legacy of Breonna Taylor.

I've been asked by many people to share a strategy, method, or formula for how the *Promise, Witness, Remembrance* exhibition came together. As the Community Engagement Strategist, I developed the mechanics of the exhibition specific to its time, location, people, and events; however, much of my methodology already existed, but had not yet been applied to systems within museums or other art institutions. These are the strategies and methods—often used by community organizers and activists—rooted in the voice of the people.

Who are those "people?" They are the people most often left out, disregarded, or dismissed. The people pushed to the margins, out of sight and out of mind. They are Black and Brown, sexual and gender minorities, persons with disabilities, those with low socioeconomic status and so many more unnamed. Since many of their voices and perspectives are unheard, they contain rich content and uncharted approaches to every subject or industry. We will learn something new each time we listen and are able to let go.

Let go of the long-held beliefs that [we] are right and [they] have nothing new to contribute. Let go of thinking that since [their] perspective doesn't come from academics, corporate executives, celebrities, or other people with privileged backgrounds then it is, therefore, inherently inferior. Let go of historical hierarchies in institutions that place value on knowledge inside museums or produced by corporations, yet disregard the knowledge of the working-class people they serve. And lastly, let go of the fear of change.

> *"If the structure does not permit dialogue the structure must be changed."*
> — Source unknown

I offer this philosophy in this book with a warning that this type of work doesn't happen without resistance. The resistance comes from every direction within the system, from the outside, from those that are there to help support the efforts, and sometimes from the very communities you hope to uplift. I encourage you to stay the course. As progress is made, others will join in to carry the load. My goal is for the next generation to not know the pain endured during our current fight for society to recognize our humanity, for them to see our wholeness and truth not just in our pain and trauma, but in our joy, laughter, and peace.

— Toya Northington, Community Engagement Strategist, Speed Art Museum

Raphaela Platow
—

Promise, Witness, Remembrance was an exhibition informed and driven by a tragedy in our community, one that no institution ever wishes to respond to. Breonna Taylor's unjust killing in the wake of other awful murders in the country by official or self-declared police outraged our Louisville community and broke open centuries-old wounds of racial discrimination and violence. The city erupted in months of demonstrations about police reform, racial justice, and the lived inequities in our city.

Following the Speed from the sidelines just before my hiring as director, then Speed Director Stephen Reily and his team asked themselves the urgent question of how an art museum should and could respond to this devastating incident and to community issues deeply rooted, awful, and complex. I observed and was inspired by an institution whose values drove everyone towards action and doing their part in providing what art and art institutions can do: framing, holding space, inviting dialogue, commemorating, seeking truth, bringing together people from different walks of life, being a safe space and brave space, humanizing, documenting, and storytelling.

I learned how last winter, the entire Speed pivoted their attention towards Breonna and her family. Her mother, Tamika Palmer, was invited to collaborate with the invited guest curator, Allison Glenn, the Speed staff, board members, and two steering committees to shape what would become the thoughtful and deeply moving exhibition *Promise, Witness, Remembrance* that evolved around Amy Sherald's powerful portrait of Breonna. Ms. Palmer's ideas and thoughts were the catalyst, driver, and facilitator for the exhibition and her words and memories of a mother shaken by grief, lifted through the deep love of her daughter, imbued the spirit of the project. Framed by works of African American artists and artists of the African diaspora, the exhibition shed a brutal light on the injustices they themselves and their kin experienced and are still experiencing in what has become the United States of America. However, there were also moments of hope, beauty, joy, and transcendence in the show epitomized by Sherald's iconic portrait of Breonna standing, both fierce and tender, and carried by an imagined future that she would never see realized. In addition, it was Ms. Palmer's deeply personal recollections of her daughter's life that created the poetic centerpiece of *Promise, Witness, Remembrance*. Her resilience, her strength, her pain, and her memory of Breonna as a young woman full of life and dreams, echo to this day through the many rooms of our museum and our souls.

In my first few weeks in my new position, I started understanding with greater nuance the unwavering contributions the entire staff, board members, and steering committee members made to this important project. They all continued their day-to-day responsibilities, but additionally all volunteered their unique expertise and time, driven by their personal convictions in support of this exhibition. It is awe-inspiring how everyone came together around the shared purpose of taking action towards truth, and to stake a claim that we as museums ought to be with and of our communities in good times and in bad. And because of our vow to serve, the Speed showed up in an unparalleled way for and through the people of Louisville.

As we continue our urgent journey to be a more equitable, inclusive arts organization that all people can find themselves, their histories, cultures, and experiences reflected in, *Promise, Witness, and Remembrance* has taken on a broader meaning. How, as an art museum, do we remember? Whose stories are we telling and who do we give voice to? How do we witness and acknowledge both our pasts and our presents? And how do we imagine our futures? That, in my mind, must be our Speed Promise moving forward: to aspire to remember, witness, and include in our speculative futures all people in our communities through art and artists and more fully become Speed for All.

— Raphaela Platow, Director, Speed Art Museum

Introducing the Key Players

It's important to note that the entire exhibition was led by Black women: myself; the Speed's community engagement strategist, Toya Northington; Tamika Palmer; her lawyer, Lonita Baker. Amy Sherald has been a very important force. The coacquisition of her portrait of Breonna Taylor by the Speed and the Smithsonian will have a positive impact on the Louisville community. And of course, Breonna Taylor herself is at the center of this conversation. And the Louisville protests were led by Black women.[1]

— ALLISON GLENN

AMY SHERALD

ARTIST, "BREONNA TAYLOR"

ABOUT AMY

Born in Columbus, Georgia, and now based in the New York City area, Amy Sherald documents contemporary African American experience in the United States through arresting, otherworldly figurative paintings. Sherald engages with the history of photography and portraiture, inviting viewers to participate in a more complex debate about accepted notions of race and representation, and to situate Black heritage centrally in American art.

Sherald received her MFA in painting from Maryland Institute College of Art and BA in painting from Clark-Atlanta University. Sherald was the first woman and first African-American to ever receive the grand prize in the 2016 Outwin Boochever Portrait Competition from the National Portrait Gallery in Washington D.C.; she also received the 2017 Anonymous Was A Woman award and the 2019 Smithsonian Ingenuity Award. In 2018, Sherald was selected by First Lady Michelle Obama to paint her portrait as an official commission for the National Portrait Gallery. Sherald's work is held in public collections such as the Whitney Museum of American Art, New York, NY; the Los Angeles County Museum of Art, Los Angeles, CA; Museum of Fine Arts Boston, Boston, MA; the Crystal Bridges Museum of American Art, Bentonville, AR; Embassy of the United States, Dakar, Senegal; Smithsonian National Museum of African American History and Culture, Washington, DC; Smithsonian National Portrait Gallery, Washington, DC; and Nasher Museum of Art, Durham, NC.

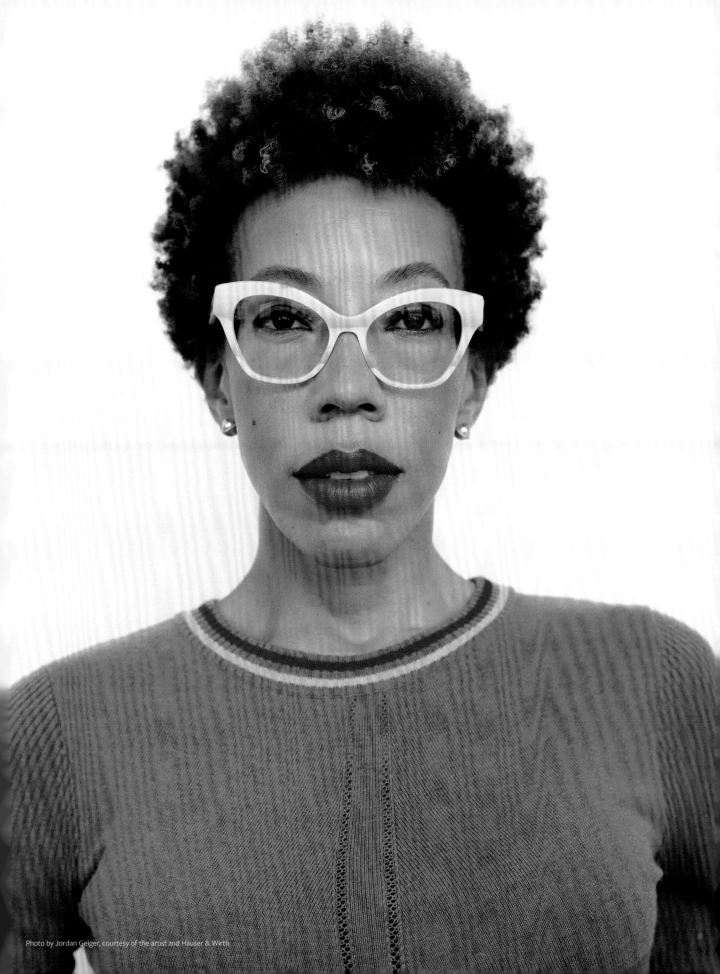

Photo by Jordan Geiger, courtesy of the artist and Hauser & Wirth

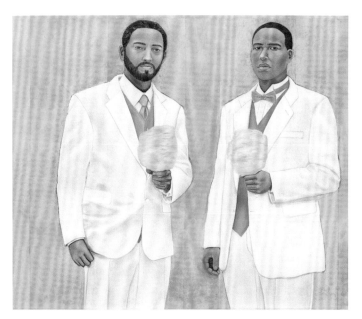

Amy Sherald
American, born 1973

High Yella Masterpiece: We Ain't No Cotton Pickin' Negroes,
Oil on canvas, 2011

This painting featured in the Speed's 2017 exhibition, *Southern Accent: Seeking the American South in Contemporary Art.* The Green Family Art Foundation. Courtesy of the artist and Hauser & Wirth, New York. © Amy Sherald.

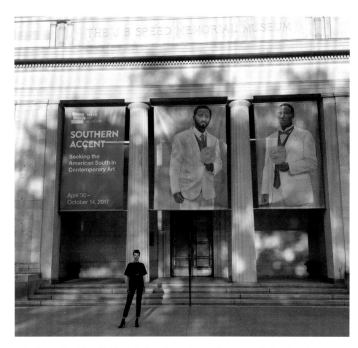

In April 2017 Amy Sherald visited the Speed to see her work presented in *Southern Accent* and on banners on the Museum's original façade, where her work would appear again in 2021.

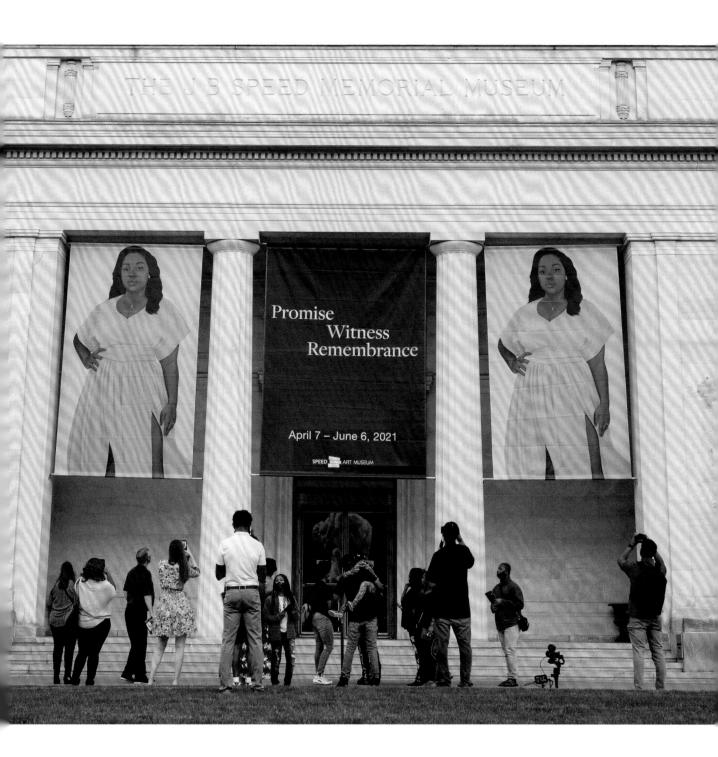

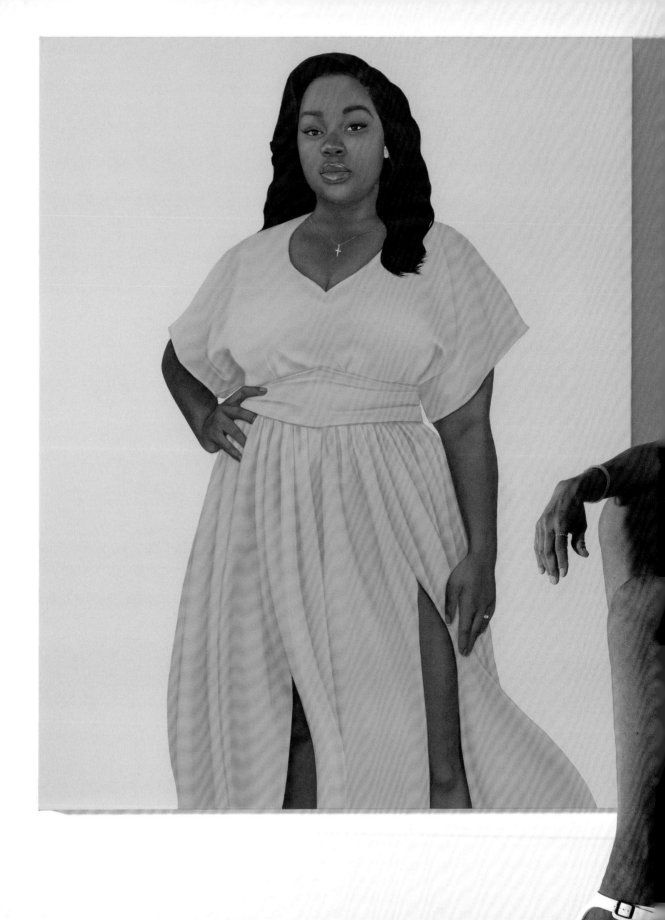

When [Ta-Nehisi] Coates asked Sherald to paint Taylor, the artist said she 'saw it as an opportunity to codify the moment." Sherald, 48, who had a heart transplant in 2012, had been unable to participate in last summer's protests amid the pandemic. The painting gave her the chance "to have a voice and to give Breonna Taylor a voice."

— *NEW YORK TIMES* [2]

AMY SHERALD: I felt that it should live out in the world. . . . I started to think about her hometown and how maybe this painting could be a Balm in Gilead for Louisville.[3]

STEPHEN REILY: We spent a lot of the summer looking internally, like a lot of institutions, articulating our own commitments to racial equity, and then, in late August, we saw, like the rest of the world, the cover of *Vanity Fair* magazine, of Amy Sherald's remarkable portrait of Louisville's Breonna Taylor. We started to have a vision of how art could serve our city in a time of need.[4]

Once we saw Amy Sherald's portrait, we reached out to Amy—we had shown her art in the past before she became world famous for the Michelle Obama portrait—and she agreed to loan the painting to Louisville.[5]

TAMIKA PALMER

MOTHER OF BREONNA TAYLOR

ABOUT TAMIKA

Tamika Palmer grew up surrounded by extended family in Grand Rapids, Michigan. Popular in school, she loved to Double Dutch, a hobby she would take up with her daughters. She got her first job as a babysitter at 15 and later worked as a nurse's aide in nursing homes. Her first daughter, Breonna Taylor, was born on June 5, 1993 and her second daughter, Ju'Niyah Palmer, was born in 1999. A passionate motorcyclist (whose motorcycle club is called "No Haterz"), Tamika Palmer moved to Louisville with her daughters in 2007 after visiting the city on a biking tour.

Palmer's life changed forever in the early hours of March 13, 2020, when she received a late-night call from her daughter's boyfriend, Kenneth Walker, who told her that someone had kicked in the door of Breonna's apartment and shot her. From that moment on, and as she learned more about the botched police raid that led to Breonna Taylor's death, Palmer became a leader in the fight for justice for her daughter and for others. Within six months after Breonna's killing, Palmer and her family entered into a settlement with the city of Louisville, the first-ever such settlement to include not just financial compensation for her family, but a commitment to specific police reforms aimed at preventing deaths like Breonna's in the future. Palmer remains a leading voice in the national fight for justice for her daughter and victims of gun and police violence everywhere.

Photo by Xavier Burrell

The key stakeholder was Ms. Palmer . . .

Whatever she says, goes.[6]

— AMY SHERALD

STEPHEN REILY: We then needed the support of Breonna Taylor's family. So, we reached out to another remarkable woman, Tamika Palmer—Breonna's mother—who has become an incredible leader in the fight for justice over her daughter's killing, and for others like it. She was excited about the opportunity, and, from the beginning, felt that she liked the portrait Amy had painted because it depicted what she called her daughter's "uplifting spirit." We realized then that we had the opportunity to try to do justice to at least one life that had been lost so tragically.[7]

Ms. Palmer . . . was the north star of the exhibit.[8]

ALLISON GLENN: It was important to get her trust more than anything. This is her daughter and the story about her daughter within the context of an exhibition, which is the field that I work within, the field of contemporary art and museum work. And stepping into the space of telling a story that is focused on a portrait that was painted of her daughter, it was extremely important to gain her trust. Everything else would follow, but that was the most critical thing.[9]

TAMIKA PALMER: A peaceful place, just to be able to come to this place and just be filled with her spirit . . . I was in awe—just the thought that people who don't even know her take time out of their day to draw something of her, or even just as simple as her name. And to see it all come together is just a blessing.[10]

ALLISON GLENN: For me, the most important thing, the successful moment in this exhibition, was that Tamika Palmer was pleased. She said she felt the exhibition was a blessing and that she felt peaceful walking into the space and seeing Breonna's portrait and her timeline—I'm paraphrasing her. She felt seen and she felt heard. That, to me, was the greatest success.[11]

ALLISON GLENN

GUEST CURATOR, SPEED ART MUSEUM

ABOUT ALLISON

Allison Glenn is a curator and writer deeply invested in working closely with artists to develop ideas, artworks, and exhibitions that respond to and transform our understanding of the world. Glenn's curatorial work focuses on the intersection of art and publics, through public art, biennials, special projects, and major new commissions by leading contemporary artists.

She is one of the curators of Counterpublic 2023, a St. Louis-based triennial. Previous curatorial roles include Senior Curator and Director of Public Art at the Contemporary Arts Museum Houston; Associate Curator, contemporary art at Crystal Bridges Museum of American Art; curatorial associate and publications manager for international art triennial Prospect New Orleans, *Prospect.4: The Lotus in Spite of the Swamp*; and a Curatorial Fellow with the City of Chicago Department of Cultural Affairs and Special Events.

Her writing has been featured in catalogs published by The Los Angeles County Museum of Art, Prospect New Orleans, Princeton Architectural Press, the Studio Museum in Harlem. She has contributed to *Artforum, ART PAPERS, Hyperallergic, Fresh Art International, ART21 Magazine*, and *Gulf Coast Quarterly*, amongst others. Glenn received dual Master's degrees from the School of the Art Institute of Chicago in Modern Art History, Theory, and Criticism and Arts Administration and Policy, and a Bachelor of Fine Art Photography with a co-major in Urban Studies from Wayne State University.

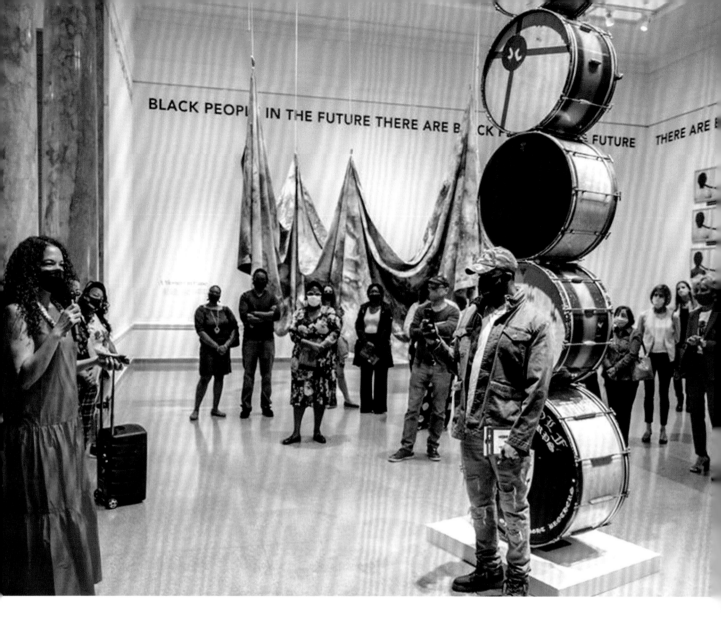

The exhibition in Louisville just made sense,
in terms of my trajectory and the work that
has become very important to me and
my curatorial practice.[12]

— ALLISON GLENN

STEPHEN REILY: We needed a curator. The Museum is in a gap, we don't have a contemporary curator right now, and we don't have a Black curator. It was very important for us to get someone who brought those qualities, but also someone who understood Amy Sherald's role in art history, understood the history of both contemporary and historic Black portraiture, and we were lucky enough to find Allison. In fact, it was a colleague of ours, another curator [Alice Gray Stites, Chief Curator and Museum Director, 21c Museum Hotel], recommended her, and then I was also in conversation with Thelma Golden— the unbelievable museum leader from the [Studio] Museum in Harlem—and Amy herself. And they all felt that Allison was the right person, so I reached out with a blind email— I had never met Allison—an email to her at Crystal Bridges, told her the pieces we had in place, that we had Amy on board, that Tamika Palmer and Breonna's family were involved as well. We also had support from Darren Walker at the Ford Foundation—who had encouraged me and our Museum to be ambitious in serving our community with art. We were delighted and fortunate that Allison said yes, that Crystal Bridges agreed to work with her schedule so that she could work on our project, and she joined our team in about early-to-mid December of 2020.[13]

ALLISON GLENN: I was invited by the Director of the Speed Museum, Stephen Reily, who sent me an email outlining the project as he saw it and letting me know that if I took this on, I'd be working closely with [Breonna Taylor's mother] Tamika Palmer as a key stakeholder. That made it clear to me that the Museum's priorities were in line. I had a few meetings with Stephen and the team at the Speed, and it became clear very quickly that the Museum had a lot of ambition for the project.[14]

I think, had he presented this any other way, I probably would have been a bit reticent. Because we've seen our colleagues with good intentions really, kind of, falter around this topic of gun violence, police brutality, and really, how to memorialize or commemorate a life within the space of an exhibition. And since Breonna's mother would have to be on board . . . it felt like the right way to do it.[15]

All the elements came together . . . I learned about the scope of the exhibition, the unveiling of the portrait and the support from the Taylor family, and it was all so thoughtful. I couldn't say no. We had never met before, but I just knew I had to do this. Breonna Taylor was just one of many who are killed by the police and don't receive the justice they deserve. This is all part of Breonna Taylor's story.[16]

What's always been very important to me is working with artists from various different perspectives, walks of life. I tend to be very much drawn to artist with different backgrounds. Artists to me, help us understand different ways of seeing the world.[17]

I realized that this project reaffirmed for me that I am most successful working close to the ground with diverse publics. That's not only where my strength is, that's also where my heart is. That's where the work feels rewarding. It's challenging institutions to radically rethink the way they present ideas through exhibitions, through solo projects, through conversations, and continuing to imagine worlds where this kind of terror doesn't exist.[18]

LEFT & BELOW
Photo by Jon Cherry

NATIONAL ADVISORY PANEL

—

I knew I needed a cabinet of people
I could trust, whom I could be vulnerable
with, who could point out blind spots, and
who knew me and my practice.[19]

— ALLISON GLENN

ALLISON GLENN: Then I convened a national panel. I was very intentional in developing the panel because of my particular position: I lost my brother to gun violence about a year and a half ago. It doesn't need to overshadow this story, but it's important to mention, because it informs a lot. I wanted a cabinet of advisers that could relate on a personal level.[20]

I was nervous and afraid of the potential of having any of my own blind spots. So, I knew that if I assembled a team that I could be honest and vulnerable with, that they would help me understand what I don't know. Because I wouldn't know it without them.[21]

I was very sensitive to the fact that I don't live in Louisville. I'm not from Louisville. And I wanted to create this framework of solidarity. The national panel was a way of saying, "We, on a national level, stand in solidarity with you." I respect the city and what it's gone through so much that I'm not going to show up as just me. I'm going to stand in concert with a group of people who have dealt with these issues before.[22]

A lot of the reasons why I put this panel together was because I wanted to respect the subject matter as a curator coming from outside of an institution, outside of a city, trying to be very sensitive, and so this team . . . really worked with me to help me understand the strengths of the curatorial framework, and then some of the challenges. And you know the strengths and challenges were that it took a lot of listening and there were many key stakeholders.[23]

I wanted to be sure that I also had professionals who either themselves had worked with a mother who was dealing with police brutality and gun violence, and who had successfully worked in the art world with the family and the mother.[24]

MECCA BROOKS
ARTS STRATEGIST

MECCA BROOKS: Maybe about 12 years ago . . . I had a good friend of mine from high school that was murdered by police in South Jersey. He was at the convenience store waiting for a ride and he was mentally ill. . . . he was dead before they got him in a cop car. The impact for me is the opportunity to reflect on another part of it that's not talked about—mental illness, and how there is no "look" for it. And the idea of when it comes to police brutality, what threat looks like . . . That was how I really entered this space, to be in the process of not only highlighting Breonna Taylor and her mother but the promise, witness, and remembrance of all the stories.[25]

—

Mecca Brooks is a cultural producer and arts strategist committed to driving connectedness in collaborative spaces. She is currently a team member at Hank Willis Thomas Studios. Previous roles and affiliations include Associate Consultant at TCC Group; Creative Consultants with Revival Arts Collective, Associate Director of ArtUP / School Partnerships at the Center for Community Partnerships / Columbia College Chicago, Lead Farmer at Bronzeville Rooftop Farm.

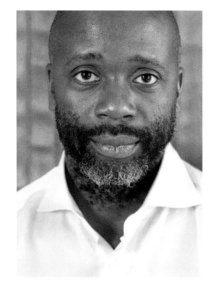

THEASTER GATES
ARTIST AND FOUNDER & EXECUTIVE
DIRECTOR OF REBUILD FOUNDATION

ALLISON GLENN: Theaster was my first phone call. Namely because of the work he's done with the Tamir Rice Foundation . . . I knew that I was gonna be working with Breonna's mother. I wanted to understand what I needed to be sensitive to, and what my responsibility was, and what my role was, and I wanted to hear it from someone who had done it successfully.[26]

I called him first, and I was like, "I'm not sure how I'm going to approach this, but I need you." And he was like, "I'm here for you."[27]

—

Theaster Gates lives and works in Chicago. Gates creates works that engage with space theory and land development, sculpture and performance. Gates is a professor at the University of Chicago in the Department of Visual Arts and the Harris School of Public Policy, and is Distinguished Visiting Artist and Director of Artist Initiatives at the Lunder Institute for American Art at Colby College.

In this exhibition [what] was so important and so crucial, and what you really held onto [in] *Promise, Witness, Remembrance,* is that this is a celebration of life.

— JON-SESRIE GOFF

JON-SESRIE GOFF
MULTIDISCIPLINARY FILMMAKER,
CURATOR, AND ARTS ADMINISTRATOR

RAYMOND GREEN
RETIRED MILITARY OFFICER AND
COUSIN OF ALTON STERLING

LA KEISHA LEEK
ARTIST ADVOCATE AND
COUSIN OF TRAYVON MARTIN

JON-SESRIE GOFF: In this exhibition [what] was so important and so crucial, and what you really held onto [in] *Promise, Witness, Remembrance,* is that this is a celebration of life. For those of us who have a spiritual belief, we know that the spirits lives on. In Breonna's spirit and the spirit of so many—too many to even name—lives on through this type of work, in this type of community building.[28]

———

Jon-Sesrie Goff is a multidisciplinary artist, curator, and arts administrator. With extensive experience in media and film production, Jon has offered his lens to a variety of projects spanning many genres including the award-winning documentaries Out in the Night *(*POV, Logo 2015*),* Evolution of a Criminal *(*Independent Lens 2015*) and* Spit on the Broom *(2019). He is in production for his feature-length documentary,* After Sherman, *which has received support from JustFilms, Firelight Media, International Documentary Association, Black Public Media, Jerome Foundation, Gucci / Tribeca Film Institute, and the Sundance Institute.*

ALLISON GLENN: Raymond is a friend here in northwest Arkansas, and his cousin is Alton Sterling. We've always joked and called him a lay person, because he's not an art person, he's a retired military officer, and went to West Point. So, there's a lot about service, and also loss, that's important in his role. And the fact that he's outside of the art world.[29]

———

Raymond Green was born in Baton Rouge, LA, and currently works and resides in Rogers, AR. He is a results-driven leader and retired Army Officer who specializes in organizational leadership and is now a Senior Account Executive for Procter & Gamble.

ALLISON GLENN: La Keisha became a friend after we worked together with Theaster [Gates]. I first started working with him around the time that her cousin Trayvon Martin was murdered, and she was struggling with how to find her voice, because the protests were all going on and all raging, and she had a bit of a difficulty balancing the personal with the universal and ubiquitous. We worked through it with a few different exhibitions, and a catalog that she developed. So, I really wanted to offer her a space here, to take what she learned and apply it to this project.[30]

———

La Keisha Leek is an administrator and artist advocate based in Chicago, where she currently serves as Administrator for Grants Management at the John D. and Catherine T. MacArthur Foundation. In 2019 she created L'Louise Arts Foundation to support the growth of early career Chicago-based artists and arts workers of color by providing thought partnership and economic resources. She is a founding member of Candor Collective and co-founder of The Petty Biennial with collaborator Sadie Woods.

I thought it felt pretty
special to come together
as a group of artists and
as a group of educators
and put our heads
together to think about
how we could make this
into a bigger moment,
and how we could allow a
space for people to have
conversation, to process
everything that's been
happening.[31]

— AMY SHERALD

AMY SHERALD
PAINTER

AMY SHERALD: I always say that I'm a
painter and that's my first language—
I understand the healing aspects of art
and how it can sit within a community . . .
I thought that we were really successful
in pulling off something—between all
of us—that allowed the Museum to
represent the community and live up
to the moment that is happening right
now and that happened in Louisville.[32]

—

*Born in Columbus, GA, Amy Sherald documents
contemporary African American experience in
the United States through arresting, otherworldly
portraits. Sherald was the first woman and first
African American ever to win the 2016 Outwin
Boochever Portrait Competition from the National
Portrait Gallery in Washington D.C.; in February
2018, the museum unveiled her portrait of former
First Lady Michelle Obama.*

HANK WILLIS THOMAS
MULTIDISCIPLINARY ARTIST,
CO-FOUNDER OF THE WIDE AWAKES
AND FOR FREEDOMS

ALLISON GLENN: I included Hank for
many reasons. Hank is such a guiding
voice in conversations about the personal
in the space of contemporary art. And
he has been so incredible in how he
uses the space of his practice to talk
about real societal issues in a way that
is accessible and meaningful.[33]

Twenty years ago, Hank lost his cousin
to gun violence and continues to make
work about it, and also be an outspoken
advocate for visibility and awareness
of loss.[34]

—

*Hank Willis Thomas is a conceptual artist working
primarily with themes related to perspective,
identity, commodity, media, and popular culture.
His work has been exhibited throughout the United
States and abroad. Thomas is the recipient of
numerous national awards, and is a former member
of the New York City Public Design Commission.*

DR. ALLISON K. YOUNG
ART HISTORIAN

ALLISON GLENN: Allison Young being an art historian in Louisiana and someone I had worked with before, she's very thoughtful and I thought it would be good to have another curatorial voice to balance it out.[35]

DR. ALLISON K. YOUNG: There's a lot of expertise and experience on this panel, but I think it is important to know that the product of the discussions are going to reach the people who are closest to the heart of the project. They're also being consulted, and knowing that the exhibition is really the result of a process of your listening and consulting, being in dialogue, and sitting with all the feedback that you're receiving.[36]

—

Dr. Allison K. Young is Assistant Professor of Art History at Louisiana State University A&M in Baton Rouge. Young's research focuses on African and African-Diasporic artists and art histories. Before joining LSU, Young was Andrew W. Mellon Foundation Fellow for Modern and Contemporary Art at the New Orleans Museum of Art.

That was how I really entered this space, to be able to be in the process of not only highlighting Breonna Taylor and her mother but the promise, witness, and remembrance of all the stories.

— MECCA BROOKS

TOYA NORTHINGTON

COMMUNITY ENGAGEMENT STRATEGIST

ABOUT TOYA

Toya Northington graduated with a Bachelor's degree in Fine Art from Georgia State University and also holds a MSc in Social Work from the University of Louisville. She has exhibited in group and solo exhibitions in Georgia and Kentucky, and has recently been involved in a number of public art projects in Louisville. Working in mixed media and across disciplines, Toya speaks of her work as pushing back at societal expectations, as an act of resistance. As a feminist and social activist she states, "my work is an acknowledgment of traumas too often experienced by women and a means to foster healing and resilience from them." Toya is the recipient of Art Meets Activism, Artist Enrichment, and The Special grants from the Kentucky Foundation for Women. In 2012 she founded artThrust, a mental health and social justice organization that empowers youth through art. She is currently the Community Engagement Strategist at the Speed Art Museum.

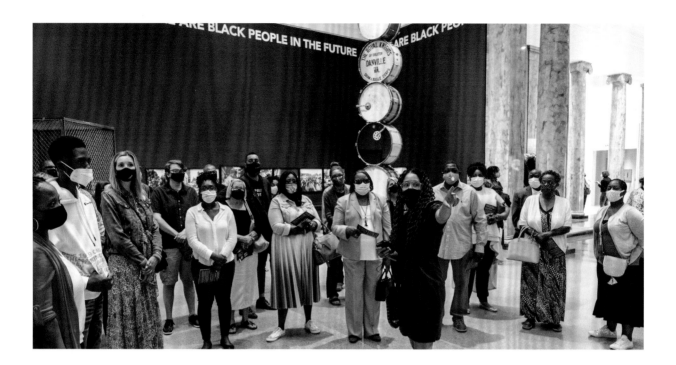

TOYA NORTHINGTON: My social practice sits at the intersections of art, mental health, and social justice. I have been using art for healing, empowerment, and to address trauma for about 10 years. First, with teen girls, then with sexual and gender minorities. I find it to be a successful therapy alternative for people that are opposed to therapy due to stigma or personal beliefs, but also a beneficial compliment to other therapeutic practices. I believe in art for art's sake, but it's so powerful for people to be transformed in the process of creating. I am passionate about sharing what I do and using collaboration as the foundation to develop evidence-based practices to inform future art-based services for other practitioners in museums, public health, and those in social work fields to inform their work with marginalized communities in the future.[37]

STEPHEN REILY: Toya has been working alongside of us at the Speed for a couple of years now. She came to the Speed with an incredible background, with a Master's in social work, her own career as an artist and researcher, and the founder of an arts-oriented nonprofit called artThrust. Toya immediately put our Community Engagement work into high gear . . . She had a full plate, but I knew that Toya was the one person within our colleague base who could manage the Community Engagement work for our current exhibit *Promise, Witness, Remembrance.*[38]

TOYA NORTHINGTON: In my day job, I am the Community Outreach Manager. I design, implement and manage all of the community outreach programs and staff including: *Speed for All,* the free membership program for anyone that wants a membership, but feels cost is a barrier; *Community Connections, our* art-based workshops that amplify the voices of marginalized groups. I also founded the *Community Connections Artist-in-Residence* through an *Our Town* NEA grant. That program allows artists from the West End of Louisville to work within their neighborhood doing art workshops and interventions with other residents about topics and themes they feel are most pressing in their community.[39]

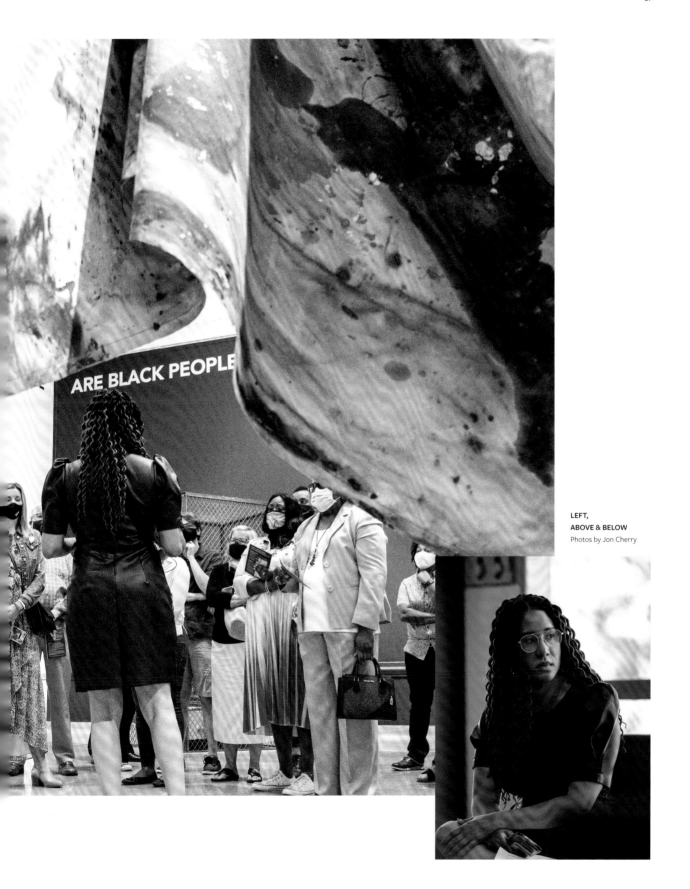

ARE BLACK PEOPLE

**LEFT,
ABOVE & BELOW**
Photos by Jon Cherry

COMMUNITY ENGAGEMENT STEERING & RESEARCH COMMITTEES

———

Community Engagement Steering Committee:

Bianca Austin

Tawana Bain

Ashley Cathey

Tiffany Farmer, LMFT

Nicole Hayden

Keturah J. Herron

Lance G. Newman II

Lopa Mehrotra

Sharlis N. Montgomery

Milly Martin

Ramona Dallum Lindsey

Ju'Niyah Palmer

Mark Pence

Dr. Brandy Kelly Pryor

Michael Wade Smith, EdD, MBA

Linda Sarsour

Antonio Taylor

Stacey Wade

Research Committee:

Dr. Maurice N. Gattis

Dr. Lesley Harris

Dr. Jelani Kerr

Dr. Emma Sterett Hong

Research Team:

Stephanie Henry, BSW, *Research Assistant*

Gaberiel Jones, Jr., PhD, MPH, *Photovoice Facilitator*

Sirene Martin, *Photovoice Facilitator*

Celes Smith, MSSW, LCSW, *Photovoice Facilitator*

Specialized Committees:

Mental Health:

Steven D. Kniffley Jr., PsyD MPA ABPR

Strategic Planning:

SteVon Edwards

Arts Activism & Education:

William Cordova

RIGHT

Photo by Anthony Northington

Pictured (left to right): Mark Pence, Keturah Herron, Toya Northington, Dr. Brandy Kelly Prior, Lopa Mehrotra, Ramona Dallum Lindsey, Nicole Hayden, Lance Newman, Sharlis Montgomery

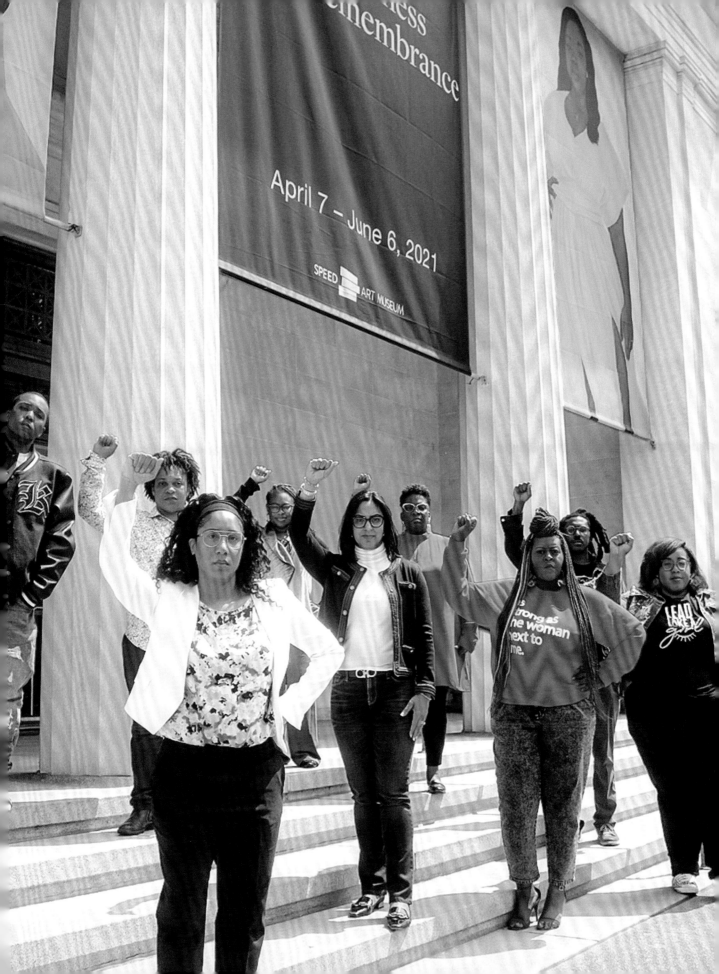

Promise, Witness, Remembrance is more than an exhibition. Under the direction of Toya Northington, it is a space for Black artists, leaders, activists, and academics to partner with the Museum's leadership, trustees, and curators to witness Black brilliance.[47]

— RAMONA DALLUM LINDSEY,
COMMUNITY ENGAGEMENT STEERING COMMITTEE MEMBER

TOYA NORTHINGTON: I knew bringing the portrait here represented so much to so many people. It was my responsibility in believing in art healing and art activism that if we could do this, we could make this community feel seen, heard and valued, and that would bring feelings of affirmation.[40]

—

The work was also supported by two external committees that I founded and led, the Community Engagement Steering Committee—a diverse group of BIPOC from various backgrounds and disciplines—and the Research Committee, a professional group of researchers from University of Louisville School of Public Health and Social Work, in conjunction with Virginia Commonwealth University School of Social Work. That was the first time I was able to work so closely with others outside the institution. Because we had so many skilled stakeholders working on this project, I was able to cheat time and accomplish things in lightning, supernatural speed.[41]

We had members from the protest community. . . . I had people from research communities. I had people who were academics. I had people that were organizational leaders, people in mental health, people who were just active in the community. . . . And then we had Breonna Taylor's family. That was key, because we can think of all kinds of things that sound good to us, but at the end of the day this was for Breonna, and Breonna's family. And we wanted to make sure that we represented her in an authentic way.[42]

—

Starting this project, I knew that there's a couple of hurdles or pitfalls that large institutions fall into when you do these big projects—especially if it's something around diversity or social practice—they'll hire someone, there'll be this Black elite person and that person will represent all the Black community or whatever that community they're seeking to reach. And with this particular subject and issue, and knowing how Breonna Taylor touched our community, I knew that was too great for me to

take on. I'm one person. I'm one perspective, I'm one opinion with my own methods. From the beginning I knew it was important to pull together a diverse committee—not just kind of the superficial community that just has the name, but no authority or no autonomy over the project—but a real Steering Committee with different perspectives, different ages, different backgrounds, different disciplines, even no discipline. Community members that have perspectives and opinions that you may not have on a lot of committees, that have a lot to say and a lot to add. And so I put together a wish list of what type of voices need to be at the table. It couldn't be perfect, right? I couldn't have everyone represented, but I wanted to get as many people at the table as possible.[43]
—

Before joining the Steering Committee, I spoke with everyone individually to answer specific questions or concerns. Their identities were anonymous throughout the process and no one knew all the members inside or outside the institution. The committee voted to make their names public. The space was intentionally BIPOC, so people felt they were in a safe and affirming space when we were together and all members were treated with the same value and respect during discussions. Both the Steering Committee and the Research Committee operated with full autonomy. The research also gathered feedback from other BIPOC people in Greater Louisville asking for their feelings about the work that we are doing, and what they would like to see in the programming around the exhibition.[44]
—

It can only be a model if people commit to the work. And sometimes that's just one conversation at a time, really listening to and hearing people's concerns and dreams and thinking how we can be best aligned with that.

Why mount an exhibition that reaches so far and resonates with so many people, if we weren't going to bring the parts of the community that could benefit the most?

And, really, what's happened with this exhibition is that it's been this great affirming space. It's heavy. The content is heavy. And it's reflective and its emotional. But at the same time, when people come in from the community, they see themselves, or they see a piece of their experience.

And so I didn't want that to be reserved for the art community and the usual people that come to see these exhibitions. I wanted it to be for everybody.[45]
—

The interesting thing is, before I got started, I did speak with some parts of the Speed community—talking with the Board of Governors, checking in with the other Trustees—and what I found was that a lot of our feelings, fears, dreams, and hopes surrounding the exhibition are very similar. There's not a big gap between what the Speed is looking to accomplish, and what the community would like to see through the exhibition. Believe it or not, there was so much overlap, and I can attest to the unifying power of a collective consciousness, a set of beliefs and moral atittudes that are bigger than a single family or event. And that can be a force within a family or society, or something bigger, maybe an event. For us, I really feel that being here and being present in Louisville—whether being part of the Black experience, or just witnessing outside the Black experience—has been a collective trauma.[46]

TOYA NORTHINGTON: This exhibition has been a way to make the invisible, recognizable and intangible, real. It is an emotional exhibition that was bold and direct in its delivery of the truth very much rooted in the Black perspective. What we found is that it allowed not only the Black community to see themselves, but it also allowed others to witness their truth in a way that was self-reflective. It is progress that these things can co-exist. We cannot move on together if we continue to ignore the pain and darkness of our past that influences things happening in the present lives of our fellow citizens. For those of us that have experienced the combined traumas of racism, violence and inequity, we cannot heal or organize against injustice if we cannot find ways to process our feeling towards the things that hurt us in healthy ways. This exhibition provided the platform to do both.[48]

Exhibition Development

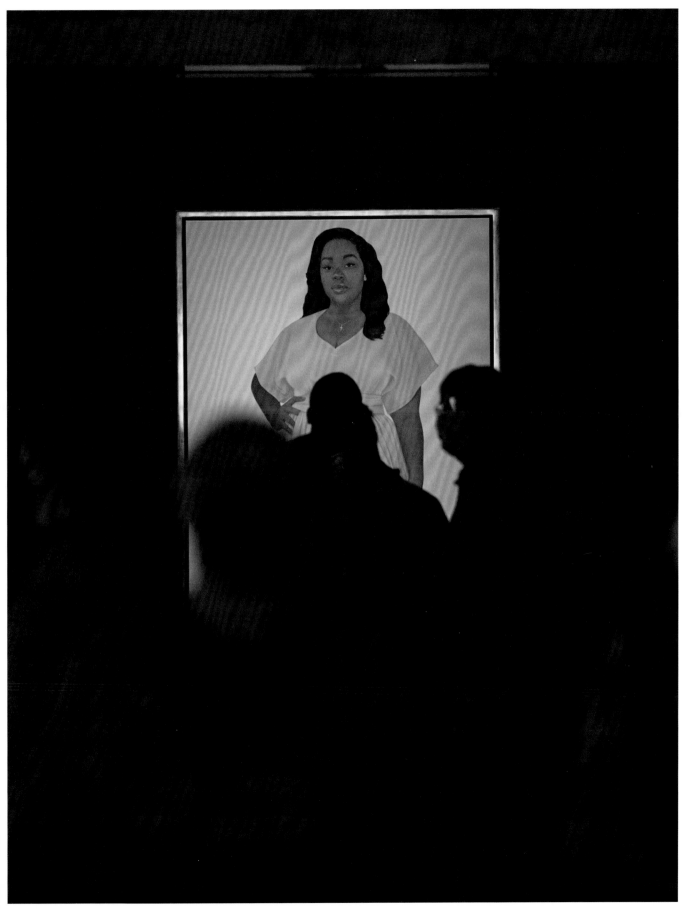

Photo by Jon Cherry

Curatorial
Framework

WHAT CAN AN EXHIBITION DO?

ALLISON GLENN: I have said this and I feel this way: there's a lot the exhibition cannot do. So I wanted to start in that place of, this is not going to change things. You know, exhibitions respond, artists help us see and understand contemporary culture. So I wanted to make sure that we weren't trying to do more than what the space of an exhibition in a museum can do while also doing more than maybe museums attempt to do—engaging a few different committees, engaging with the family.[49]

[Glenn] also looked back at journalist Ta-Nehisi Coates' book *'Between the World and Me'*, which touches on "themes of loss and the inequity of certain people in front of the eyes of the law as citizens," Glenn says. His insights seemed particularly relevant as Coates had invited Sherald to paint Taylor's portrait in his role as guest editor of *Vanity Fair*. In his writing, Coates talks about parents and the sacrifices they make for their children. Glenn says she thought about the "weight of that," and "all the care that goes into a life and then having that life abruptly taken." -Barron's[50]

ALLISON GLENN: I made a few distinct choices, and one was that I wasn't going to show any traumatic imagery, because I don't think people need to be retraumatized. I wanted to provide a platform for people to feel—and by people, I mean visitors, but also the Louisville community—to feel seen.[51]

STEPHEN REILY: I think our goal is to help the community—through art—feel whatever they need to feel. It's not our job to tell them what to feel but I think there is a need to grieve in Louisville and there is a need for each person to make sense of what we've been through and how we can find a way forward.[52]

ALLISON GLENN: Art has the opportunity for people to process. There's a quote as I was developing the exhibition, which read: 'In order for hurt to heal, hurt has to be heard.' I'm not assuming that this exhibition can heal the community, but creating space for people within a museum, for those who historically have not felt included, this space is for them. Inroads to this conversation can build more trust. I'm not a legislator or politician but I can do these things with the exhibition, I hope that's what this does.[53]

Promise

What promises do you feel compelled to make after visiting this exhibition?

I came to see this exhibit
with my oldest daughter. She is
one of my 3 beautiful black daughters.
I choke back anger and tears, TORN...
As a father I promise to protect and
nurture, to think that I would eve,
fail to keep that promise ... I WILL NOT!

Promise
 Witness
 Remembrance

Witness

What have you witnessed in the past year?
What actions are you taking to enact change?

We are in a time of
 Reckoning
So much pain and loss has
filled our lives, some newly
surfacing or arriving to conscious-
ness for new witnesses.
 We must grieve and we must
Heal to build a new our HEALTH
 People and Planet

Promise
 Witness
 Remembrance

EKB

SPEED ART MUSEUM

Remembrance

How are you celebrating Breonna Taylor's life and keeping her memory alive?

this exhibit allows us
to grieve - thank you
i celebrate breonna by
prioritizing black
women's voices and
perspective.

Promise
 Witness
 Remembrance

SPEED ART MUSEUM

I remember a moment. . . . being reminded again to
ground myself in her guidance and in her voice.
And ground myself in that conversation.[57]

— ALLISON GLENN

THE TITLE

ALLISON GLENN: An exhibition is one moment. It's temporal, and it cannot hold everything. So I wanted to align with Tamika Palmer and understand what she thought the exhibition could do, what it could mean for her and her daughter's legacy. And Ms. Palmer is very clear. She is very generous. She is very kind, and she is very forthcoming about what she wants. I developed the exhibition's three sections from a text message she sent me. She didn't say, "Promise, witness, remembrance," but I inferred those terms from her message, and they became the title of the exhibition and the curatorial framework.[54]

—

This was [Ms. Palmer's] reply:

"This exhibition will continue to do what Bre has always done for us and that is to continue to bring people together only this time, people are wanting to learn her story and to continue to stand for her, and even celebrate how she changed the world; the mark that she left upon all of us, the struggles we went and are continuing to go through to get justice for her, and the laws and policies that were changed because of the injustice that she experienced."

And from this reply, I identified three opportunities to create a framework, and one was "the mark she left upon all of us," and that, for me, feels like a promise. The promise of a life. The promise of a human. And then "The struggles we went and are continuing to go through to get justice for her," I wanted to think about, and witness that. And then, "The laws and policies that were changed because of the injustice that she experienced." That completes the theme of promise, witness, and remembrance to me.[55]

STEPHEN REILY: Allison interpreted Tamika's answer into these themes, which again, addressed Allison's goal that the exhibit be both personal, local, and national. The promise of a young life, when it's lost, how you witness and then remember her, those lives. On a local level, the promise to "protect and serve," how do you witness that failure, and then how do you remember that. And on a national level, what are our nation's promises, who are those included and protected within those promises, how do we witness those when we don't live up to them, and how do we remember them.[56]

Promise
Witness
Remembrance

↑

GALLERIES 1 – 5

Promise

MAY 26TH 2021

What promises do you feel compelled to make after visiting this exhibition?

I PROMISE to do my best to make sure that the "American Promise" is no longer a dream deferred for large segments of our population.

I will not be complicit in a system set up to favor others while building itself on the backs of those it is oppressing.

Promise
Witness
Remembrance

SPEED ART MUSEUM

Witness

What have you witnessed in the past year?
What actions are you taking to enact change?

I will bear witness of my people's beauty, creativity, innovation, and Resilence in the face of this country's cruelty.

Arrest the cops that Killed Breonna Taylor!

ess
brance

SPEED ART MUSEUM

Remembrance

06.12.2021

How are you celebrating Breonna Taylor's life and keeping her memory alive?

By visiting the Museum where her Legacy was on display. Promise, Witness, & Remembrance. In memory of Breonna Taylor, a young black woman who was loved & will be missed. Your legacy will live foreveR.

Promise
Witness
Remembrance

SPEED ART MUSEUM

Artwork Selection & Thematic Development

BRINGING THE LOCAL & NATIONAL TOGETHER

STEPHEN REILY: Allison Glenn took what might have been a limitation— the fact that she did not live in Louisville—and turned it into a dynamic tension between a personal, local story (the killing of Breonna Taylor), and the nation's reflection on too many Black lives lost to gun violence. In some cases, Allison chose works that directly expressed that dual theme; in others, individual artists and artworks—and stories about them—drew out their own local / national connections in serendipitous ways. This section tells some of those stories (each artwork is described fully in the next section).

ALLISON GLENN: One of the big questions I had was, "I come from another place, I'm not in your communities, so how can I create a conversation that comes from the national context, with this cohort of folks that represent different regions of our country, and be in conversation with local interests?"[58]

—

I spent time in Louisville. I read everything I could. I listened to podcasts. And there's a relationship I can't exactly put my finger on, but I grew up in Detroit and have worked in New Orleans, and Louisville is another port city with a French connection. It's the border of the North and the South. It's where Lewis and Clark started their expedition, and I'm fascinated with the ideology behind Western expansion. Some loops closed for me when I visited. For example, that horrible slavery-era phrase "being sold down river." While down the river is New Orleans, the origin of the phrase is in Louisville.[59]

—

What's happened in Louisville is not an isolated occurrence, but rather an echo of the paradox of the time and place we are living in. Breonna Taylor's story is part of a larger history of the United States that we must contend with. We live in a country where a Black woman is Vice President, but the family of Breonna Taylor has not gotten the justice they've sought.[60]

STEPHEN REILY: [Allison] deliberately built this kind of dynamism into the exhibit, between both the national and the local, understanding that she had the opportunity to address something with us that was of, and for, our city, but also do it against the backdrop of the legacy of racial inequity, the legacies of gun violence.[61]

After the *Vanity Fair* cover was released and the painting was in my studio, I recognized that "Something else has to happen here" and I started to think about sending the painting to Louisville. . . . where she's from, to the Speed Museum.[62]

— AMY SHERALD

LOCAL / NATIONAL
1. The Portrait

AMY SHERALD: I thought about how the National Museum of African American History and Culture would be able to place it within a historical context, along the timeline that they have. And just being a part of the Smithsonian Institution, being in D.C., juxtaposed to the White House, all these different things.[62]

STEPHEN REILY: [Amy] wanted the portrait to be owned in partnership by the Speed and by the Smithsonian's Museum of African American History and Culture, making Breonna Taylor's portrait part of the cultural legacy of Breonna's hometown, as well as the national story of Black lives in America.[63]

ALLISON GLENN: I knew about the painting's co-acquisition early on, so between the NMAAHC and the Speed I wanted to point to the local and national in every aspect of how the work would be handled.[64]

LOCAL / NATIONAL
2. "The Spirit of Freedom"

What I really liked about the conversation with Ed [Hamilton] is that the bust that the Speed owns was actually created in preparation for the larger sculpture that is in D.C. It did a few things for me: it spoke to the local, national, and the Speed's collection, while setting the stage for more dialogue.[65]

— ALLISON GLENN

LOCAL / NATIONAL
3. The Speed's Collection in The Spotlight

ALLISON GLENN: There are a few winks in this exhibition. And one of them is that [Sam Gilliam's] *Carousel Form II* was on the cover of *Art in America* in September / October 1970, and it was accompanied by an article titled, *Black Art in America,* so at that moment, this painting was on the cover of a magazine that was commenting on the art of our time, specifically made by a Black artist. And, of course, the Sherald is on the cover of *Vanity Fair*.[66]

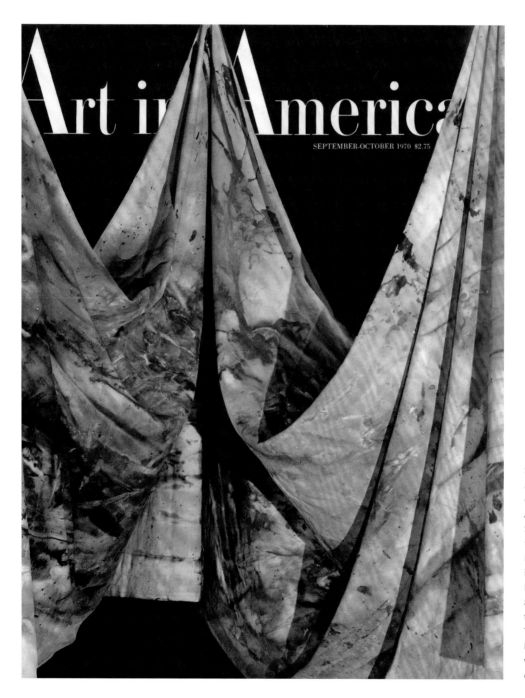

Sam Gilliam's *Carousel Form II* was featured on the cover of *Art in America* magazine for September / October 1970 and was featured in the story "Black Art in America" by curator Barbara Rose. Gilliam, a longtime member of the Speed's Board of Trustees, helped the Museum acquire this work for its permanent collection in 2013.

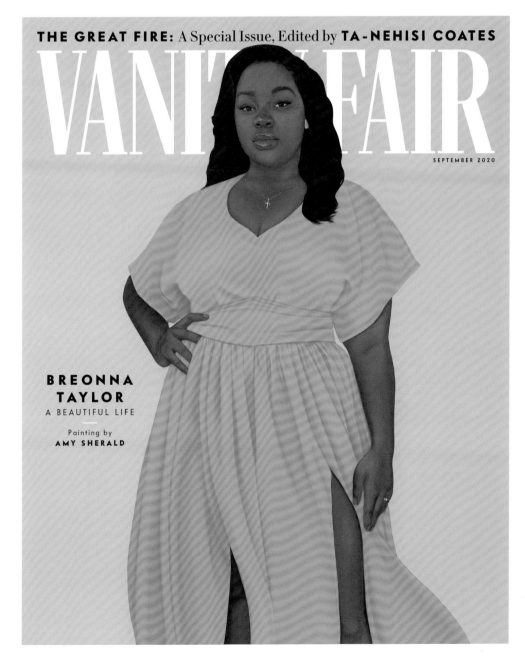

THE GREAT FIRE: A Special Issue, Edited by **TA-NEHISI COATES**

VANITY FAIR

SEPTEMBER 2020

BREONNA TAYLOR
A BEAUTIFUL LIFE
——
Painting by
AMY SHERALD

50 years after *Art in America* featured Sam Gilliam on its cover, *Vanity Fair* magazine commissioned and featured Amy Sherald's portrait of Breonna Taylor on its cover for September 2020. This work would also enter the Speed's permanent collection, under a co-ownership agreement with the National Museum of African American History and Culture.

Every sacred document and hallowed institution in our history conspired to convince the African in America that when God made the African, that God was guilty of creative malfeasance.

— DR. KEVIN W. COSBY

LOCAL / NATIONAL
4. "The Star Spangled Banner"

ALLISON GLENN: During my research, Stephen [Reily] sent me a video of the Reverend Dr. Kevin Cosby when he was speaking at Muhammad Ali's funeral, specifically about the "Star-Spangled Banner." I was looking at this work by Bethany Collins, and Stephen said, "You should watch this video." Reverend Cosby talks about the third verse of the "Star-Spangled Banner," in particular that this is the original verse that Francis Scott Key penned—and we don't learn the third verse—but it is the one where he goes from asking for—really demanding—emancipation from British rule on one hand, but then upholding the tenets of enslavement in another. And it's all articulated through our national anthem.[67]

RV. DR. KEVIN W. COSBY (Senior Pastor, St. Stephen Baptist Church, speaking at Muhammad Ali's Memorial Service in Louisville): Every sacred document in our history, every hallowed institution, conspired to convince the African in America that when God made the African, that God was guilty of creative malfeasance. All of our sacrosanct documents, from the Constitution, said to the Negro that you're "nobody." The Constitution said that we were "three-fifths of a person." Decisions by the Supreme Court, like the Dred Scott decision, said to the Negro, to the African, that you "had no rights that whites were bound to respect." And even Francis Scott Key, in his writing of the Star-Spangled Banner—we sing verse one, but in verse three he celebrates slavery by saying, "No refuge can save the hireling and slave from the [terror of flight or the gloom of the grave].[68]

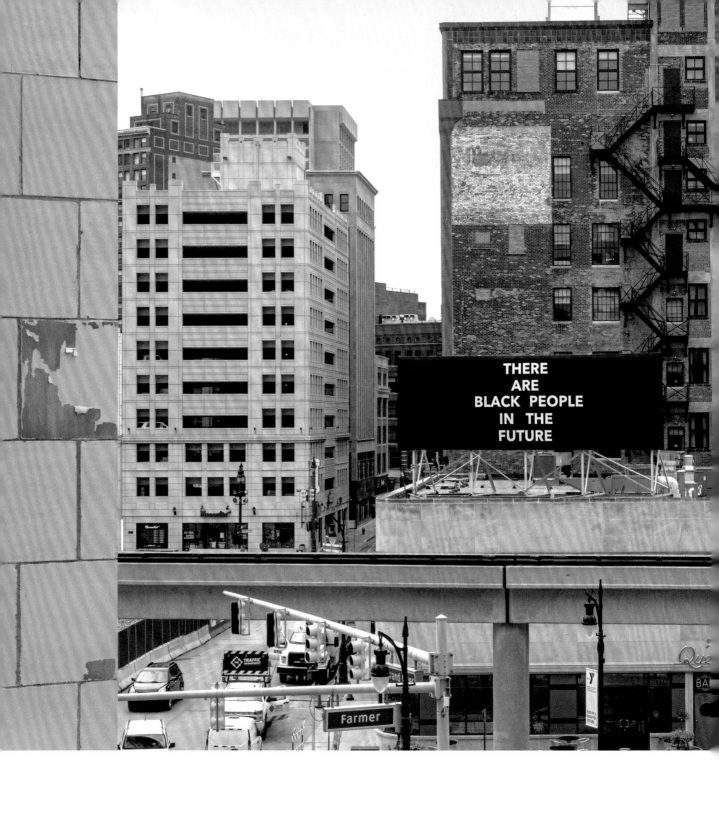

Photo by Library Street Collective

The collaboration is that Alisha allows this sentence to exist in the world, she just asks that when museums do exhibit it, that they hire local artists, or poets, or writers to respond to the work . . . And that will be another opportunity to work with the local community.[69]

—ALLISON GLENN

LOCAL / NATIONAL
5. Alisha Wormsley's "There Are Black People in The Future"

SIDDHARTHA MITTER: Can the exhibition benefit the Louisville arts scene beyond the Museum?

ALLISON GLENN: I think of Alisha Wormsley's work, "There Are Black People in the Future," which will be installed like ticker-tape in the second gallery. As part of Alisha's practice, she requires that the Museum give honorariums to three local artists [later increased to five] to respond to that idea. The Louisville Steering Committee will decide how to carry that out.[70]

Collaboration

STEPHEN REILY: The most complicated part of planning this exhibition came in the way we worked to bring together the vision of a gifted out-of-town curator with the raw feelings of people in a city that had suffered so much loss, and lost so much trust, in 2020. Everyone involved was sensitive to the risks inherent in this effort. Were we trying to do this too soon? Would we end up hurting more than helping?

—

As the Museum's director, I took responsibility for charting this course among my colleagues, our Board, and our community. Allison Glenn and Toya Northington reported directly to me during the planning of the exhibition and I was in close and regular contact with them both. The first section tells the story of how they wisely formed advisory groups to extend our relationships, inform our decisions, and support each of their efforts. What became more complicated was bringing all of those viewpoints together to decide on a final list of artworks for the exhibition. We collectively entered uncharted territory at this point, opening ourselves to divergent opinions, disagreement, even failure. It wasn't easy, especially with all meetings conducted via Zoom (COVID vaccines were not broadly available in Kentucky until March), but an unusually large number of stakeholders (which included Tamika Palmer and Amy Sherald) remained open to the uncertainties inherent to the process itself and open to our shared intent to honor the memory of Breonna Taylor while also serving our community in its time of trial.

ALLISON GLENN: I first developed a proposal and presented it to the National Panel. They gave me feedback about what was working, what wasn't working, some strengths, some areas for improvement. I refined it and then I presented it to the Louisville Steering Committee. . . . They were not afraid to be vocal, which is good.[71]

—

I wanted to create a conversation between the local community and the national community—whether in the art world or among private citizens. Toya Northington, the Community Engagement Strategist at the Speed Art Museum, developed a Louisville Advisory Committee. They gave me great feedback and suggestions. It was a different kind of curatorial process: I wasn't necessarily trying to drive a thesis based on research into an idea or an artist. It was really built on conversations about how a museum can get it right, how the art world can respond, what does it mean to collaborate in this space.[72]

—

I worked very closely with this group of people [the National Advisory Panel], and first presented my curatorial framework to them early in the new year. Then I presented it to the Louisville Steering Committee, where I heard from Committee members about how they saw the Speed Museum. One member said to me that growing up they would go to the Speed and not see any work by people who looked like them, or representations of people who looked like them, so they felt that there was a sense that the work that is about specifically the Black community wasn't valuable. And that resonated quite a bit with me.[73]

MECCA BROOKS: We were going in a direction of your vision when we initially talked, but as we went along and as you took it to the community, your ability to be fluid enough to allow them to have their voice, and their views, and their opinions—and even though it might have got a little uncomfortable, I was just really happy to see it. I was happy to just see it persevere and that's the kind of work that, I think, sets the stage; it's a model for how museum institutions could really start to work more intentionally with communities, particularly around topics like this.[74]

JON-SESRIE GOFF: What echoes true and sort of resonates with my own practice and approach, is the way that you were able to create this living double-consciousness. You were able to give it back, and you were able to hold at the same time something that's both the survey of contemporary art, and something that is resonant with the urgency of the moment.[75]

ALLISON GLENN: The opportunity is to show what it means to listen. I don't think museums are going to get everything right. Cultural workers aren't going to get everything right. But when you listen, you provide opportunities for accessibility, for inroads, for connection. And I hope the end result provides a platform for people to feel heard, and perhaps to process the past year.[76]

When we started this project it was still really raw here. Still a lot of pain, still a lot of hurt—it still is—but we were fresh on it at that time. It was important if we were going to take on this and really do it justice, we had to be true about the representation.

— TOYA NORTHINGTON

Black Artists

STEPHEN REILY: So, Allison came to the table with a vision that was a little different. She had an idea of a lot of Black artists, but not only Black artists, but the committee had a different view?

TOYA NORTHINGTON: Yes, and I think because the community lives in the context of what's happened here. When we started this project it was still really raw here, you know? Still a lot of pain, still a lot of hurt—it still is—but we were fresh on it at that time. It was important if we were going to take on this and really do it justice, we had to be true about the representation.[77]

—

ALLISON GLENN: To tell this story, I didn't necessarily think that every artist had to be a Black artist. But after listening, I understood the importance of visibility, to the Louisville community, of presenting a show of only Black artists in this space. That was an "aha!" moment: this is the community's desire, and I can be flexible and nimble, I can be nimble in this way, without having to compromise any curatorial framework. And then it became deeper. The site of the exhibition are galleries that usually hold the Dutch and Flemish collections: we've got 22-foot ceilings, terrazzo floors, marble doorways. It became clear that an effect would be a kind of decolonizing of that museum space.[78]

—

Realizing that through that simple gesture of deinstalling all the Dutch / Flemish collection that is on view—including the gorgeous Rembrandt—that we could afford a platform for folks who felt that perhaps the institution wasn't a place for them.[79]

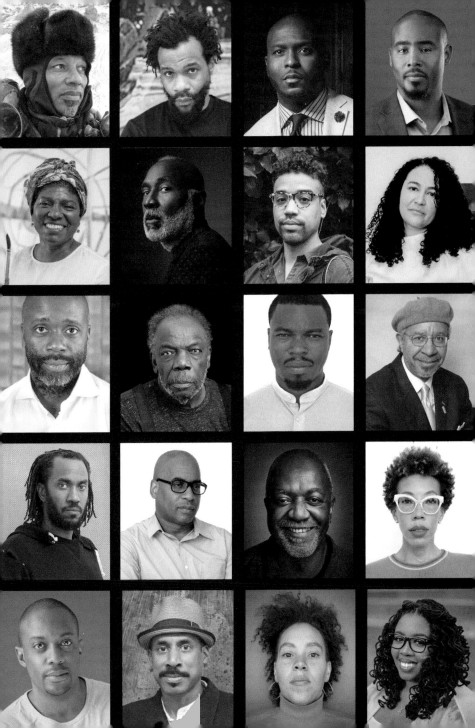

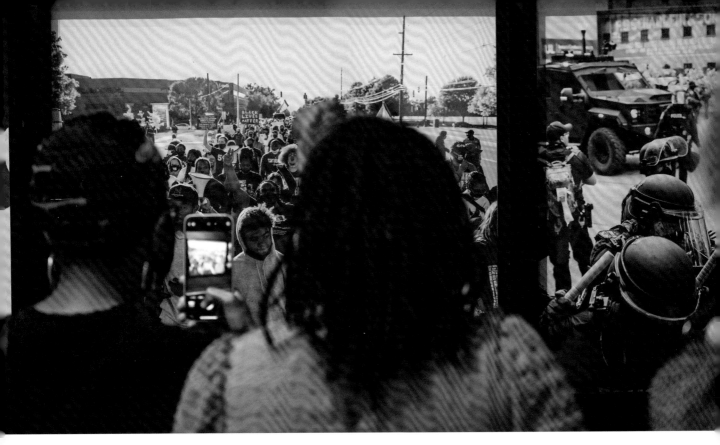

Photo by Jon Cherry

Local Artists /
Protest Photographs

TOYA NORTHINGTON: We know about museums' histories as a whole—the Speed is no exception—and we're not known for elevating local. Usually, you don't get success till you move away. You find your success somewhere else and then you're brought into the museum system. There's a whole structure behind that. But it was important to say, who is here that has been overlooked? Or who is from Louisville that is ready to be launched into this higher level of the art world but hasn't been given that chance. And that goes back to correcting the imbalance. So not just the local people that everyone knows that everyone loves, and has seen over years, but how can we elevate new faces like new voices. So this is a launching pad, and it really goes back to how we are thinking about uprising, and social justice here. This was our way to elevate the community to the next level through the art world.[80]

The Steering Committee built this incredible spreadsheet
of photographers who were at the protest. I chose five.
Breonna Taylor's story includes all of these people
around it, and I wanted to honor them.[83]

— ALLISON GLENN

TOYA NORTHINGTON: To give Allison credit—it's not often that you not only have a Steering Committee to get perspective—we weren't really asking . . . "Could you please?" "Could you consider it?" We were like "No. This is our list of things that we would like to see in this exhibition." And one was: we need to elevate someone who hasn't been elevated before.[81]

ALLISON GLENN: When I met with the Steering Committee they really wanted to have more local artists represented, and so, oftentimes as a Curator in this kind of position you're balancing your own expectations of an institution that wants to see things a particular way, the expectations of these committees that want to see things a particular way, the expectations of yourself—developed partially through your thesis or curatorial framework which becomes an extension of who you are and your work style—and then, of course, as I mentioned before, Tamika Palmer being the key stakeholder and most important voice in the room to me. I thought to myself that there was definitely room for the local here, and one of the two ways that happened was when I mentioned to the Steering Committee that I'd love to show photographs from the protest movement. At the time I lived in Arkansas, I couldn't do studio visits like I normally would—we were in an expedited timeline also, and travel wasn't safe, so I asked them if they could assemble a list of artists and photojournalists that they knew were at the protests. They created this spreadsheet of about maybe 40 names of photographers and videographers who are at the protests every day, and from that spreadsheet I combed through and selected five photographers from Louisville.[82] One of the biggest bit of feedback that I received was that people felt visible. And it was really exciting to be able to watch people find themselves in the photographs.[84]

STEPHEN REILY: When we had our very first tour for our colleagues in the exhibit, one of our friends and colleagues [Shantel Stubbs from the Education department] said "I don't know if you all know this, but I'm in one of these protest photos." And there she is, holding a camera. So, she, in turn, was a protest photographer.[85]

This was our way to elevate the community
to the next level through the art world.[80]

— TOYA NORTHINGTON

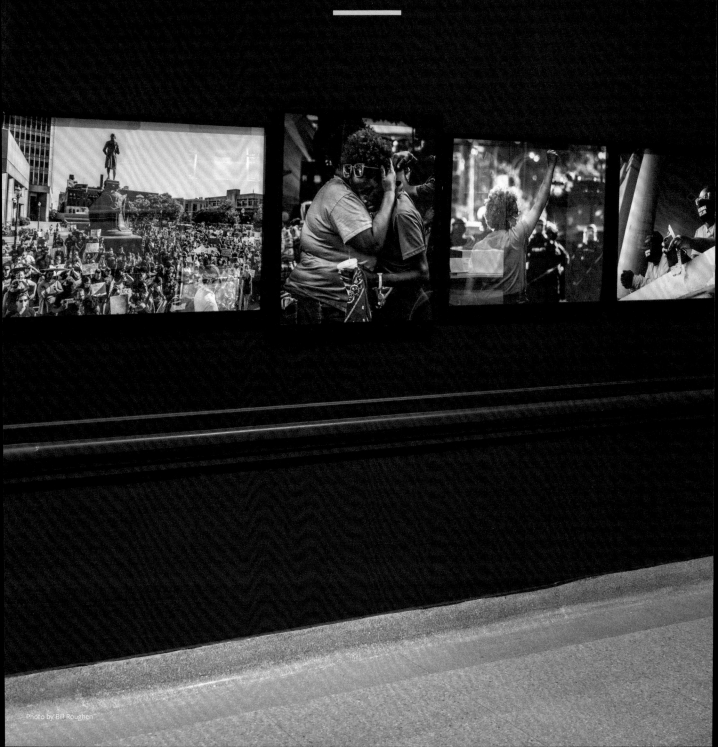

Color

STEPHEN REILY: [Allison] presented, what I believe was a near complete checklist, and [the Community Engagement Steering Committee] had a very specific kind of initial aesthetic reaction.

TOYA NORTHINGTON: When we saw the exhibition checklist, we wanted to see Breonna, not a general version of racism, or social justice. We were like "Okay, where's Breonna represented in this checklist?" And of course, we have Breonna Taylor's family [on the Community Engagement Steering Committee], so in case you don't take our word for it, we're going to ask "Was this Breonna?" The idea was that we can't forget that this exhibition started because of Breonna Taylor, and it was important to redefine the narrative around her life and who she was as a person. The call out was, "Breonna was lively. Breonna was fun. Breonna loved color. She loved to laugh. So, we need some more life into this exhibition. We need more color. We need more movement. We need more light."[86]

ALLISON GLENN: A lot of the feedback I got from the Louisville Steering Committee is, "how is this about Breonna Taylor?" And I realized that some things needed to be a little more overt or direct.[87]

Breonna loved color. She loved to laugh. So, we need some more life into this exhibition. We need more color. We need more movement. We need more light.[86]

— TOYA NORTHINGTON

The
Artworks

Promise

National anthems, voting rights, constitutions, and a military that protects the rights of citizens can all be seen as symbolic representations of a nation and its promise. The promise of the United States is rooted in what our forefathers called "unalienable rights," which are outlined within our founding documents—including life, liberty, and the pursuit of happiness.

In the exhibition's first gallery, contemporary artists explore the shared beliefs and values of the United States of America through the symbols that uphold them: the Star-Spangled Banner, Presidential elections, the Preamble to the Constitution, and the military. These works ask us to consider these symbols of the United States, and how they have changed and shifted over time, provoking questions such as:

What does the promise of the United States mean to its citizens?

—

To whom are these rights afforded?

—

How do we ensure that these rights are protected in the future?

ALLISON GLENN: The first section is "Promise," which is the promise of a nation, and the symbols that the promise is meant to afford its citizens. Key things like national anthems, flags, voting rights, and the military that uphold them, are what artists and artworks in this section look at.[88]

—

What I wanted to do there was provide a framework to understand the rest of the exhibition. That section is meant to drive home the truth we all know: that the United States was founded on horrible inequities, and the inefficacies of our system are inherently indebted to that founding.[89]

—

To understand this particular moment in time, we have to look back and understand others before it. Hinging on this idea that the family of Breonna Taylor has not gotten the justice they seek, we have to, from my perspective, this exhibition, and this section, we aimed to unpack how something like this could occur in a nation laden with promises.[90]

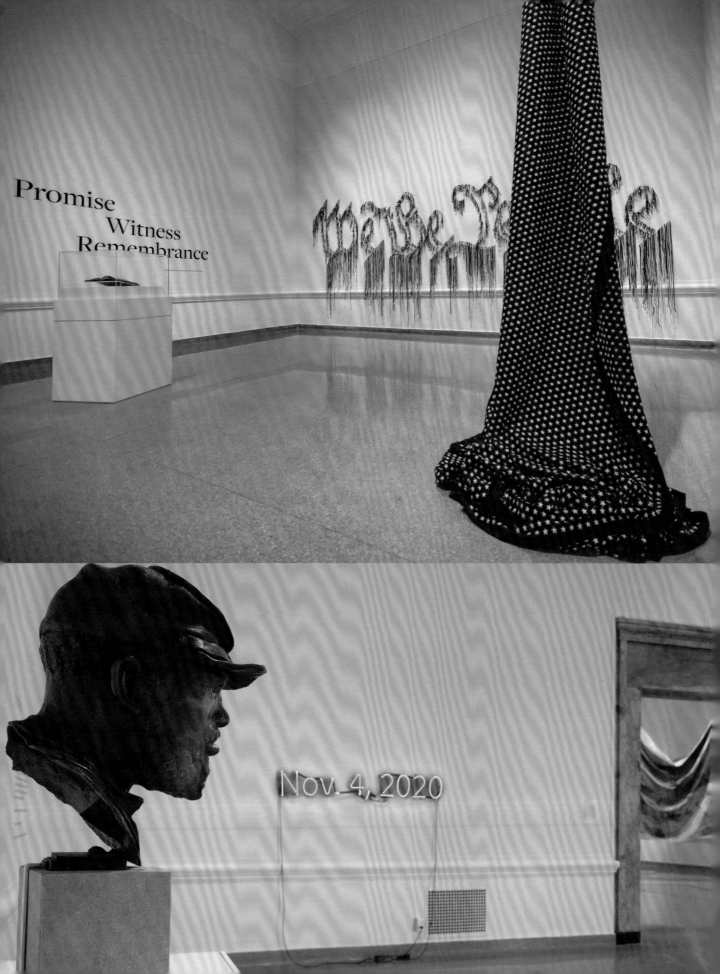

Promise
Witness
Remembrance

We The People

Nov. 4, 2020

The concept I really wanted to get at with the "Promise" section is this idea of a nation, what citizenship affords a citizen, and which symbols articulate these freedoms and protections. And so, really looking at these symbols: the Preamble to the Constitution, the American flag, the military, voting rights, and national anthems, and how artists have perhaps problematized these symbols to get at the core, which is that the United States inherently, does not value everyone as equal in the way that we promise it, with these various symbols of our country.[91]

— ALLISON GLENN

TOP LEFT
Photo by Xavier Burrell

BOTTOM LEFT
Photo by Bill Roughen

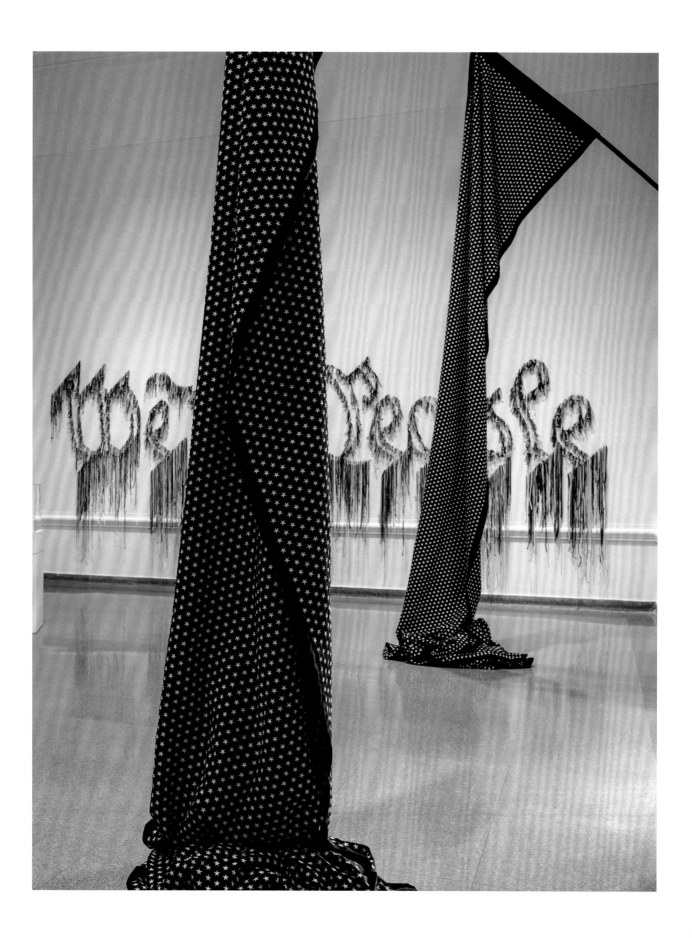

I wanted to borrow from these tropes of nationalism because I think we're in a moment where we're dealing with a lot of them, yet still living in a space that does not feel democratic. There are works by Hank Willis Thomas in the "Promise" section, where we installed *15,433 (2019)* and *19,281 (2020)* [both 2021]; two flags whose stars represent those individuals killed by gun violence in America in 2019 and 2020.[92]

— ALLISON GLENN

These two flags are part of an ongoing, annual series that artist Hank Willis Thomas calls his "Fallen Stars" series, which first began in 2016. Here Thomas has appropriated the iconography of the American flag. Instead of representing states, Thomas's stars represent each person murdered by gun violence in the United States in the year the flag was created. These textile flags memorialize the thousands of people lost in 2019 and 2020—including Breonna Taylor, Travis Nagdy, David McAtee, and Tyler Gerth—while, as Thomas has stated, paying "homage to the countless loved ones who carry perpetual grief and trauma as unacknowledged victims of gun violence in America."

Hank Willis Thomas
American, born 1976

15,433 (2019), 2021
Embroidered stars on polyester fabric

Courtesy of the artist and Jack Shainman Gallery,
New York L2021.12.2

Hank Willis Thomas
American, born 1976

19,281 (2020), 2021
Embroidered stars on polyester fabric

Courtesy of the artist and Jack Shainman Gallery,
New York L2021.12.3

———

Unfortunately, the 19,281 stars on Hank Willis Thomas' [2020] flag flanking the gallery entrance represent failed promises. . . . Every embroidered star on [this] flag is a tribute to a victim of this denied promise as a consequence of their death in 2020 by state-sanctioned gun violence. Represented among these stars are Louisville, Kentucky's Breonna Taylor, Travis Nagdy, David McAtee, and Tyler Gerth.[93]

- RAMONA DALLUM LINDSEY
(STEERING COMMITTEE MEMBER)

———

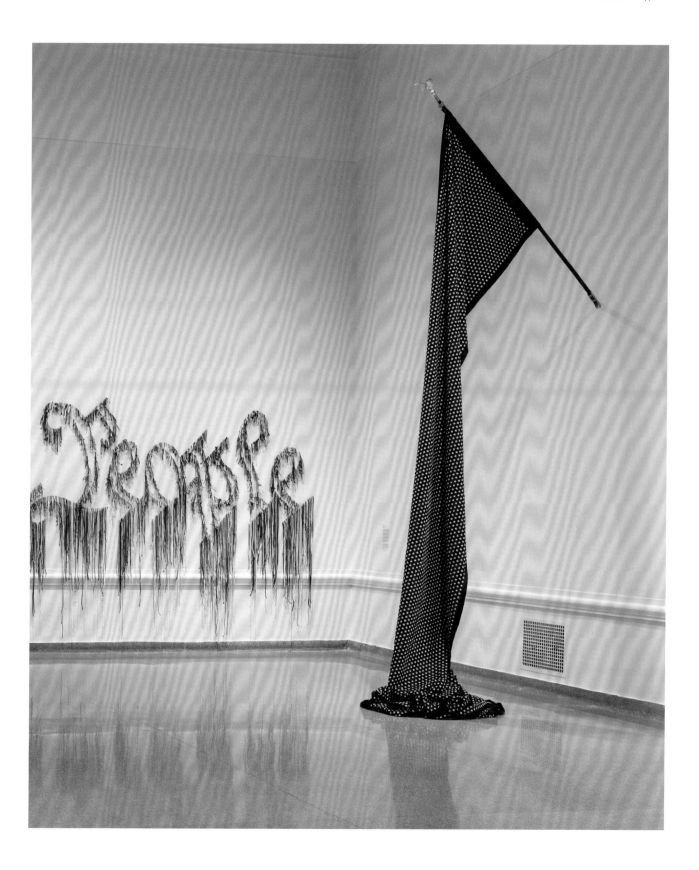

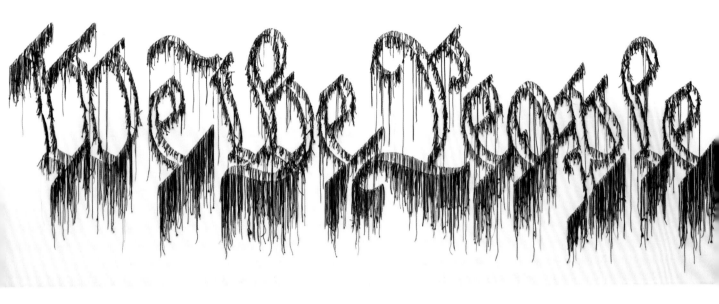

Nari Ward used multicolored shoelaces to create this wall drawing of the first three words of the Preamble to the Constitution: "We the People." Ward is known for creating large-scale works from found objects. Here, the use of shoelaces makes the text slightly difficult to read, prompting a closer look. The Constitution of the United States was adopted as our founding document in 1789, two years after it was secretly drafted and thirteen years after the Declaration of Independence severed the American colonies' ties to England. As enslavement was already established in the Western Hemisphere and women did not have the right to vote, it is paradoxical to consider who our forefathers were referring to with the words "We the People."

We the People of the United States, in Order to form a more perfect Union, establish Justice, insure domestic Tranquility, provide for the common defense, promote the general Welfare, and secure the Blessings of Liberty to ourselves and our Posterity, do ordain and establish this Constitution for the United States of America.

-Preamble to the US Constitution

Nari Ward
American, born Jamaica, 1963

We the People, 2011
Shoelaces

Collection of the Speed Art Museum,
Gift of Speed Contemporary 2016.1

RIGHT
Photo by Jon Cherry

I feel like this work echoes and reverberates,

because the questions you can ask are,

who are the people?

Who's we?[94]

— ALLISON GLENN

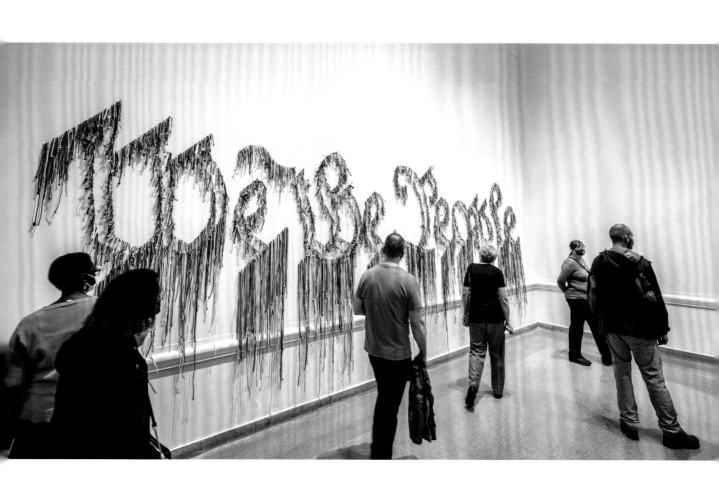

Farewell to the Star Spangled Banner

"Nannie Grey" (Mrs. E. D. Hundley) 1861

Let tyrants and slaves submissively tremble And bow down their necks 'neath the juggernaut car; But brave men will rise in the strength of a nation, And cry 'Give me freedom, or else give me war!" Farewell forever, the star-spangled banner No longer shall wave o'er the land of the free; But we'll unfurl to the broad breeze of Hea- Thirteen bright stars round the Palmetto tree.

2. We honor, yes honor, bold South Carolina.
Though small she may be, she's as brave as the best;
With flag-ship of State, she's out on the ocean
Buffering the waves of a dark billow's crest.
Farewell forever, etc.

3. We honor, yes honor, our seceding sisters
Who launched this brave bark alone on the sea,
Though storms may howl and thunder distraction,
We'll hurl to the blast the proud Palmetto tree.
Farewell forever, etc.

4. And when to the conflict the others cry onward,
Virginia will be first to rush to the fight,
She'll break down the iceberg of northern coercion
And rise in her glory of Freedom and right.
Farewell forever, etc.

5. When the fifteen sisters in a bright constellation,
Shall dazzling shine in a nation's emblem sky;
With no hands to oppose, nor foes to oppress them,
They will shine there forever, a light to every eye.
Farewell forever, etc.

With *The Star Spangled Banner: A Hymnal*, Bethany Collins continues her investigation into instances of contrafactum in American national anthems. Contrafactum is a type of song where the melody remains constant while the lyrics shift. Collins has laser-cut the musical score of 100 versions of "The Star Spangled Banner," and then assembled them into a hymnal book. The laser cutting process burns the pages of the book. While the lyrics of the different versions remain readable, the hymnal's unifying tune has been all but burned away. In its many lyrical variations, *The Star Spangled Banner: A Hymnal* is a chronological retelling of American history, politics, and culture through one song.

Bethany Collins
American, born 1984

The Star Spangled Banner: A Hymnal, 2020
100 laser cut leaves

Collection of the Speed Art Museum, Louisville, Kentucky.
Purchased with funds from the Alice Speed Stoll Endowed Art
Acquisition Fund 2021.1.

Bethany Collins' piece of sound art is paired with her *The Star Spangled Banner: A Hymnal*. Originally written in a major key, "The Star Spangled Banner" is typically sung in jubilant voice at the beginning of a moment of collective celebration—from sporting events to presidential inaugurations. In the wake of a particularly turbulent election year, this version of "The Star Spangled Banner" marks endings rather than beginnings, and mourning over celebration. To create this sound work, Collins combined eight abolitionist versions of our national anthem, each sung in a mournful style. A single version played in the galleries at the end of every hour throughout the day.

Bethany Collins

American, born 1984

The Star Spangled Banner, 2021

One channel sound recording, two wall-mounted speakers

Collection of the Speed Art Museum, Louisville, Kentucky. Purchased with funds from the Alice Speed Stoll Endowed Art Acquisition Fund 2021.6

LEFT
Photo by Bill Roughen

ABOVE
Photo by Xavier Burrell

BELOW
Photo by Jon Cherry

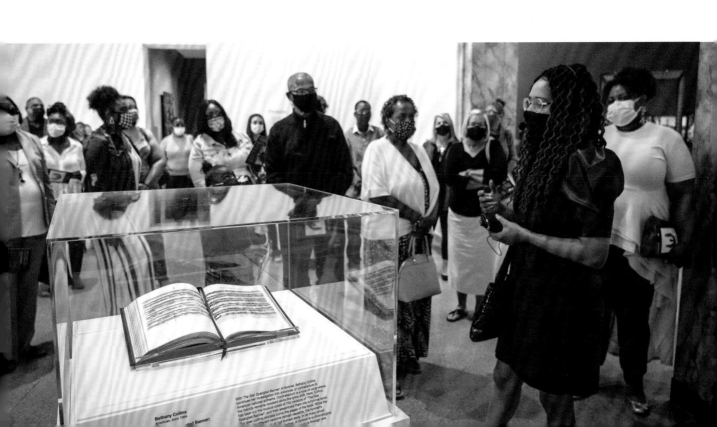

Ed Hamilton's bust of the Negro Civil War officer is a moving
reminder that in 1865, nearly 100 years after America's founders
penned "We the People," Black men and women chose to risk
their lives in the pursuit of their families' freedom
to live as full human beings.[95]

— RAMONA DALLUM LINDSEY
(STEERING COMMITTEE MEMBER)

This soldier represents the more than 200,000 Black men who fought for the Union Army during the Civil War, a time when the question of Emancipation still loomed heavily in the United States. In 1998, Louisville sculptor Ed Hamilton unveiled *The Spirit of Freedom*, the first national monument dedicated to the African American soldiers and sailors who fought during the Civil War. Located in Washington, D.C., the monument includes a full-length version of this figure standing beneath a personification of the Spirit of Freedom, a female figure who guides and protects him in his quest for freedom.

Ed Hamilton
American, born 1947

Untitled, 2000
Bronze, limestone

Collection of the Speed Art Museum, Louisville, Kentucky.
Gift of Dr. and Mrs. S. Pearson Auerbach 2000.17.

As Ligon says about this piece:

"The emergency started generations ago for Indigenous people who resided here before the colonizers arrived and for the enslaved Africans brought to these shores over 400 years ago."[96]

— ALLISON GLENN

Aftermath depicts the date "Nov. 4, 2020," the day following the 2020 U.S. Presidential election, in a bright red neon Myriad font. The neon was lit before, during, and after the election, and continues to be illuminated to signify that we are presently living in an "aftermath" which, for the artist, is a current and ongoing disaster. Viewed within the context of the global coronavirus pandemic, our perception of dates has become especially charged; days blur together or function as signposts for progress or regression. Ligon's neon highlights this tension, commanding attention while also allowing space for individual associations.

Glenn Ligon
American, born 1960

Aftermath, 2020
Neon

Courtesy of the artist and Hauser & Wirth L2021.8

RIGHT
Ron Amstutz; Courtesy of the artist,
Hauser & Wirth, New York,
Regen Projects, Los Angeles,
Thomas Dane Gallery, London
and Chantal Crousel, Paris

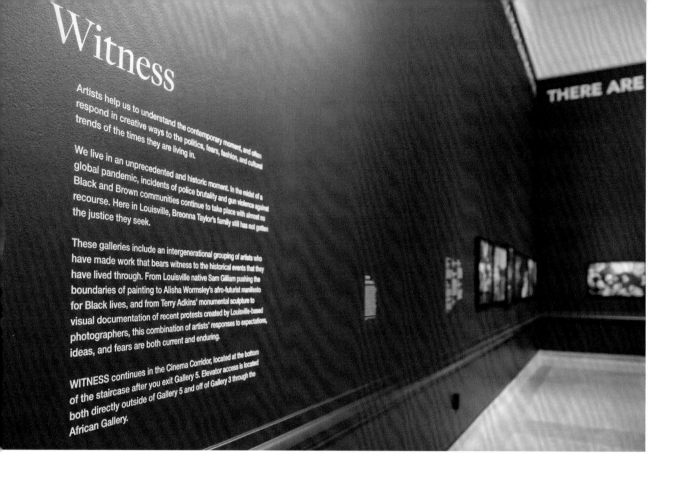

Witness

Artists help us to understand the contemporary moment, and often respond in creative ways to the politics, fears, fashion, and cultural trends of the times they are living in.

We live in an unprecedented and historic moment. In the midst of a global pandemic, incidents of police brutality and gun violence against Black and Brown communities continue to take place with almost no recourse. Here in Louisville, Breonna Taylor's family still has not gotten the justice they seek.

These galleries include an intergenerational grouping of artists who have made work that bears witness to the historical events that they have lived through. From Louisville native Sam Gilliam pushing the boundaries of painting to Alisha Wormsley's afro-futurist manifesto for Black lives, and from Terry Adkins' monumental sculpture to visual documentation of recent protests created by Louisville-based photographers, this combination of artists' responses to expectations, ideas, and fears are both current and enduring.

WITNESS continues in the Cinema Corridor, located at the bottom of the staircase after you exit Gallery 5. Elevator access is located both directly outside of Gallery 5 and off of Gallery 3 through the African Gallery.

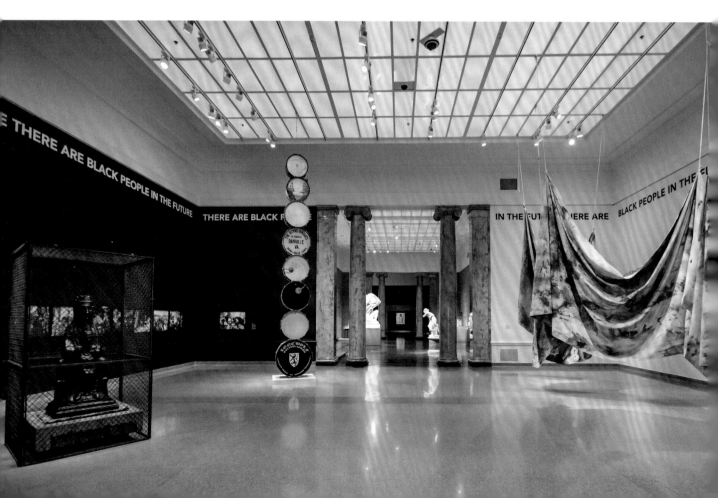

Witness

Artists help us to understand the contemporary moment, often responding to the politics, fears, fashion, and cultural trends of the times they are living in.

We live in an unprecedented and historic moment. In the midst of a global pandemic, incidents of police brutality and gun violence against Black and Brown communities continue to take place with almost no recourse. Here in Louisville, Breonna Taylor's family still has not gotten the justice they deserve.

The works in the exhibition's second section include an intergenerational grouping of artists who have made work that bears witnesses to the historical events that they have lived through. From Louisville native Sam Gilliam pushing the boundaries of painting to Alisha Wormsley's Afro-Futurist Manifesto for Black lives, and from Terry Adkins' monumental sculpture to visual documentation of recent protests created by Louisville-based photographers, this combination of artists' responses to expectations, ideas, and fears are both current and enduring.

ALLISON GLENN: The next section, "Witness," thinks not only about the curatorial framework, but also about visitors to the Museum. I anticipate many will be first time visitors, so this portion of the exhibition really unpacks what artists do. Artists help us understand the contemporary moment. And in this section, I've paired historical works with more contemporary ones, to tell a larger story about witnessing and sometimes protesting.[97]

—

In the "Witness" section, you'll see a mixture of works that are timely yet enduring. We're in the midst of a global pandemic. Breonna Taylor's family has not received the justice they seek. This section was also an opportunity to present the work that had happened during the protest, which was really important to Ms. Palmer. These galleries include artworks that respond to this moment, as well as other moments of conflict, change, and unrest in the 20th and 21st centuries.[98]

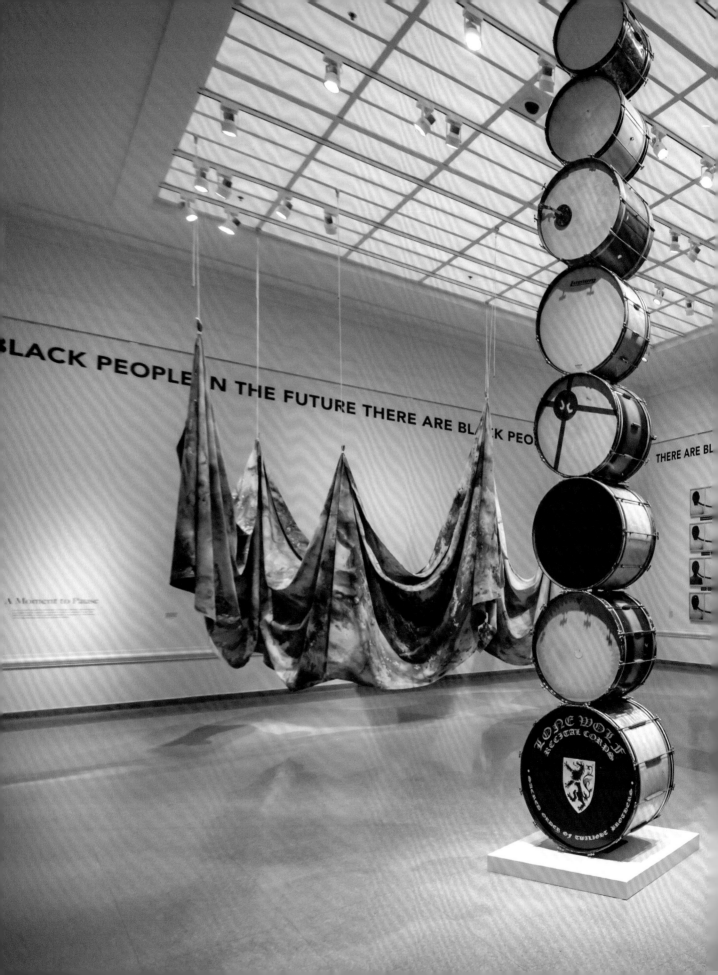

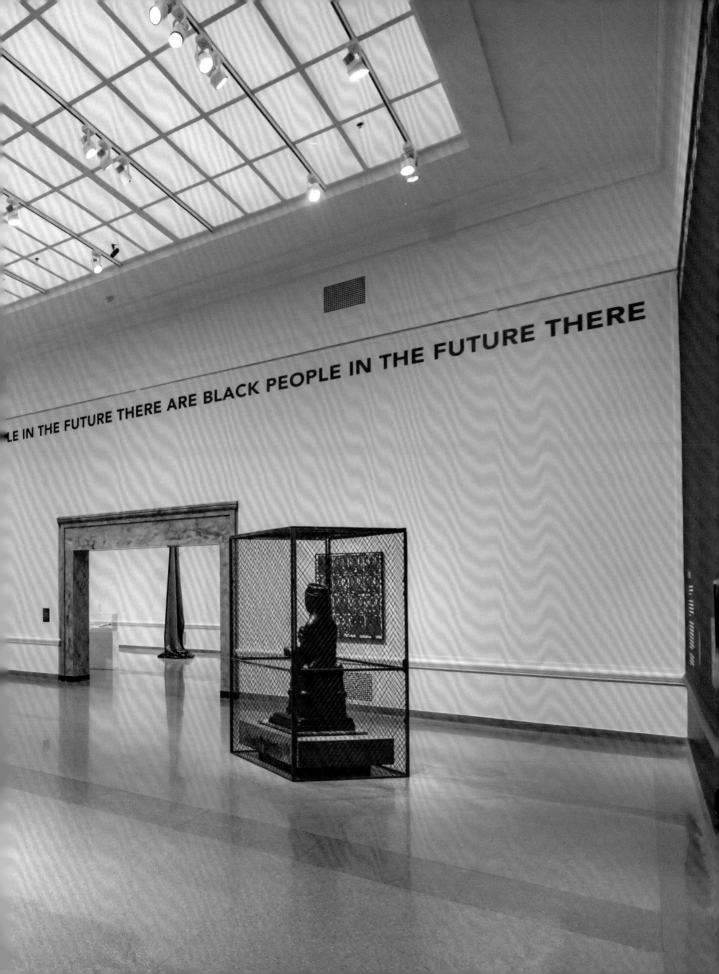

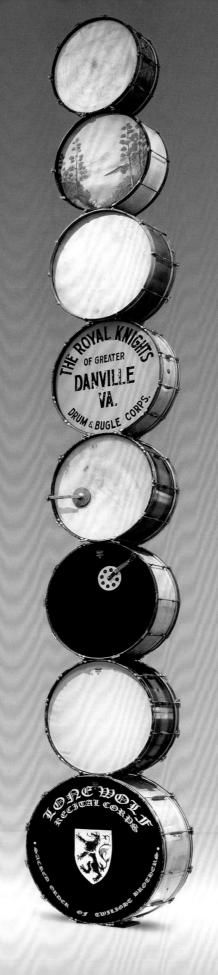

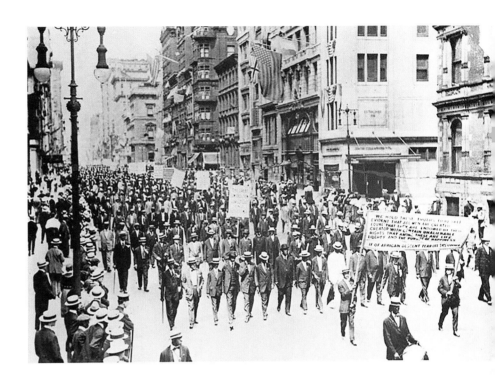

Muffled Drums is comprised of eight found instruments, vertically stacked in a column that extends over twenty feet high. Throughout his practice, artist Terry Adkins connected history and time through found objects, process, performance, and sound. One of the tallest sculptures that Adkins ever created, this work pays homage to the Silent Protest Parade, a demonstration that marked the beginning of organized protests for equal rights and justice for Black people in the United States.

On Sunday, July 20, 1917, W.E.B. Du Bois and the NAACP organized a silent protest to march down Fifth Avenue in New York. The idea for this event, which was constituted a collective response to a series of lynchings around the country and the particularly violent East St. Louis Riot, was first suggested at a meeting in 1916. *New York Times* coverage of the parade referred to the 8,000 protesters as "marching to the beat of muffled drums."

Originally produced with eleven drums, this sculpture is sometimes displayed with eight, as seen here, for Adkins' affinity toward the symmetry and repetition of the number. Both solemn and monumental, the piece aptly creates a conversation between the protest photographs from 2020, connecting the movement for Black lives to over a century's worth of organizing.

PREVIOUS PAGE
Photo by Xavier Burrell

LEFT
Photo by Bill Roughen

ABOVE
Image credit: Schomburg Center for Research in Black Culture, Photographs and Prints Division, The New York Public Library. "Silent Protest parade on Fifth Avenue, New York City, July 28, 1917, in response to the East St. Louis race riot" The New York Public Library Digital Collections. 1917.

Terry Adkins
American, 1953-2014

Muffled Drums (from "Darkwater"), 2003
Bass drums, mufflers

Purchased using funds provided by the 2013 Outset / Frieze Art Fair Fund to benefit the Tate Collection 2014 L2021.15

There are a couple of works that I can't believe we pulled off these loans, and one of them is Terry Adkins' *Muffled Drums*. It was . . . conversations, relations, but also a lot of luck and timing that this work is stateside, and was in between venues in the United States, and therefore we could borrow it. . . . Of course, showing this work in Louisville is much better than putting it in storage.[99]

—

I also chose to hang the [protest] photographs tight and horizontally, knowing that *Muffled Drums* was going to have such height. I wanted to have the horizontal timeline of photographs intersect with it. *Muffled Drums* commemorates [W. E. B.] Du Bois' organizing of one of the first Black-led protests for Black lives . . . I wanted to create a historical framework of a century of protests for Black lives and to highlight the impact of these protests nationally and globally.[100]

— ALLISON GLENN

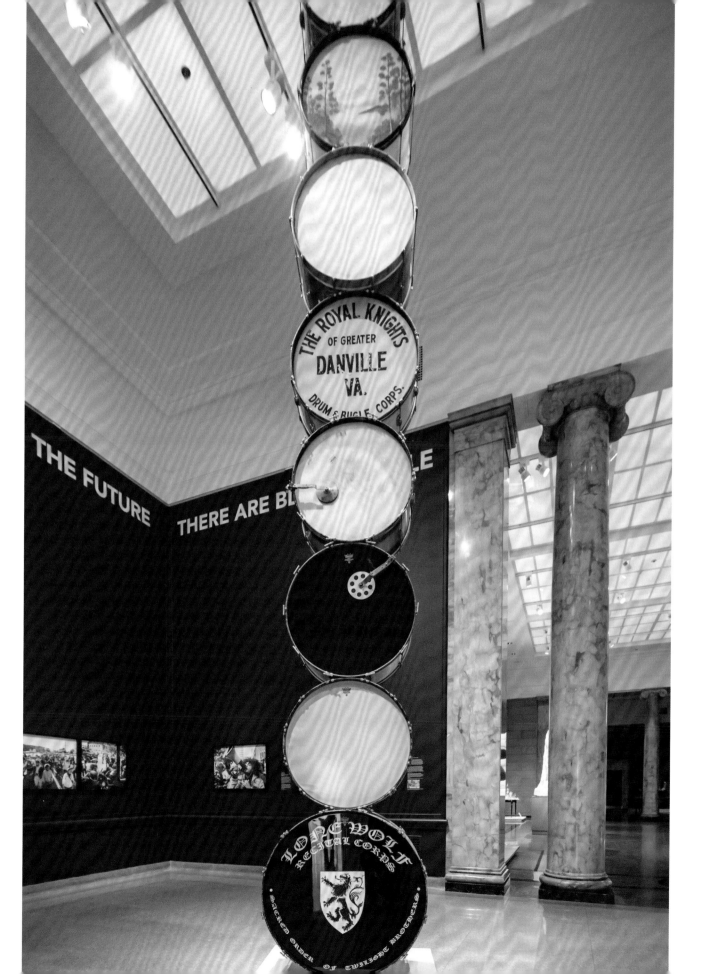

They require the audience to witness the erasure of this Black woman or these Black women in these images that I have, right? But it also then requires the viewer to also project the promise back onto those empty spaces.[101]

- NOEL W ANDERSON

In this body of work, Louisville native Noel W Anderson problematizes representation of Black women in print media by altering popular beauty advertisements found in vintage *Ebony* magazines. By removing the faces of models from the advertisements, Anderson highlights the implied act of erasure that these advertisements enact upon the very consumers they are designed to target. Much like Rashid Johnson's *November 3, 2020* painting, seen on page 144, Anderson's works on paper oscillate between figuration and abstraction, pointing to the image while simultaneously denying it. For the artist, this new field allows for both inquiry and projection, while creating a space to imagine alternative identities.

Noel W Anderson
American, born 1981

Sly Wink, 2012-2018
Erased *Ebony* Magazine

Courtesy of the artist,
from his private collection

LEFT
Courtesy of the artist

Noel W Anderson

American, born 1981

Check the skin, 2012-2018

Erased *Ebony* Magazine

Courtesy of the artist,
from his private collection

Woman There Is...

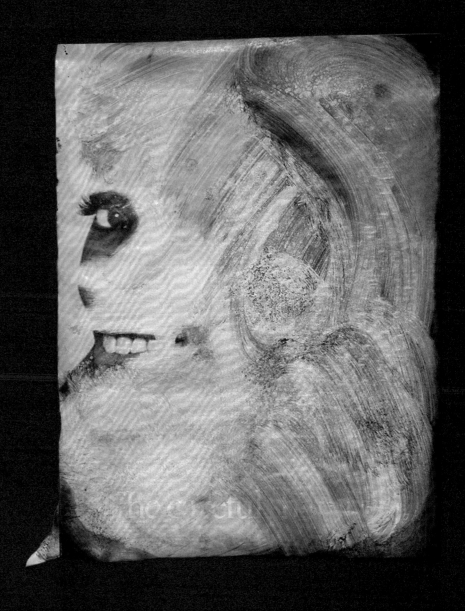

Noel W Anderson
American, born 1981

Rinse, 2012-2018
Erased *Ebony* Magazine

Courtesy of the artist,
from his private collection

There is a wonderful interview where [Noel] talks about going
to the Speed and actually looking at the paintings in these
galleries. He said he would sneak away from his friends and go
there and just really be fascinated by painting, and how when
he moved to New York . . . he had that same relationship with
the Met. So, on so many levels, including Noel was a no-brainer.
Also being able to include his work at the Speed Museum, in the
galleries that he frequented as he was developing his artistic
voice, just feels so dynamic.[102]

—

Noel W Anderson is on faculty at NYU in the Printmaking
Department. He was born and raised in Louisville and has never
had an exhibition in his hometown. . . . And he also said he
used to go to the Speed Museum and look at the Dutch and
Flemish paintings and be very inspired, and talked about how
they informed his practice. . . . Thinking also about this idea of
witnessing and someone like Noel W Anderson who was born
and raised in your city, who has a prestigious role at a leading
institution in New York, and found his calling by going to the
Speed Museum. To be able to witness him and give him
his first exhibition in Louisville is phenomenal.[103]

- ALLISON GLENN

N THE FU RE THER ARE

I THE FUTURE

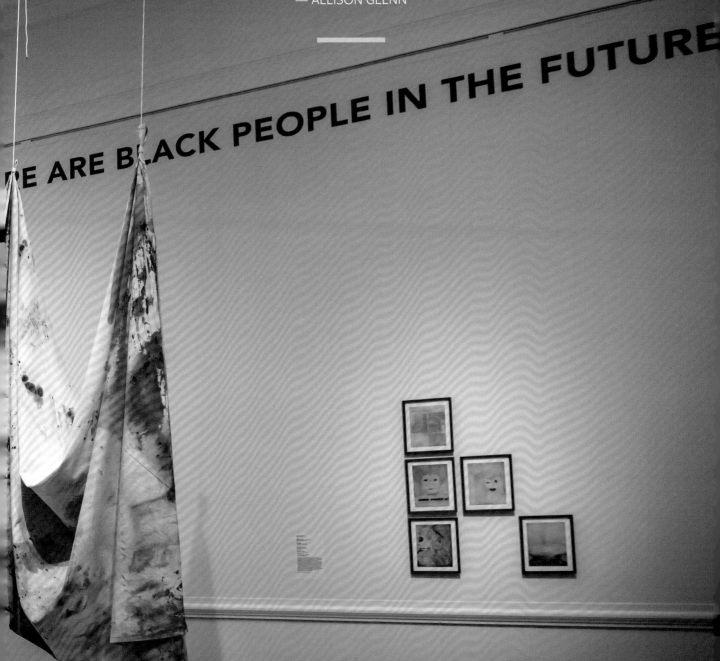

We did a little walk through on FaceTime and [Noel] said "Oh, my grandma knew Sam [Gilliam], and she would be delighted to know that his work is adjacent to mine."[104]

— ALLISON GLENN

BEYOND THIS POINT PROMISE IS **DEMANDED!**

BY NOEL W ANDERSON, PUBLISHED MAY 11, 2021 IN *BURNAWAY*

Beyond this point, imagination is considered.

It began with a reflection. *A dream?* Peering into the shadow of the past, we witness a 16-year-old Black male teenager seeking something beyond the available, or at least what he thought possible for himself. Athletic outlets are a constant point of return and limitation for most Black children, he was no exception. Arenas, fields, courts—all locations for the projection of a Black child's imagination. What these early sites made believable were the accessibility of social mobility, a path towards Black affluence and generational wealth. In the shadows of those institutions he found intimidation, anger, and violence. Athletics can be a dirty sport. While he did participate, he understood something else was possible. *Beyond?* I think we've gone too far, for we can see the ancestors waving, ushering us into a recognition of kinship by the very enactment of dreaming. The shared goal of dreaming is escape—not to be present in the trauma, but to steal away. *Steal away, steal away, steal away to...* The now obvious but once hidden message of this lyric instructed our ancestors towards fugitivity—whether in life or in death. *Beyond this point imagination and fugitivity are suggested!*

And it is in this loose understanding of dreaming-as-escape that I practiced a particular kind of fugitivity. As that 16-year-old, I would sneak into the Speed Art Museum. Not disclosing to my parents where I was going, probably lying, while incriminating a friend by offering his name up as collateral: "I'm going to J's house." I was on my way. My secret trips to the Speed activated my ancestral ability to dream, to *steal away to art*. Within this privileged form of tactical invisibility, I became intimate with Cranach the Younger, Dürer, and Rembrandt. Disclosed to me while walking alone in the halls of this mausoleum were the invisibility, and in most cases exclusion, of complex Black subjects. Here I was required to dream of models whose narratives could not be reduced to the shadow of a servant's role.

This was the memory that was evoked when Allison Glenn, Speed Art Museum's guest curator, asked if I would like to participate in celebrating Breonna Taylor's life. The exhibition *Promise, Witness, Remembrance* is both the praise of a life taken too soon,

as well as a return to my dream's original location: the Speed Art Museum. What started out as a requirement to imagine—the interminable speculation and phantasmic imagery evoked by dreaming, that produced so many possible surrogates for the museum's *Portrait of a Forty-Year-Old Woman* (1634) by Rembrandt—ended in a commitment to reframe the initial encounter within the museum.

Beyond this point imagination and fugitivity are required!

Glenn and her team aided me in reframing the secret visits. Initially the museum-as-mausoleum necessitated dreaming. However, in its "progressive" form it reads as a promise to visibility. The nascent practice of inclusive curation highlights the distinction between dreams and promises. While a dream can live in your head and assume any form, promises, like goals, manifest in the performative; both require action to be realized. This exhibition is *that* action. *Promise, Witness, Remembrance* puts the performative into play. Amy Sherald's portrait of Breonna Taylor updates Rembrandt's muse with a poise and grace fitting of celebration. *Surrogate installed.* By fulfilling the promise of visibility through her painting, Sherald bypasses the initial act of dreaming. *Promise fulfilled.*

With my contribution, I return not as fugitive sneaking to the museum to imagine locations beyond but as collaborator. It is my hope that in this return to the dream's origin, my works, like Amy Sherald's, can aid in further practicing promise's performative power. The erased *Ebony* works, which are included in the exhibition, strip the original magazine pages of ink, reducing the papers back to faintly empty surfaces. The seemingly blank space flees immediate comprehension. *Reinvestment in fugitivity.* Evacuated of its initial image, the "tabula rosa" effect demands the viewer project their own ideas and images on the page.

Beyond this point promise is DEMANDED![105]

Protest Photographs

The six protest photographs in the exhibition represented the collaborative partnership between a curator and a community. They also represented the intensity of what Louisville experienced in the middle of 2020 and were hung tightly, in chronological order, beginning with a photograph from June 6 (the day after what would have been Breonna Taylor's 27th birthday) and ending with one from September 24.

— STEPHEN REILY

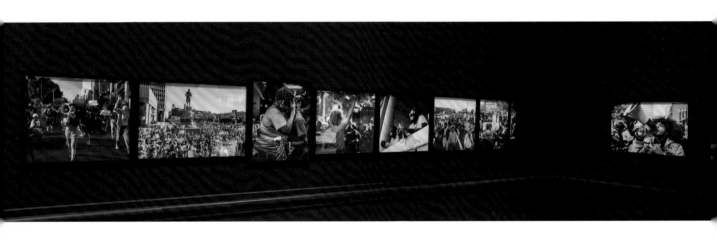

One of the things that kept coming up for me in that process—what we all agreed on—is that we really wanted to represent Black voices, Black stories, Black photographers, and we all met in the middle and not wanting to apologize for that. But also getting images that really captured what was happening, so finding that balance.[106]

— MECCA BROOKS

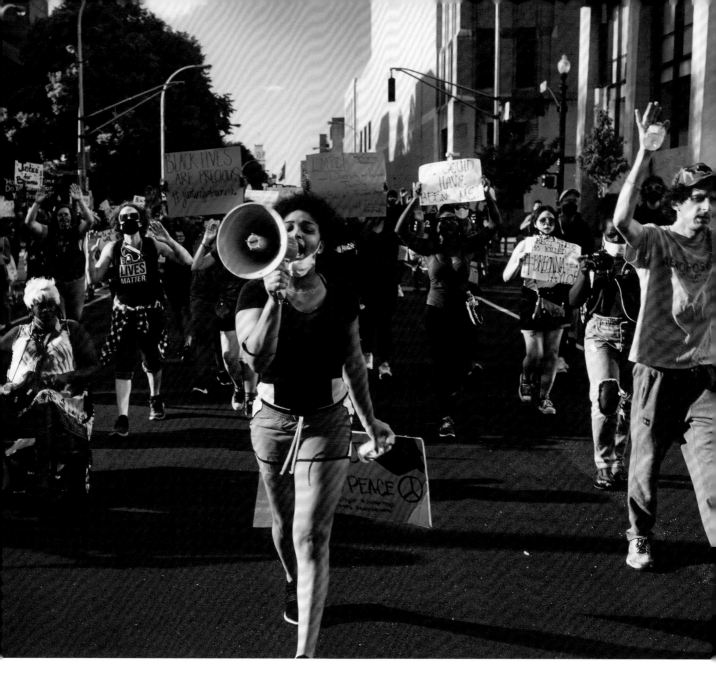

Vibrant color emanates from bright turquoise protest signs that frame the young woman at the center of this image. Erik Branch's eye pulls the viewer into the scene, taking us on a journey to the moments that marked significant days of the protests of 2020. With *Say Her Name*, a female protestor commands the frame, shouting into a megaphone as she leads a crowd of vigilant resistors. Both photographs by Erik Branch bear witness to the multitude of ways that Black women occupied leadership roles in the Louisville protests.

Erik Branch
American, born 1979

Say Her Name, June 6, 2020, (printed 2021)
Giclée print on Hahnemuhle rag paper

Collection of the Speed Art Museum, Louisville, Kentucky. Purchased with funds from the Alice Speed Stoll Endowed Art Acquisition Fund 2021.11.2

LEFT
Photo by Bill Roughen

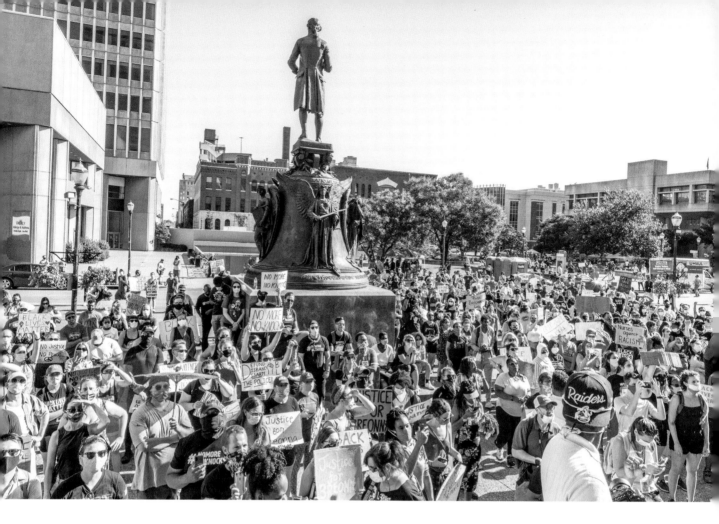

Louisville photographer Tyler Gerth documented the protests for racial justice during summer 2020. Gerth's photograph captures an energized crowd as it gathers to fill a city square. On Saturday, June 27, 2020, Gerth was tragically shot and killed when a gunman opened fire into the crowds gathered in Jefferson Square. The text below was taken from Gerth's Instagram, followed by a statement from his sister, Brittany Loewen.

"When we come together and unite under one banner we can make a change. #blacklivesmatter #blm #cometogether #justice #standup #standtogether #breonnaslaw #everythinglouisville #kentucky #photography"

The image was taken June 11, 2020 as crowds were gathered in preparation for the passing of "Breonna's Law." Tyler described: "To get the evening started, various artists and young people got the crowd excited to watch the law get passed live." There was much joy, celebration and pride this day as it felt like Louisville was setting an example for the nation to follow. As Tyler noted, "This is a great first step."

16 days later, Tyler was taken from us.

Tyler Gerth
American, 1992-2020

Untitled, June 11, 2020
Giclée print on Hahnemuhle rag paper

Collection of the Speed Art Museum, Louisville, Kentucky. Purchased with funds from the Alice Speed Stoll Endowed Art Acquisition Fund 2021.8

Breonna Taylor's story includes all of these people around it, and I wanted to honor them, including the many who were lost to gun violence, such as Tyler Gerth, one of the five photographers. He was shot and killed at the protest. The show was the first posthumous exhibition of his pictures. I worked with his sisters to select the images.[107]

— ALLISON GLENN

BELOW
Courtesy of Building Equal Bridges,
The Tyler Gerth Memorial Foundation

Photo by Tyler Gerth

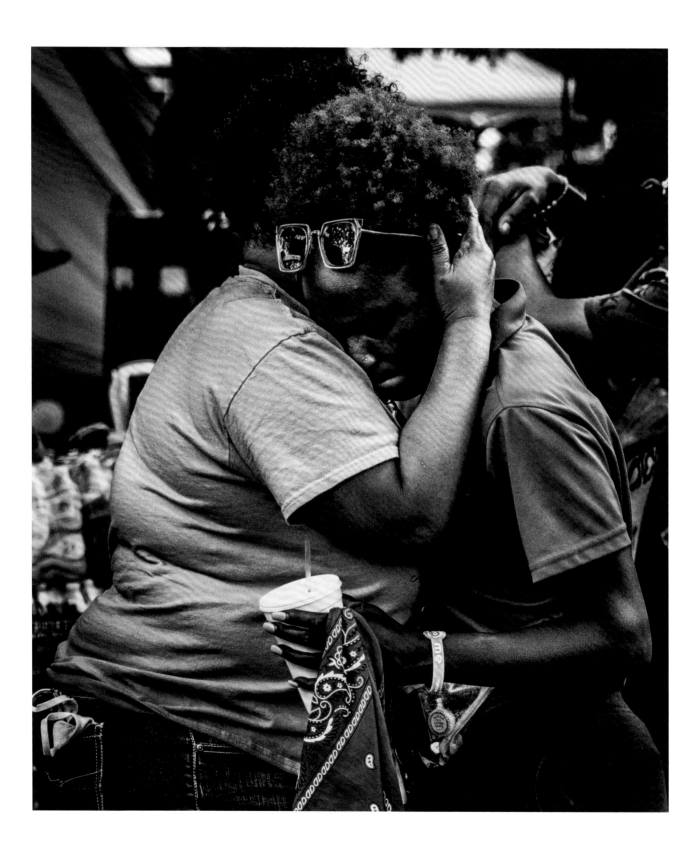

Of course, I wanted to include a Black woman photographer.
T. A. Yero took some very powerful photographs.[108]

- ALLISON GLENN

This black-and-white photograph (and the one that follows) by T.A. Yero were taken on the same day in June, and capture moments both before and during an interaction with the police amidst a peaceful protest organized for mothers and daughters. *Healing* depicts two women embracing at the protest, which, according to Yero, provided an opportunity for strangers to acknowledge one another's vulnerability and offer comfort. Not fifteen minutes later, when protesters and officers from a nearby march crossed paths with this peaceful demonstration, some in attendance had to act swiftly to protect the group from the incoming police force. In *Who Has the Power?*, the young woman pictured with her hand held high in the air was among those who chose to occupy the front lines, so as to protect community members who were more vulnerable and allow them to leave the site before the police moved forward. Her courageous act of resilience stands as an iconic symbol for collective power, care, and grace in the face of adversity.

T.A. Yero
American, born 1986

Healing, 2020, (printed 2021)
Giclée print on Hahnemuhle
rag paper

Collection of the Speed Art Museum, Louisville, Kentucky. Purchased with
funds from the Alice Speed Stoll Endowed Art Acquisition Fund 2021.12.1

———

I get to say, you know, "my pictures were in a museum," but it's
also sad because, my pictures were in a museum because
I witnessed injustice that happened, and the aftermath.[109]

- T.A. YERO

———

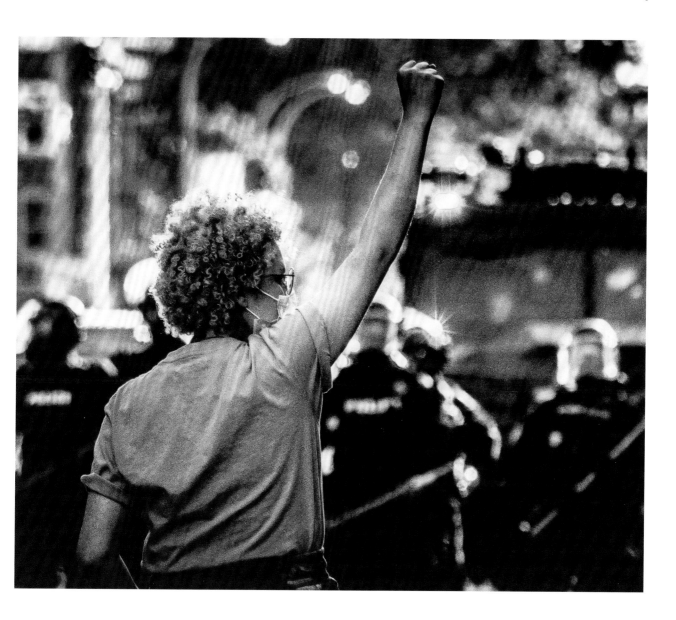

T.A. Yero

American, born 1986

Who has the Power?, 2020, (printed 2021)

Giclée print on Hahnemuhle
rag paper

Collection of the Speed Art Museum, Louisville, Kentucky. Purchased with
funds from the Alice Speed Stoll Endowed Art Acquisition Fund 2021.12.2

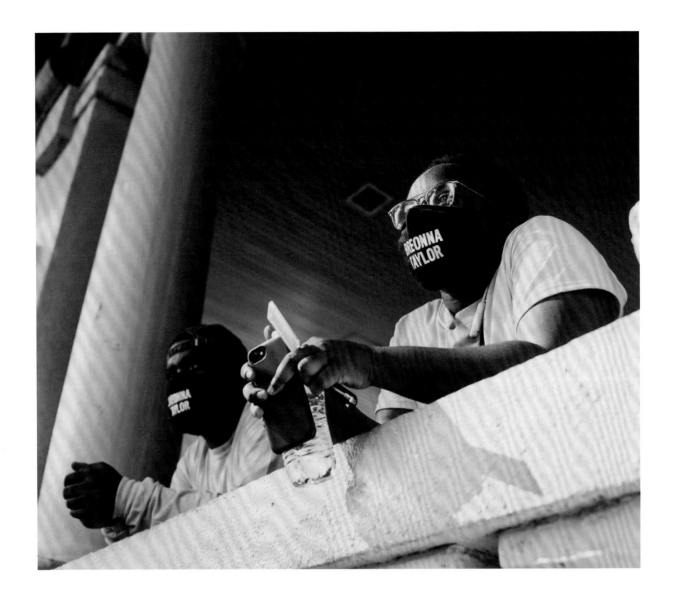

Erik Branch
American, born 1979

We Honor Breonna, August 23, 2020 (printed 2021)
Giclée print on Hahnemuhle rag paper

Collection of the Speed Art Museum, Louisville, Kentucky. Purchased with
funds from the Alice Speed Stoll Endowed Art Acquisition Fund 2021.11.1

Remembrance

How are you celebrating Breonna Taylor's life and keeping her memory alive?

Breonna Taylor
WILL
Change The World!

Promise
Witness
Remembrance

Witness

What have you witnessed in the past year?
What actions are you taking to enact change?

I don't know how long it will take me
to "get over" what we lived through in
Louisville in the summer of 2020 -
being out on the streets and the
square at day and at night - seeing police
violently beat protestors right infront
of my eyes - too terrified to risk
being beaten - the national guard -
the helicopters - the phalanxes of police
in military gear - this country, this
city are all so broken.

Remembrance itself is an act → an action

← I will never let these
Memories go and never
accept not what happened her was at.

Promise
Witness
Remembrance

SPEED ART MUSEUM

Witness

What have you witnessed in the past year?
What actions are you taking to enact change?

PeOple
✓

I witnessed alot of ~~people~~ protesting
due to the death of Breonna Taylor.
—Danae

Promise
Witness
Remembrance

SPEED ART MUSEUM

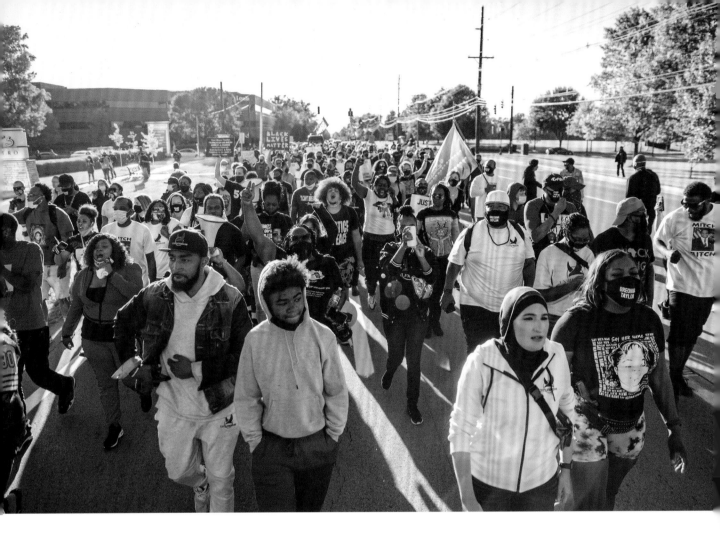

Xavier Burrell captured the tempo of the city before and after the announcement of the grand jury's decision regarding the investigation into the actions of police officers Brett Hankinson, Myles Cosgrove, and Jonathan Mattingly in the home of Breonna Taylor and Kenneth Walker on March 13, 2020. *SAY HER NAME!!* was taken six days before the delivery of the grand jury's announcement, when protestors marched with members of Breonna Taylor's family rallying at the Kentucky Attorney General's Louisville office. Captured from a high overhead angle, Burrell's photograph captures the energy of the crowd as it moves toward Cameron's office.

Xavier Burrell

American, born Germany, 1979

SAY HER NAME!!, September 18, 2020

Giclée print on Hahnemuhle rag paper

Collection of the Speed Art Museum, Louisville, Kentucky. Purchased with funds from the Alice Speed Stoll Endowed Art Acquisition Fund 2021.10.1

Some artworks respond directly to Taylor, like a selection of photos taken by Xavier Burrell at a protest in Louisville after Taylor was killed, where protesters chanted "Say Her Name!"[110]

— *THE GUARDIAN*

The Frontlines (on the following page) shows armed police officers overwhelming a protestor who, according to Xavier Burrell, was pulled off of the sidewalk into the street. Earlier that day, Kentucky Attorney General Daniel Cameron announced the grand jury's decision. Taken from the crowded street, Burrell's photograph captures the Louisville Metro Police Department as they face off with protestors after the verdict was announced, outside of Cameron's office.

Ultimately, Hankinson was the only officer charged with wanton endangerment, for repeatedly firing his weapon into surrounding apartments.

FOLLOWING PAGE
Xavier Burrell
American, born Germany, 1979

The Frontlines, September 23, 2020
Giclée print on Hahnemuhle rag paper

Collection of the Speed Art Museum, Louisville, Kentucky. Purchased with funds from the Alice Speed Stoll Endowed Art Acquisition Fund 2021.10.2

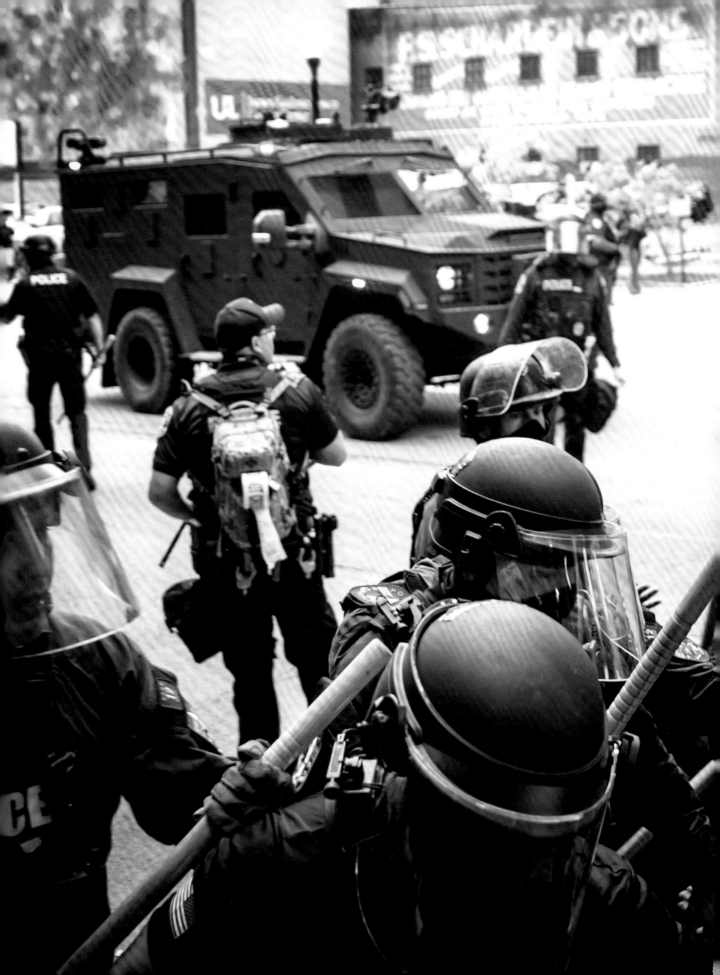

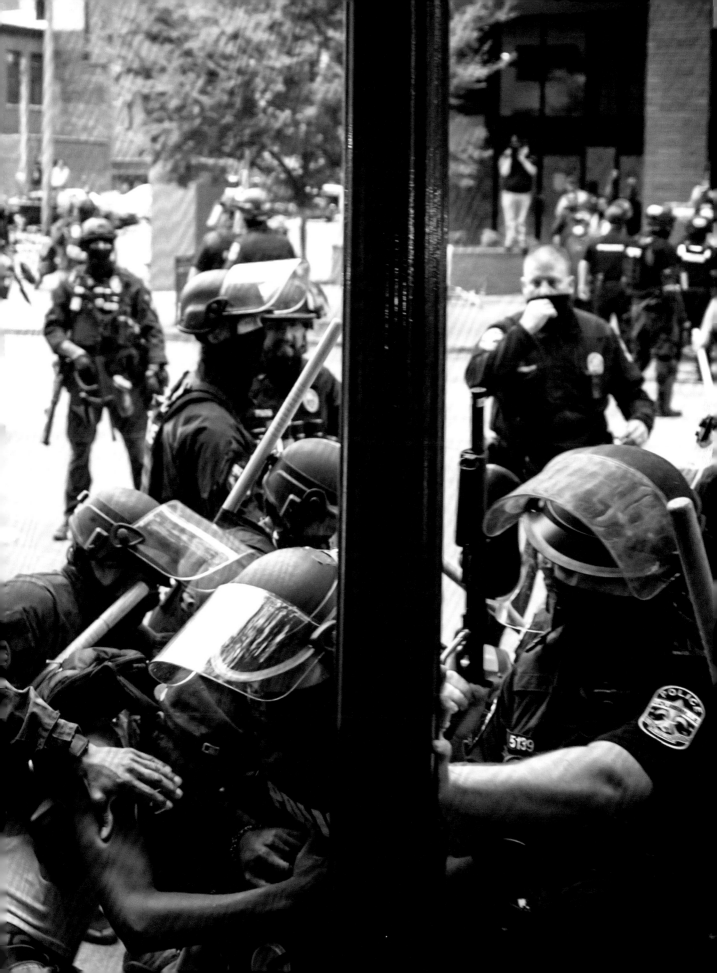

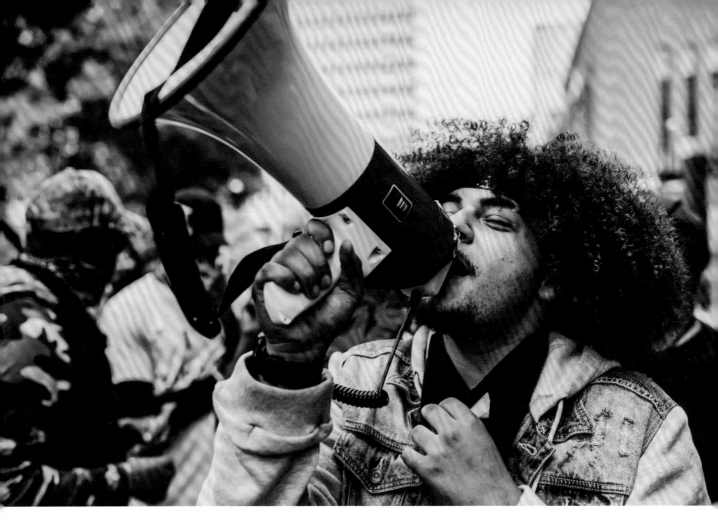

On September 24, 2020, protestors in Louisville took to the streets after Kentucky Attorney General Daniel Cameron announced the indictment of only one of the three Metro Police Department officers involved in the death of Breonna Taylor during a no-knock raid executed on her apartment. In this photograph taken on that day by Jon P. Cherry, activist and community leader Travis Nagdy is pictured with megaphone in hand, demanding the release of jailed protestors.

Nagdy was a key figure in the 2020 Louisville protests for Black lives that began after the murder of Taylor. This portrait shows Nagdy standing in his power as a leader and visionary who was finding his voice within the movement. On Sunday, November 23, 2020, Nagdy was killed by gun violence, in an incident unrelated to the protests.

Jon P. Cherry
American, born 1989

Open Up the Cells, September 24, 2020 (printed 2021)
Giclée print on Hahnemuhle rag paper

Collection of the Speed Art Museum, Louisville, Kentucky. Purchased with funds from the Alice Speed Stoll Endowed Art Acquisition Fund 2021.9

My friend convinced me to bring one of my cameras, noting that this was something that may need documenting. Seven people had been injured in a mass shooting in downtown Louisville. It was May 28, 2020. From that night onward, most of my year would be dedicated to capturing the moments of the movement in the streets, courtrooms, and conference halls of Louisville, Kentucky. Never would I have imagined that less than a year later, some of my work and the work of others documenting protests for racial justice in Louisville would make its way into an art exhibit at the Speed Art Museum."

- JON P. CHERRY

I would say he's one of the leading voices of photographers who are documenting the protests. Jon has been really wonderful in connecting me to people and making certain things visible to me that I might not know, because I'm not from Louisville, I don't live here.[112]

- ALLISON GLENN

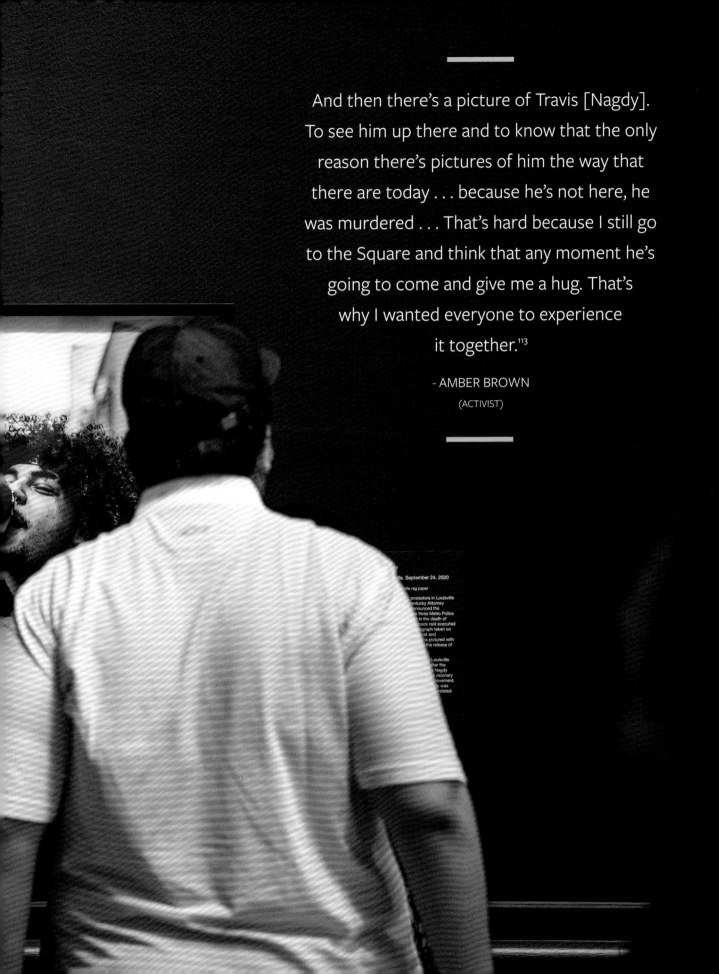

And then there's a picture of Travis [Nagdy].
To see him up there and to know that the only
reason there's pictures of him the way that
there are today . . . because he's not here, he
was murdered . . . That's hard because I still go
to the Square and think that any moment he's
going to come and give me a hug. That's
why I wanted everyone to experience
it together."[13]

- AMBER BROWN
(ACTIVIST)

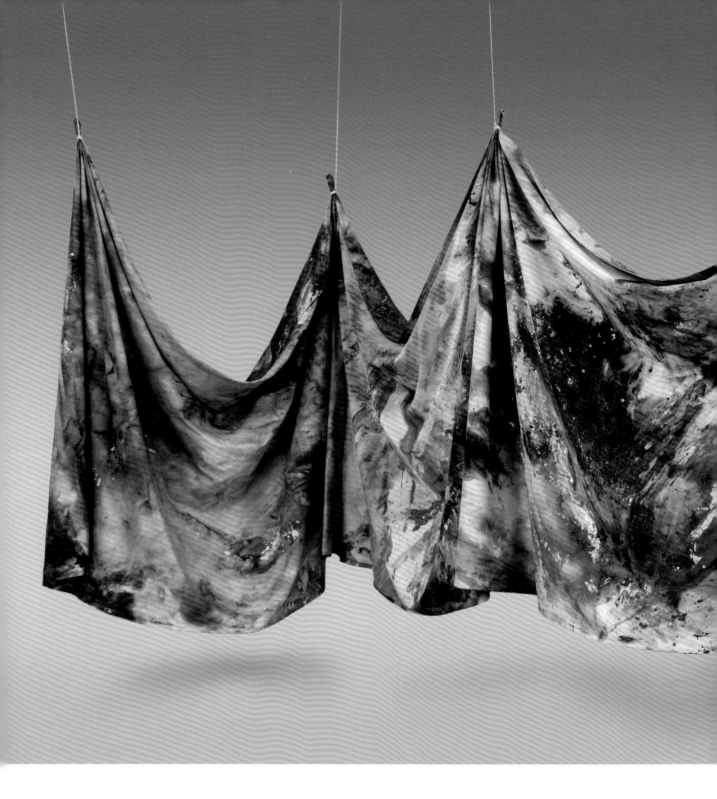

Sam Gilliam

American, born 1933

Carousel Form II, 1969

Acrylic on canvas

Collection of the Speed Art Museum,
Gift of the artist 2013.6

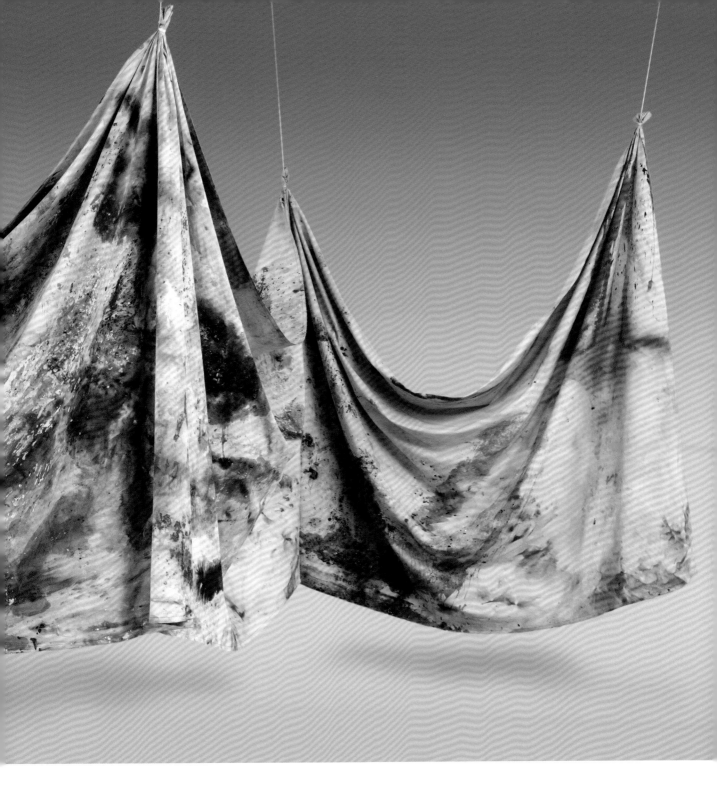

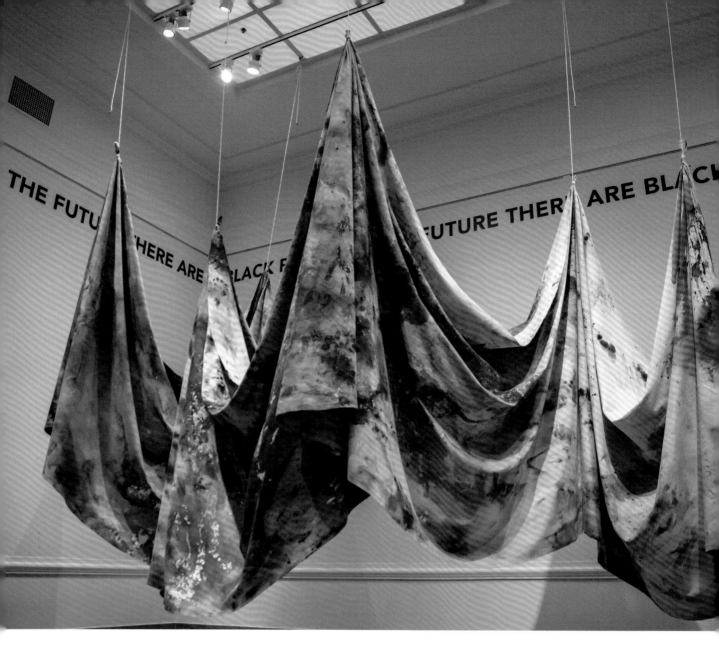

For Louisville-born Sam Gilliam, the imprints of a time and space on the body are imbued within the fields of colorful acrylic paint applied onto these large drapes of fabric. Created during the height of the Civil Rights Movement, Gilliam's *Carousel Form II* can be seen as a protest in itself. It was featured on the cover of *Art in America* (September / October 1970), accompanied by an article titled "Black Art in America." By employing abstraction in his work, Gilliam simultaneously refused the boundaries of the canvas as well as the expectations of representation that were inherent to the discourse around Black artistic production during this time. *Carousel Form II* is one of only eight monumental drape paintings the artist has created.

ABOVE

Photo by Xavier Burrell

ALLISON GLENN: He works with abstraction and the freedom that abstraction provides. It offers an expanded protest of what a painting can be.[114]

—

The larger Black arts movement in the '60s and the '70s was about positive imagery. And there were all these expectations of representation, essentially that Black artists would be making work that showed and depicted Black people, and the Black experience. And Sam Gilliam was not interested in doing that. Sam is interested in paint as a material, and he's interested in moving beyond the boundaries of the canvas and also these expectations of representation placed onto his body. So again, really engaging with pushing beyond, to perhaps protest and witness how his engagement with abstraction paved the way for a younger generation of artists like Rashid Johnson, who is also in the exhibition, to think about abstraction.[115]

—

And there is Sam Gilliam, who grew up and studied in Louisville, protesting against the expectation that his work as a Black male painter was to carry the weight of representation, as part of a movement toward positive imagery. His resisting that becomes a protest in itself. And it sets the stage for someone like Rashid Johnson to work within conceptual art and abstraction, but more freely.[116]

A leading member of the Washington school of color painting, Gilliam has moved away from his early stained canvases (which were indebted to Morris Louis and Kenneth Noland) toward a highly original statement. Like a number of young American painters who are attempting to push abstract painting beyond the easel convention, Gilliam has begun to take his brilliantly spattered and tinted canvases off the stretcher, treating canvas as fabric and draping it informally on the wall or suspending it from the ceiling.[117]
– BARBARA ROSE, *ART IN AMERICA,* SEPTEMBER / OCTOBER 1970

Sam Gilliam's massive unstretched painting "Carousel Form II" (1969) was installed completely off the wall. The colorful fabric draped from the ceiling issued a vibrant call to reclaim expression. When Gilliam began producing these works during the civil rights era, he was asserting his voice through form and, by insisting on abstraction, challenging what a Black artist was expected to make.[118]
– BRIANNA HARLAN, *ART IN AMERICA,* JUNE 2021

The drape, the parabola, the ways that viewers sightlines, the way that you're implicated by walking around this draped canvas, the way that your body and your eye understand the painting in that space is expanded . . . I found out yesterday from the Registrar [Hannah McAulay] that the way we've installed it is the first time that viewers can walk all the way around it, so that's very exciting. It's operating as a sculpture, but lives in the space in between sculpture and painting.[119]

— ALLISON GLENN

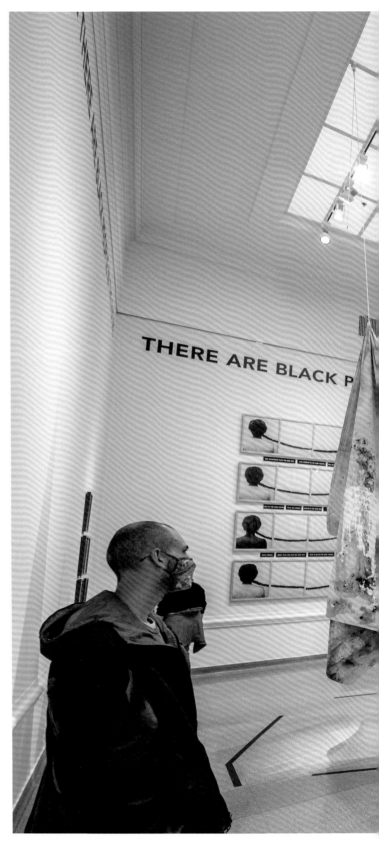

Photo by Jon Cherry

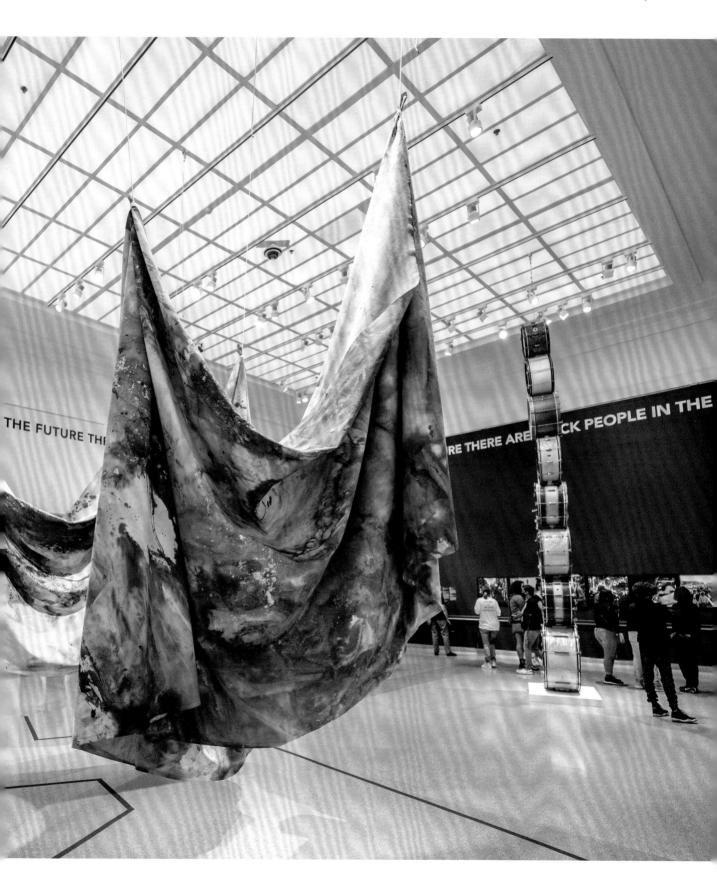

I had Alisha Wormsley in mind because, going back to the portrait and thinking about the ring that Amy painted on Breonna's hand, thinking about this idea of time and the future. And although I imagined, and am sensitive to the fact that, your city is still very much grieving, I wanted to provide an opportunity for the consideration of "future."[120]

— ALLISON GLENN

There Are Black People in the Future is an Afrofuturist interdisciplinary body of work that includes video, prints, collages, sculptures, and billboards. In 2018, the text was removed by developers from a billboard in a newly gentrified neighborhood in Pittsburgh. For Alisha Wormsley, its removal transformed this sentence into a movement, one in which the public is encouraged to use her words for the betterment of the world around them. In this exhibition, Wormsley's vinyl text runs continuously along the top of the gallery walls, articulating Afrofuturist visions of a future that is bright. At the artist's request, the Speed Art Museum invited five Louisville-based cultural producers to respond to this text, which are featured later in this book.

Alisha B. Wormsley
American, born 1978

There Are Black People in the Future, 2011-present
Vinyl letters

Courtesy of Alisha B. Wormsley L2021.13

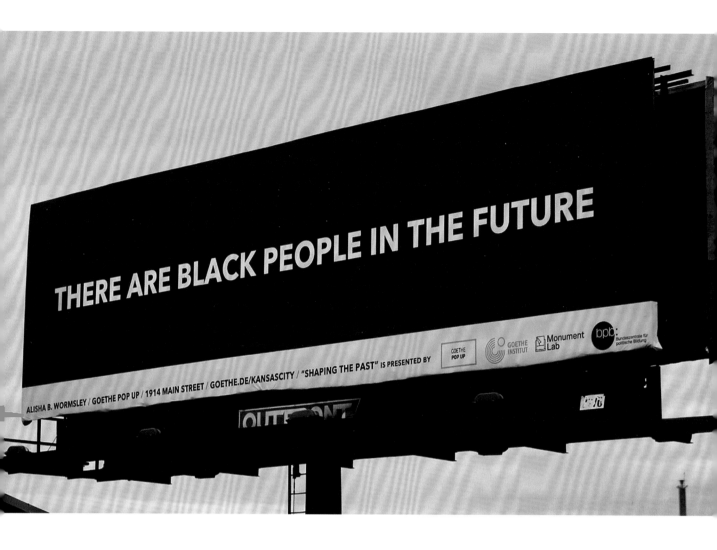

THERE ARE BLACK PEOPLE IN THE FUTURE

ALISHA B. WORMSLEY / GOETHE POP UP / 1914 MAIN STREET / GOETHE.DE/KANSASCITY / "SHAPING THE PAST" IS PRESENTED BY

GOETHE POP UP

GOETHE INSTITUT

Monument Lab

bpb Bundeszentrale für politische Bildung

ALLISON GLENN: This particular text is taken from a billboard that the artist installed in Pittsburg, in a time when an area of town was being gentrified rapidly and people were being pushed out, and primarily Black families and individuals. So this billboard was installed, and it was eventually deinstalled by developers, who felt that the presence of this statement was an affront to the work they were trying to do. And the irony is so thick. Alisha has since offered this text in multiple manifestations—it's been on billboards, it's been on yard signs—and I wanted to actually run this, like ticker tape, across the top of the galleries.[121]

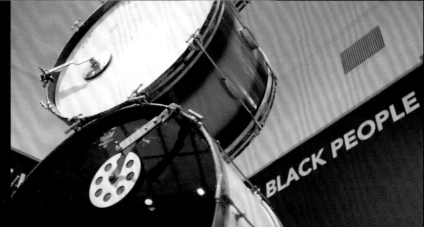

THERE ARE B

BLACK PEOPLE

IN THE FUTURE

"There are Black people in the future." No matter how often America tries to snuff out the stars of Black brilliance, America's Blackness was here in the past, is here now, and will be here in the future.[122]

— RAMONA DALLUM LINDSEY

(STEERING COMMITTEE MEMBER)

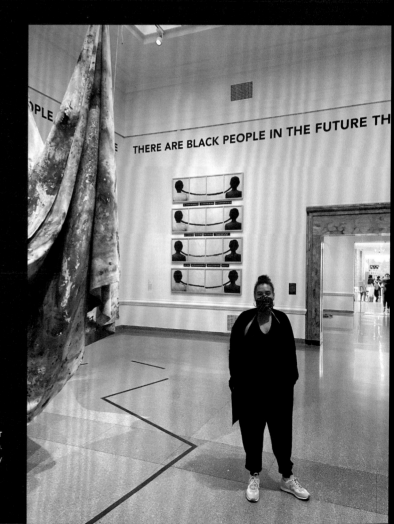

RIGHT
Artist Alisha Wormsley visits the exhibition.
Photo by Stephen Reily

A GUIDED MEDITATION
BY TRICIA HERSEY, THE NAP MINISTRY

Tricia Hersey founded The Nap Ministry in 2016 to examine the liberating power of rest. Through collective rest experiences, performance art, immersive workshops, and social media, The Nap Ministry examines rest as a form of resistance and reparations. With the goal of offering visitors a respite while touring *Promise, Witness, Remembrance* (or afterwards), Allison Glenn invited Tricia Hersey to develop a guided meditation made available to the public by free text link.

This is grief work.

Imagination work.

You are enough.

Rest is a sacred act.

Grieving is a sacred act.

Your body is sacred.

Our bodies are a site of liberation.

Wherever our bodies are, we can find rest.

Breathe. Breathe deeper.

Inhale. Hold for four seconds. And slowly exhale.

Keep breathing.

Thank you for living.

Thank you for resisting.

Thank you for thriving.

Thank you for resting.

You are not what white supremacy told you.

It is a lie.

You can rest.

You are entitled to rest.

You are enough now.

We are all connected.

There is a quiet freedom in your heart.

There is a quiet freedom in your rest.

You can just be.

You are enough.

Our grief is a healing force.

Our rest is a healing force.

Keep breathing.

Keep living.

Rest is a meticulous love practice.

Our collective rest will save us.

Our collective imagining has saved us.

Rest is your divine right.

Rest is a divine right.

Rest is a human right.

You are enough.

This is a moment of care.

This is a moment to listen.

This is a moment to grieve.

This is a moment to lament.

And may a soft space to rest open up

in your heart.

May deep rest come to us always.

Hold on. Hold On.

You are enough.

The systems cannot have you.

Declare the systems cannot have us.

In our living, we are divine.

In our death, we are divine.

The end is just the beginning.

You can soften.

You can rest.

Our radical community care will save us.

Our deep connected care has saved us.

Keep connecting.

Keep breathing.

Breathe in slowly from your belly.

The deepest breath, up through your chest.

Hold.

Imagine a new world.

Exhale.

Imagine a new world rooted in liberation.

You can just be.

You are entitled to rest.

We are enough.

Keep breathing.

Keep resting.

Thank you for living.

You are enough now.

Rest.

Silence is a sound.

Slowing down is our divine right.

This is a pause.

A moment of care.

A moment of deep imagination.

A moment to rest.

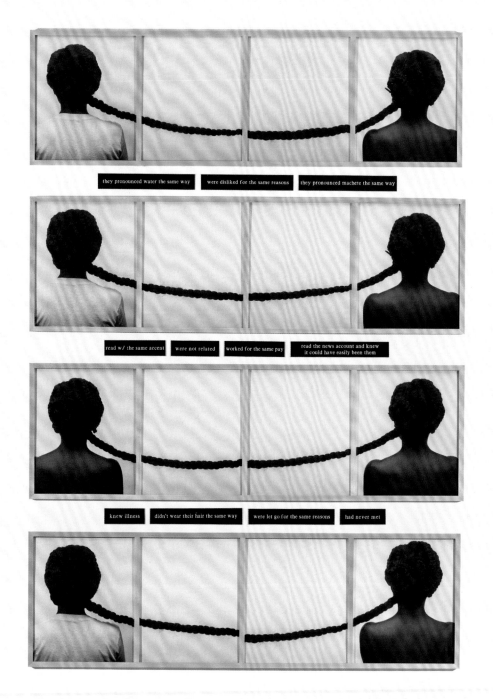

> It speaks to the assumptions, the personal and ubiquitous, and it really asks you to ask questions about the assumptions you might make about a body based on the things you don't know.[123]

> — ALLISON GLENN

"were disliked for the same reasons"
"were not related"
"read the news account and knew it could have easily been them"
"had never met"

In Lorna Simpson's *Same*, a rhythmic, repeated image of the backs of two women with their hair braided together frames the edges of a series of color Polaroids. These women have similar skin tones and hair texture. Without the inclusion of their facial features to distinguish them from one another, we are left wondering who these women are, if they are related, friends, strangers, or perhaps the same person. All too easily, a case of mistaken identity, or assumptions about a person based on their skin tone, can lead to horrific outcomes. It is a common experience among people of color in a white supremacist society to experience this reduction, or erasure, of their facial characteristics due to implicit bias. Interspersed within the photographs are statements that Simpson uses to anchor the work in conversations on assumptions that are made about Black women based solely on appearance.

Lorna Simpson
American, born 1960

Same, 1991
16 color Polaroids in four frames
with 11 plastic plaques

Collection of the Speed Art Museum, Louisville, Kentucky.
Gift of the New Art Collectors 1991.22.2 a-e

When I first started doing my research, I went back to every article,
I went back to the *Vanity Fair* interview between Ta-Nehisi [Coates]
and Tamika Palmer, and there was one section where Ms. Palmer talks
about Breonna's grandfather being unable to watch the news because,
at the time, the media portrayal was that she was a drug dealer. It broke
his heart because he knew that his granddaughter was not that person.
And this work [*Same*] really spoke to me, for so many reasons.[123]

—

It points to this idea of assumptions that are made about certain
people and certain bodies, based on how people look. And it's really
quite straightforward, right? And within this series of stacked Polaroids,
the artist has placed text. And so, some of the text is "were disliked
for the same reasons," "were not related," "read the news account
and knew it could have easily been them." I don't think I really
have to explain the connections there.[124]

— ALLISON GLENN

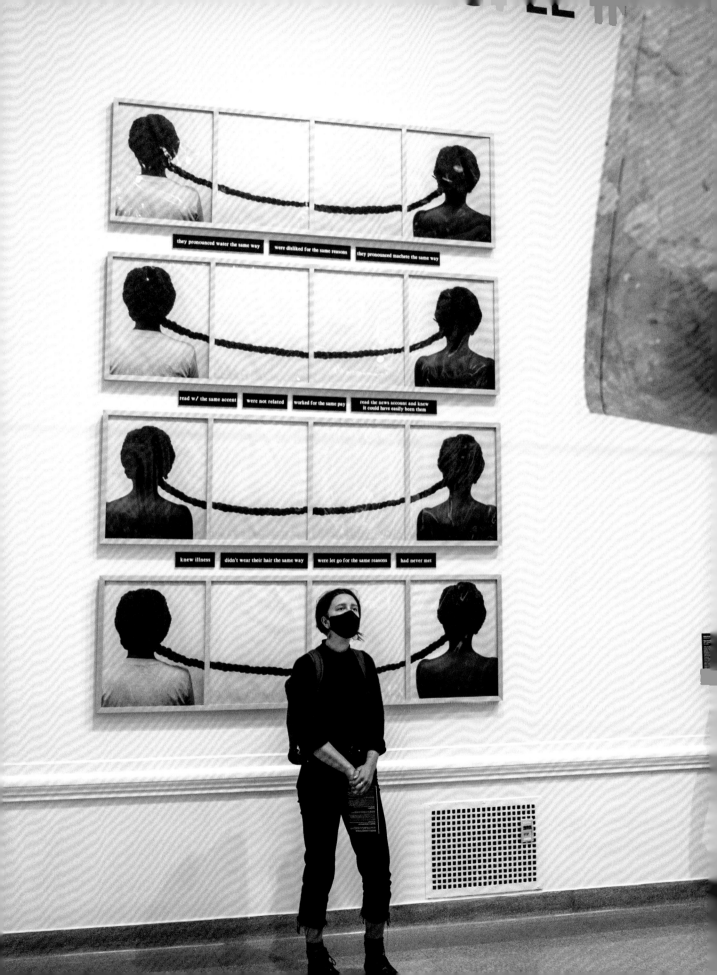

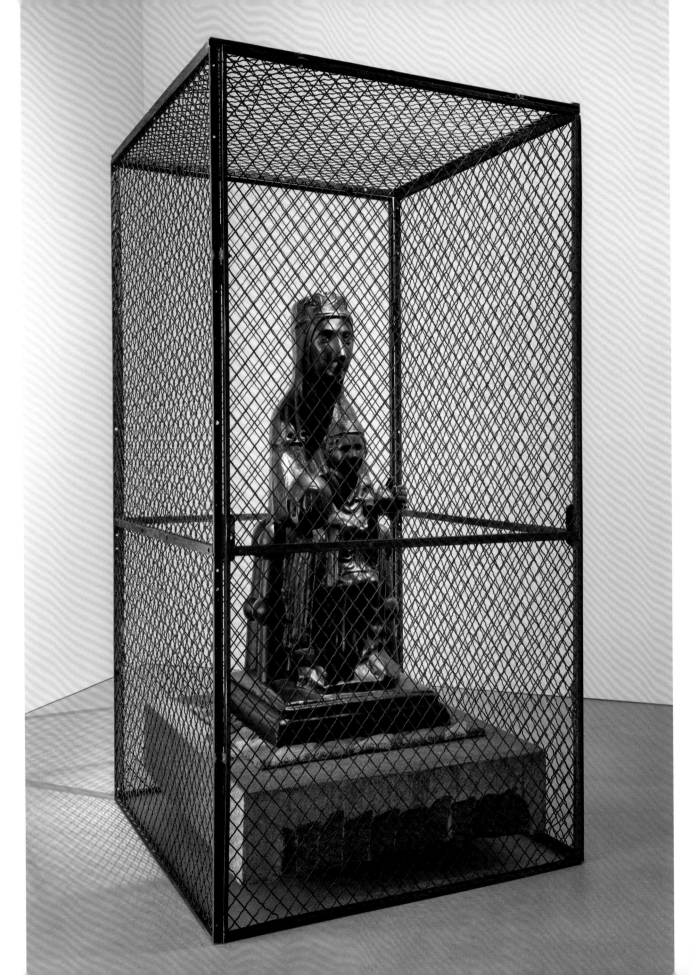

In this work by Theaster Gates, a bronze sculpture of Black Madonna and Child are surrounded by a fence enclosure. Despite the use of very heavy materials, the artist has created a form that seems to levitate. Is this cage intended to protect or restrict? The title is taken from the first line of "Alright," a song by Kendrick Lamar that is a direct reference to Alice Walker's book *The Color Purple* (1982) and its film adaption (1985) starring Oprah Winfrey. At the height of the film, Winfrey's character Sofia chooses to fight back against adversity, stating "Alls my life I had to fight . . ." Both Lamar's lyrics and Sofia's defiance are a protest, rejection, and reminder that—despite all odds—one can overcome. Its usage by Gates points to the strength and perseverance of Black women.

Theaster Gates

American, born 1973

Alls my life I has to fight, 2019

Metal, bronze, Cerulean granite, and carpet

Gray, Chicago / New York and Tia Collection, Santa Fe L2021.17

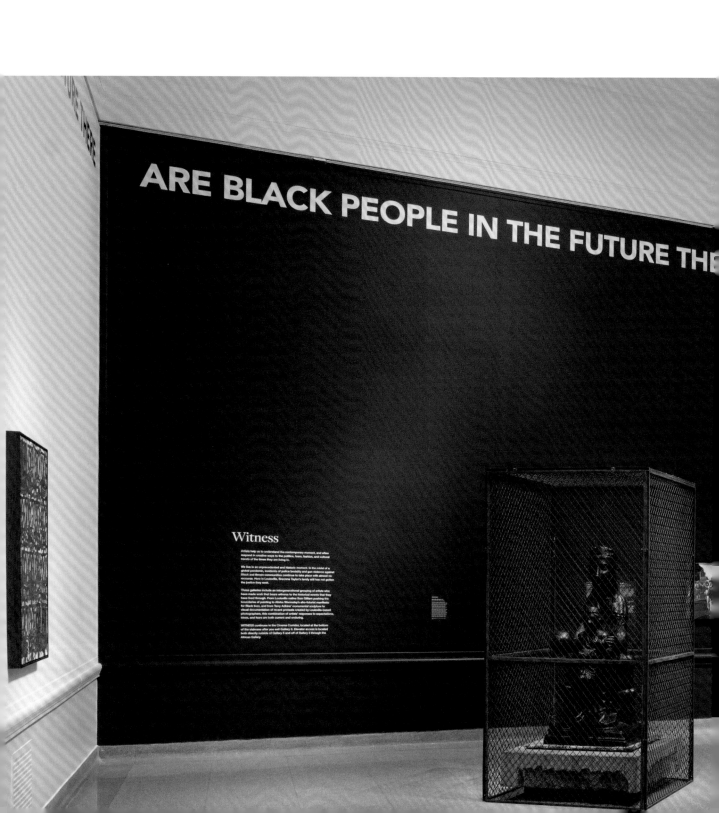

ARE BLACK PEOPLE IN THE FUTURE THE

Witness

Artists help us to understand the contemporary moment, and often respond in creative ways to the politics, lives, fashion, and cultural trends of the times they are living in.

We live in an unprecedented and historic moment. In the midst of a global pandemic, incidents of police brutality and gun violence against Black and Brown communities continue to take place with almost no recourse. Here in Louisville, Breonna Taylor's family still has not gotten the justice they seek.

These galleries include an intergenerational grouping of artists who have made work that bears witness to the historical events that they have lived through. From Louisville native Sam Gilliam pushing the boundaries of painting to Afrika Warhosky's afro-futurist manifesto for Black lives, and from Terry Adkins' monumental sculpture to visual documentation of recent protests created by Louisville-based photographers, this combination of artists' responses to expectations, ideas, and fears are both current and enduring.

WITNESS continues in the Cinema Corridor, located at the bottom of this staircase after you exit Gallery 5. Elevator access is located both directly outside of Gallery 5 and off of Gallery 3 through the African Gallery.

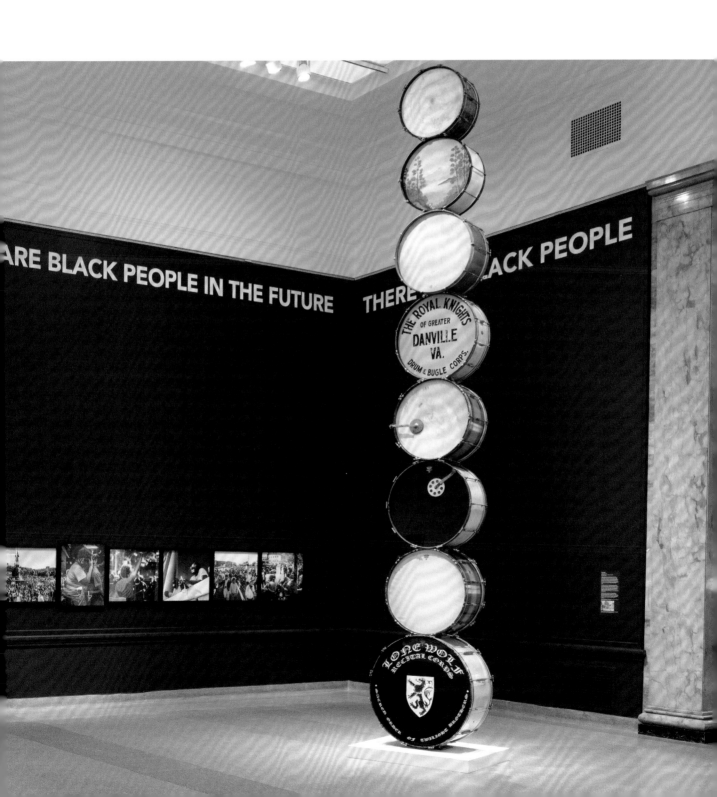

———

I have to say that almost every artist that I reached out to
jumped at the opportunity to participate however they could.
The artist Rashid Johnson's contribution was through
his private collection.[125]

- ALLISON GLENN

———

This oil on linen painting is part of a larger series of works that Rashid Johnson began during the onset of the global coronavirus pandemic. Here, Johnson has updated the visual language of his long-established "Anxious Men" series, in which hurried, expressionistic marks create abstracted representations of faces that express the fundamental tensions and traumas that course through contemporary life. The organizing principle of this composition is the minimalist grid, a form that allows Johnson to disrupt art histories that often exclude people of color.

Here, thick, bright red curvilinear strokes build upon the painting's surface, pointing to the heightened state of tension and trauma around the contested outcome of the 2020 U.S. Presidential election.

Rashid Johnson
American, born 1977

Anxious Red Painting, November 3, 2020, 2020
Oil on linen

Courtesy of the artist L2021.6

Kahlil Joseph's *BLKNWS®* is an endeavor into what the artist has called "conceptual journalism." Conceived of as a continuously updated stream, *BLKNWS®* consists of digital information—including cell phone videos, Instagram stories, photographs, archival footage, news reels, and Internet memes—that Joseph and other fugitive newscasters collage together into an unending Black news stream. In 2020, the country witnessed numerous accounts of police brutality and violence against Black people often that rapidly circulated through the 24-hour news cycle. Commenting on media biases while operating on the premise that all new information can be news, *BLKNWS®* carves out an actual and conceptual space to center Blackness, providing a remedy to the endless barrage of media inaccurately portraying Black life, culture, and people.

Kahlil Joseph
American, born 1981

BLKNWS®, (2018–ongoing)
Two-channel fugitive newscast

Courtesy the artist L2021.7

You walk down the stairs and Kahlil Joseph's *BLKNWS®* is on view, and this is intentional for many reasons. Kahlil's work, he calls it "conceptual journalism" and is a continuously updated stream . . . it includes cell phone videos, Instagram stories, photographs, archival footage, and news reels that Joseph and other fugitive newscasters collaged together in an unending Black news stream. So, it carves out an actual conceptual space to center Blackness, providing a remedy to the endless barrage of media inaccurately portraying Black life, culture, and people. And so, it imagines a space, it imagines a future, it imagines a sight that centers and decenters at the same time.[126]

— ALLISON GLENN

What was really exciting to me, was thinking about artists who are already engaging with some ideas around media and representation. And this work by Kahlil Joseph is called *BLKNWS*®, and what's unique about this particular project is that it's what he calls "conceptual journalism." It's around this idea that all digital information that can be culled from the Internet, is news, and also—this particular work provides a platform for what he calls "fugitive newscasters" to create content. This particular work is very strong because it imagines a different perspective on representation in media.[127]

— ALLISON GLENN

Remembrance

The final section of the exhibition, in two galleries, included artworks created in remembrance of lives lost too soon to gun violence. In the first gallery, a selection of artworks responds to the Mother Emanuel A.M.E. Church shooting in Charleston, South Carolina in 2015, the police killing of Michael Brown in Ferguson, Missouri in 2014, and the overwhelmingly common loss of young Black men to gun violence in America. The final gallery includes Amy Sherald's portrait of Breonna Taylor, commissioned by Ta-Nehisi Coates for the September 2020 issue of *Vanity Fair*, a painting seen by the public for the first time in this exhibition.

"Remembrance" is a section that looks at artworks that have been created to honor those lost to gun violence and/or police brutality, and their legacies.[128]

—

I wanted to include artists who have created works that are in either direct reference to incidences of police brutality and/or gun violence in Black and Brown communities, or broadly.[129]

- ALLISON GLENN

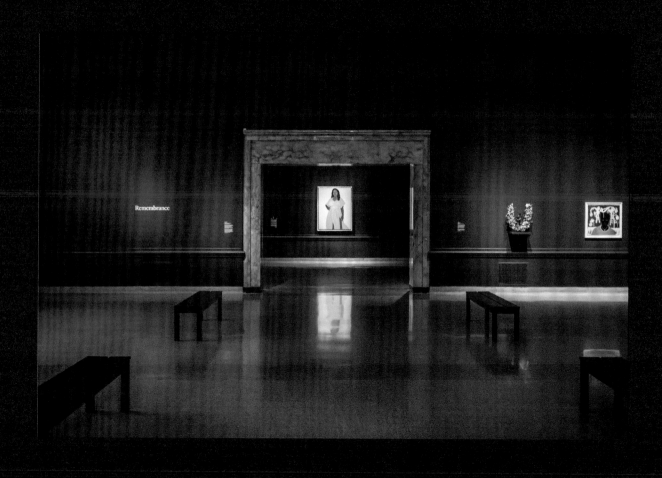

In 2015, a racially-motivated mass shooting at Emanuel African Methodist Episcopal Church in Charleston, South Carolina killed nine people—including senior pastor and South Carolina state Senator Reverend Clementa Pinckney—during a Bible study session in the basement of the church.

Jon-Sesrie Goff created *A Site of Reckoning* during the aftermath of this terrorist attack, carried out by a self-identified White supremacist.

In Goff's film, the prominence of the church (often referred to as "Mother Emanuel") retains its position as the center of community. Interior and exterior views of the church are accompanied by Sonia Sanchez and Sweet Honey in the Rock echoing the bittersweet lines from *Stay on the Battlefield*. The narrative is a personal one. Rev. Pinckney was a mentor to Goff, and Goff's father, Norvel Goff, Sr., served as the interim minister of Emanuel A.M.E. immediately following the death of Rev. Pinckney.

Jon-Sesrie Goff
American, born 1983

A Site of Reckoning: Battlefield, 2016
High-definition video, with sound Duration:
4 minutes 47 seconds, looped

Courtesy of the artist L2021.5

Creating *A Site of Reckoning: Battlefield* was my way to heal,
my way to say "Look, these are the eyes through which I'm
experiencing this moment." When my father preached the first
Sunday after the shootings, he had a line in his sermon that said
"The blood of the Mother Emanuel Nine requires us to stay on
the battlefield until there is no more fight to be fought." That
was just playing in my head. And then I landed on the song and
then I recalled Sonia Sanchez and Sweet Honey in the Rock's
version of it, and it came together in a single night. It may have
felt like a moment of inspiration, but it had been building for my
lifetime and generations before me. So, when I was finally able to
assemble these images and this sonic experience, this was just
my way of healing, you know. And I did it for me selfishly, so it
wasn't to necessarily speak to an audience, but it was to
release these images that weren't just in my camera
but are branded in my mind.[130]

— JON-SESRIE GOFF

The film is really beautiful and it has a wonderful audio component that, again, will bring you through the space, almost like a processional.[131]

— ALLISON GLENN

LEFT
Photo by Xavier Burrell

FOLLOWING PAGE
Photo by Jon Cherry

The symbolic nature of transformation that the butterfly represents is, for María Magdalena Campos-Pons, embedded in the spiritual and natural realms. For the artist, the butterfly holds memory and ancestral wisdom, and therefore represents her belief that Breonna Taylor's beauty and goodness are still with us. The central panel depicts the eyes of a butterfly, serving as a metaphor for a "seer," knowledge, and protection. Flanking the eyes are two photographs of botanical elements, which the artist has used in her work for decades, in various ways. There is something about the narrative or geography of the flower that captivates the artist, and connects back to the butterfly, nature, and life.

María Magdalena Campos-Pons
American, born Cuba, 1959

Butterfly Eyes (for Breonna Taylor), 2021
Mixed medium, watercolor, ink, gouache,
digital print on Arches archival paper

Collection of the Speed Art Museum, Louisville, Kentucky. Purchased with funds from the Alice Speed Stoll Endowed Art Acquisition Fund and the generous donations of Jeffrey and Susan Callen, Sally and Stanley Macdonald, Dr. Rebecca Terry and Mr. Pete Thompson, Victoria and Paul Diaz, Juliet Gray and Mathias Kolehmainen, Lopa and Rishabh Mehrotra, Sarah and Chuck O'Koon, Ruth Simons, and Linda and Chris Valentine 2021.7

THE RISE OF BUTTERFLY EYES
MARÍA MAGDALENA CAMPOS-PONS, PUBLISHED ON MAY 13, 2021 IN BURNAWAY

Luminous splash of colors, a light stroke in midair; flipping and

folding a touch so delicate, a contour of such precision,

Yesterday a cocoon today a rapturous, ebullient expanding wings

Tracing spaces not yet inhabited.

Edges in soft transitions from blue to black, purple, gold

Saffron, ochre, gold drip from the lips red corner in the ascension.

Infinite's loops, vertigo. A delirious smile. They hit the body

The Eyes multiplies with blizzard force, there is storm of jewel gazes.

María Magdalena Campos-Pons, Nashville 2021.[132]

The reason to include Marshall in this section, is also
that Amy speaks often about the rich, dark skin tones
that Kerry James Marshall uses when depicting people.
And in the similar fashion, Amy has this grisaille, this
kind of gray tone that she uses to depict people and
skin tones. So there's a nod to the way that Kerry James
Marshall has influenced someone like Amy Sherald, the
way that this portrait represents, for Marshall, young
Black men broadly, and how it's in dialogue with other
artists who have made work in homage to loss.[133]

— ALLISON GLENN

Lost Boys: AKA BB is part of Marshall's *Lost Boys* portrait series, which derives its name from the band of young orphaned characters in J.M. Barrie's book *Peter Pan*. Marshall reframes Peter Pan's Neverland, presenting America as a place where oppression, incarceration, and death deprive young Black men of the opportunity to grow up. Through referencing the reverential, memorial forms of ancient Egyptian funeral portraits and Renaissance icons, Marshall imbues his work with a tone of loss. The emphasized Blackness of Marshall's figures directly responds to and counters a lack of representation in American art.

Kerry James Marshall
American, born 1955

Lost Boys: AKA BB, 1993
Acrylic and collage on canvas mounted on board

Art Bridges Collection L2019.9

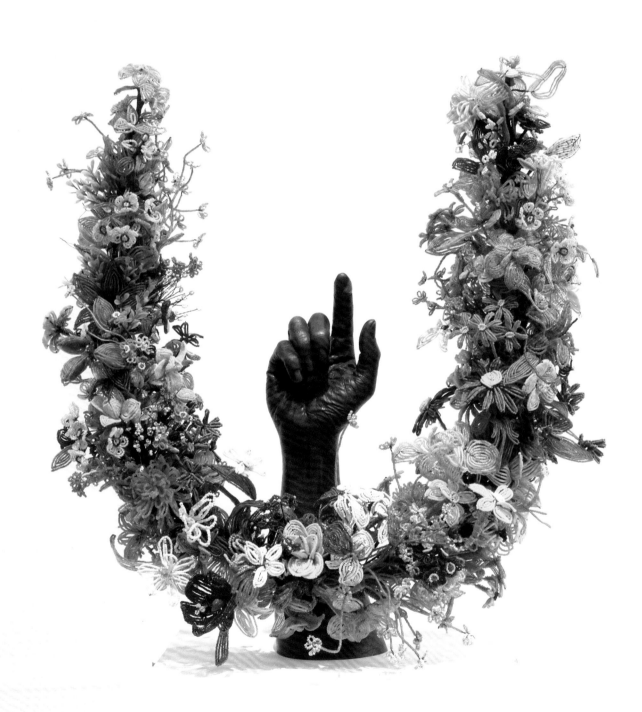

He made this artwork after hearing about the shooting of
Michael Brown. A cast of his hand forms to a point with his
fingers, forming a gun. For me, it's about the perception of
"armed and dangerous." It could have been anyone.
How perception can inform reaction.[134]

— ALLISON GLENN

Both a memorial to victims of gun violence and a call to action, *Unarmed* features Nick Cave's raised hand, cast as if pointing a gun. Following the fatal shooting of Michael Brown in 2014, protesters across the country raised their own hands, adopting the rallying cry "hands up, don't shoot." To this day, this gesture of protest unites those who believe that Black lives matter.

For Cave, these gestures of protest mark a refusal to engage with power on power's terms, serving as the catalyst for change to radically alter our collective condition and make freedom for all a reality.

Nick Cave
American, born 1959

Unarmed, 2018
Sculpture, cast bronze,
metal and vintage beaded flowers

Courtesy of the artist L2021.3

LEFT
Courtesy of the artist and
Wendi Norris Gallery, San Francisco

Hank Willis Thomas' understanding of cultural memory is deeply personal. Over time, through distinct bodies of work, Thomas has addressed a sense of longing and loss that resonates among all people. The words seen here were written in cursive on the back of a vintage postcard the artist found at the Amistad Center for Art and Culture at the Wadsworth Atheneum Museum of Art. The front of the postcard was a full-length photograph of a man. Studio-style portraits like this were widely distributed within the Black community from 1900 to 1919. Much like Kahlil Joseph's *BLKNWS®* assumes the control of the circulation of images created by Black people, by exhibiting the desire to represent oneself and be known from one's perspective, the postcard and statement assume a certain control of one's image.

Hank Willis Thomas
American, born 1976

Remember Me, 2014
Neon

Courtesy of the artist and Jack Shainman Gallery, New York L2021.12.1

I made this portrait for her family.[135]

— AMY SHERALD

This painting of Breonna Taylor by Amy Sherald exemplifies the power of portraiture. Here, Breonna's contrapposto pose, with her hand confidently poised on her hip, suggests a quiet calm and ease; she returns your gaze. Her skin tone is painted in Sherald's signature grisaille, which, for the artist, subverts associations made between race and skin tone. Working closely with Taylor's mother, Tamika Palmer, Sherald developed an understanding of who Taylor was to her family. The distinct choice to use turquoise as the color of both the background and dress was, for Sherald, an opportunity that, "allow[s] you to focus on her face and look in her eyes."

Sherald's portrait includes the engagement ring that symbolized the love that Breonna's partner, Kenneth Walker, had for her and the future they imagined together; this reminds us that this is a story about love as much as it is about loss. For the artist, Taylor "has this otherworldly feel, kind of ethereal, very peaceful."

Sherald came to national prominence in 2016 for painting the official portrait of First Lady Michelle Obama. From its earliest days, portraiture was often reserved for those of wealth and power, including the monarchy, wealthy merchant class, and religious leaders. Capturing Breonna Taylor's essence in a portrait speaks to and honors the role her story, image, and likeness has had— and continues to have—on the world.

Amy Sherald
American, born 1973

Breonna Taylor, 2020
Oil on canvas

The Speed Art Museum, Louisville, Kentucky. Museum purchase made possible by a grant from the Ford Foundation; and the Smithsonian National Museum of African American History and Culture, purchase made possible by a gift from Kate Capshaw and Steven Spielberg / The Hearthland Foundation 2021.2

RIGHT
Photo by Joseph Hyde

Remembrance

How are you celebrating Breonna Taylor's life and keeping her memory alive?

Her portrait takes my breath away.

Promise
Witness
Remembrance

Remembrance

How are you celebrating Breonna Taylor's life and keeping her memory alive?

Continue saying her name and continue demanding justice. She is to be shown love through our continued actions. But also, by holding moments of silence in sadness, to continue grieving, to strive for a healthier community.

I celebrate Breonna Taylor's life by showering love to those alive now. And stand in confidence as her portraits show.

Promise
Witness
Remembrance

SPEED ART MUSEUM

Remembrance

How are you celebrating Breonna Taylor's life and keeping her memory alive?

Thank you for this memorial

Promise
Witness
Remembrance

SPEED ART MUSEUM

⸻

Amy Sherald's portrait of Breonna Taylor
may prove to be the most important
painting of the 21st century.

— *FORBES* [137]

⸻

AMY SHERALD: Producing this image keeps Breonna alive forever.[136]

—

I made the portrait for Breonna Taylor's family, first and foremost, and so it was important for this work to be seen first in this community, in Louisville. I want to honor Breonna's memory, and to provide some inspiration to the ongoing struggle for justice.[138]

ALLISON GLENN: I knew I wanted it to be by itself . . . After discussions with the National Advisory Panel, it became clear that a really great impact would be to see the Sherald the minute you walked into the galleries . . . It's really about the portrait of Breonna Taylor being the guiding light that brings you through the exhibition. And it really points to how the painting really is the anchor because it's the portrait of a woman who lived in Louisville, whose family lives in Louisville, who is the reason the show is happening.[139]

STEPHEN REILY: And what we saw over time was that by placing the portrait within sight at all times, you may lose it for a moment as you move through the galleries, but then there it is again. By the time you approach it, you've actually accomplished some grieving, and some processing. In fact, we were anticipating and wanting to support people with very strong emotional reactions, and they did have them, but honestly, not quite to the degree that we expected. I think it's because of they were able to see the portrait coming, and knowing they were going to have this encounter once they reached the fifth and, more or less, the final gallery of the exhibit.[140]

ALLISON GLENN: The wall color will be what's called "Galaxy Black," it's like a purple-black. And this is because one of Breonna's favorite colors was purple.[141]

Amy was definitely very careful in her tender
portrayal that includes the engagement ring,
that reminds that this is a story about love,
as much as it is about loss. Whether it's the love
of her family, the love of her partner, the love
of her friends, and it's important that
we focus on that too.[142]

— ALLISON GLENN

LEFT & RIGHT
Photos by Joseph Hyde

STEPHEN REILY: I walk 180 degrees around her and she's looking at you whatever angle. The humanity of this face created by oil paint is incredible. Tell me how you do it?

AMY SHERALD: I wish I knew how. I go in the studio and I do what I do. But if I had to name it, I think that it's probably the fact that there are so many layers of paint on the face. I see that a lot of artists work fairly quickly and they're able to render her whole face in a short amount of time, but for me it's something that I take day by day, and I usually spend about two weeks—two weeks alone—on the face. And I psychologically can't move on to the rest of the painting until the face is done, so I start at the top and I work my way down. And I go from dark to light, and by, I don't know, day 12 or day 13, I'm usually dry scumbling highlights on the skin. I usually go from a process of painting to what I call "unpainting," because I'm not actually loading my brush with paint and putting paint on, but I'm scrubbing paint on and kind of wiping it off a little bit, to get the effect that I want of skin—the texture of it and suppleness.[143]

STEPHEN REILY: So, the depth is added at the very end. You use a dry paint.

AMY SHERALD: Yeah, the light is able to capture the smallest things. Just a little light around the lip, or you know this area right here on her chin, and the fullness in her cheeks. Those are the things that I don't like to use hard highlights for. I like the light to look natural on the skin and that's the way that I've taught myself how to do it.[144]

AMY SHERALD: I can't put it into words—but I had to go back and I spent probably two days trying to mix the dress, because the background color was easy enough, but getting that dress to glow the way that it does. I couldn't just use a regular turquoise color—it's the hardest I've ever worked to mix the color, actually. I feel like I should probably tube it, because I don't know if I can do it again. I didn't use white, I think that's one thing that I decided to take away, was not to use white. Because it tends to flatten things out, so I use an Old Holland yellow light. I usually use that in place of white in a lot of my colors, because it's like the palest, palest, palest of yellows and it really gives everything a glow. And then the right balance of blues, and then finally I found something that just worked. It was hard. It really was.[145]

—

I feel like there's some outside force that's—call it what you want—but you're tapping into something when you're working. And being able to tap into that energy, whether it be a model that's in front of me, or whether it be Breonna's energy from all the pictures that I study from her, from a couple of videos that I saw that had her voice, where I was able to hear her laugh . . . All those things kind of feed into the psychology of making the work. Artists and painters that have the capacity to become conduits for that kind of energy, the work is really special.[146]

—

The wind was blowing when I photographed the model. It was like five minutes from a thunderstorm, and it actually started to rain when we were photographing, and so I would get a gust of wind, and I would try to capture that, because I was like, "it would be great if this painting could move, and if it wasn't still, and it had the energy that portrayed her presence."[147]

—

I thought about justice. I thought about the Statue of Liberty. There's so many things that that came into my mind. I thought about Joan of Arc. Women in these strong stances, a powerful stance, that are offering up hope, in a way. I think Lady Justice was one image. . . . And a Greek goddess.[148]

—

You know, for me, in all of my work, it's important that the subject be present with the audience. Especially in this one. I don't think I ever will make a painting where at least one of the subjects isn't engaged with the audience. Especially with her, it's a confrontation— a gentle confrontation—and a conversation with the viewer about her life and who she represents now. Painting it any other way wouldn't have served her the way that I wanted to. And leave her legacy in this way, the way that I wanted to.[149]

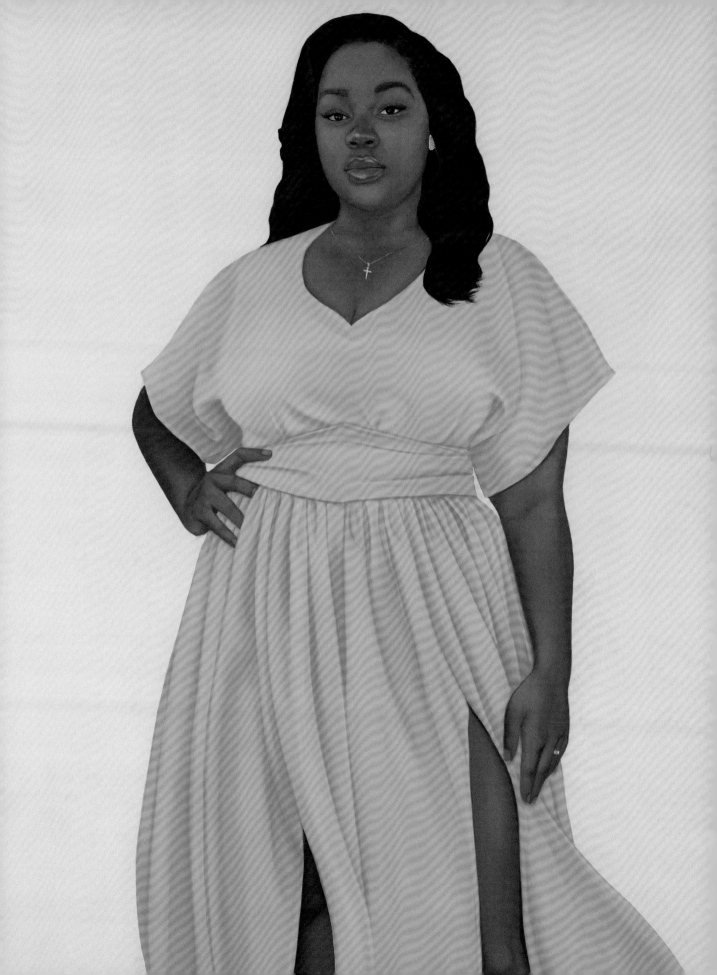

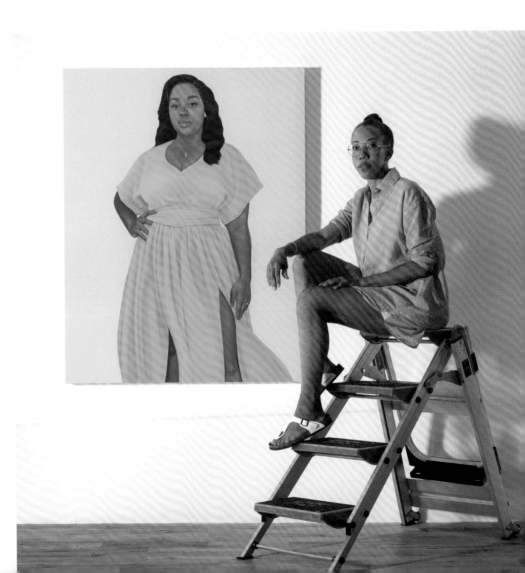

ABOVE
Photo by Xavier Burrell

RIGHT
Photo by Joseph Hyde
Courtesy of Hauser and Wirth

Amy Sherald
Gives Back

STEPHEN REILY: From the time of its creation, Amy Sherald wanted her portrait of Breonna Taylor to be shared by the Speed Art Museum and the Smithsonian's National Museum of African American History and Culture, ensuring that Breonna Taylor's life would remain part of the historical and cultural legacy of both her hometown and of the nation. To support that vision, the Ford Foundation (led by Darren Walker) and the Hearthland Foundation (created by Kate Capshaw and Steven Spielberg) donated the funds for the acquisition of the portrait by both institutions, which entered into a partnership for its shared ownership and rotating display between Louisville and Washington, D.C.

In consultation with Tamika Palmer, Amy Sherald then donated all of the funds from the sale of the portrait to the University of Louisville (on whose campus the Speed Art Museum is located) to create the Breonna Taylor Legacy Fellowship and the Breonna Taylor Legacy Scholarship. The Breonna Taylor Legacy Fellowship is open to Brandeis School of Law students who secure a legal volunteer position with a social justice nonprofit organization or agency. The Breonna Taylor Legacy Scholarship is open to undergraduate students at the University of Louisville who demonstrate a commitment to social justice. The innovative structure of Sherald's gift creates a long-term investment in the fight against inequality, starting in Breonna Taylor's hometown.

Timeline

ALLISON GLENN: When I presented my exhibition proposal to Tamika Palmer for consideration, I told her I knew that we needed to include a timeline of her daughter's life to tie the exhibition together. I said, "I'm not the person to write it," and she said, "Oh, I'll write it." She wrote the text on the walls of the gallery in which Amy Sherald's portrait is installed and therefore became the authorial and the authoritative voice in that space.[150]

—

During installation, there were discussions regarding whether or not we should include a label to contextualize the tone of the timeline, as the institutional voice is very different than a mother's voice about her daughter's life. There were good points for and against didactics. I felt strongly that we did not need to put up a label to tell people why we've given space to Tamika Palmer. That is not decentering. Decentering is giving the space. The team ultimately understood the importance and impact and agreed.[152]

—

I would say that the timeline captures perseverance, and I'll tell you why: the story of this person, in the way that her mother tells it, is the closest truth, I think, to who she is—it's the closest truth that any of us can get. It's closer than this exhibition idea, it's closer than any news account, because it's the story of her daughter's life. And it doesn't start with the incident on March 13—it ends with it. Which is essentially where the exhibition picks up. I've watched her family and the community really preserve, in not only seeking justice, but also connecting to people. You know, when you're able to understand that she was a person, and that her mom's biggest concern was that she was going to be engaging with people who had COVID, because she was an emergency medical technician who worked in the ER. It gives you a different perspective of a person, and perhaps, not what we received from news outlets and not what we received from outside her circle.[153]

I can't imagine anyone more able to
write this narrative than her mom.[151]

— ALLISON GLENN

June 5, 1993
4:37 AM

1999

After 18 1/2 hours of labor and an emergency cesarean, Miss Breonna made her debut . . . Determined to move around on her own, and so anxious to show her strength, she started walking at nine months.

Her childhood was a breeze. She was easy to care for, really almost too easy. She was full of life and had an old soul that she got from my mother. Those years flew by, eager to learn and teach.

She became a big sister— a job she took seriously.

Breonna was smart and flew through elementary and middle school.

Before we knew it,
it was 2007,

February 2008

2011

and she was a freshman at Kelloggsville High School in Wyoming, MI. Breonna spent her time singing, skating and biking through those years.

That year, I felt my girls had more to offer the world than Michigan had to offer them, so I made an abrupt decision to move to Louisville, Kentucky. I had only visited Louisville a few times before to see friends, but those visits made me want my girls to be a part of this city.

When I would visit, there was always something going on for kids. There was a number of things that kept them busy — including free concerts and giveaways— out of the streets, and away from the vicious cycle that I watched repeat itself over and over again in Michigan.

Breonna came to finish her freshman year at Western High School. The love she had for this place spoke volumes and put me at peace with knowing I had done the right thing.

Breonna wrote - "I am a strong, intelligent, beautiful Black woman who has grown so much, I'm very far from the girl that I used to be . . . thanks to hard work and dedication. I now know what they mean when they say hard work pays off. I'm now 17 years old and a senior in high school it's such a joy to look back and see that I've made it this far, it wasn't easy but well worth it. Here I am now with only 11 more days of school left & only 16 more days till my graduation day. CLASS of 2K11 . . . here I come! I can't wait to prove everyone that ever doubted me wrong. When I walk across that stage and get my diploma handed to me; I won't be thinking this is the end rather more like 'this is only the beginning' I will now be starting my journey to adult life!

Breonna was ready.

Fast forward to January 2020.

She had conquered high school, and was so keen on being her best self. She was heading off to start at University of Kentucky, which I knew would be a task for her. Not that she couldn't do it, but I knew she would not be able to stomach being away from home. I was right—she absolutely hated that part of it. Breonna moved back home, working two jobs, and determined as ever. She did home health, drove the TARC3 [Paratransit service], and then decided to mix the things she loved, driving and helping people, so she went on to become an EMT . . . Loved the job, but hated the hours and the pay, wrestled with herself about moving on to a better job, one that would allow her to move on to be what she really wanted to be, which is a nurse; a job that would allow for time for herself, Kenny, family and friends— even school.

Breonna was a planner, she critiqued her every move and wanted my blessing on everything. I would always say: "Don't be somewhere that will make you miserable in the long run." With that being said, she went into the ER as an Emergency Room Technician and absolutely loved every moment of it: the job, the hours and her co-workers, and they loved her, she was happy and on her way, she said.

Breonna writes on social media 2020 is her year, never did we imagine just how so. This year was taking her places: trips with friends, starting school, getting a house and starting a family—all her words and trust she started strong.

March 12, 2020

Breonna calls me to first complain
about her sister Ju'Niyah not cleaning
up before she left for a trip, but quickly
moved on to ask what I was doing.
I said "Nothing," she replied, "good you
could get up and cook for me," I laughed
and said, "not today." We talked about
working, with the pandemic starting.
I informed her how extra careful she
needed to be, because they would see
those patients before anyone else. She
said, "Momma I got this. I gotta do what
I gotta do. I'm going to take care of these
patients then finish getting ready for
my girls trip." Boy she was excited—
so was I, because now the subject wasn't
me cooking for her and Kenny. She said
it'll be a date night dinner and movies.
I said, "Good, have fun." We hung up.
She posted later that night about having
fun at dinner with her bestie (Kenny of
course) then heading home to watch a
movie and they did just that.

It was Friday, March 13, 2020 at about 12:38 AM when our entire world would be shattered forever:

It started with a call from Kenny. It was normal to receive a call from
them at that time of day, but this call would be different. This call would
be a scream for help, a cry for Bre to hold on, and a shattering of my
world . . . I was more concerned with her washing her hands and staying
protected at work during COVID than I was with LMPD breaking down
her door, murdering her, and charging her bestie—her love, Kenny—
with attempted murder of one of the people who busted down her
door, with no regard for the human lives on the other side of it, firing
at least 32 shots, and never would I imagine being denied justice.

- Tamika Palmer

Exhibition Opens

———

At this moment in America, it is hard to imagine a more consequential exhibition than *Promise, Witness, Remembrance* at the Speed Art Museum in Louisville— Breonna Taylor's hometown.[154]

— GREGORY VOLK, *HYPERALLERGIC*

———

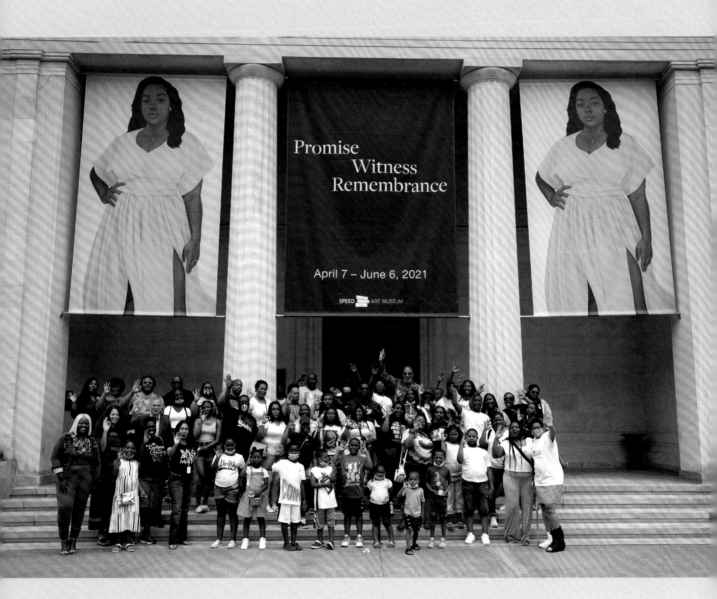

Promise
Witness
Remembrance

April 7 – June 6, 2021

SPEED ART MUSEUM

Conventional encyclopedic museums—like the Speed, the largest and oldest art museum in Kentucky—are glacial machines. Their major exhibitions are usually years in the planning. Borrowing objects from other museums can be a red tape tangle. "Historical" shows, by definition, are usually confined to events and cultures of the past. *Promise, Witness, Remembrance* revises all of that. It speeds up exhibition production, focuses on the present, and in doing so reaches out to new audiences vital to the institutional future.[155]

—

As far as I know, *Promise, Witness, Remembrance* is the only large-scale institutional show to date that addresses the important episode in our contemporary national history that Taylor's violent death, and the communal reaction to it, represent.[156]

— HOLLAND COTTER, *NEW YORK TIMES*

2 ART

Stepping inside a van Gogh painting. BY CHRISTINA MORALES

6 POP MUSIC

The performance lineup for the Grammys. BY BEN SISARIO

3 BOOKS

His trilogy inspired the love-struck to put locks on bridges.

BY ANNA MOMIGLIANO

NEWS | CRITICISM

Arts
The New York Times

MONDAY, MARCH 8, 2021 C1

K N

Picturing Justice

Amy Sherald wants her painting of Breonna Taylor to 'live out in the world.'

By ROBIN POGREBIN

Typically, Amy Sherald's gallery would handle the sale of her artwork to a collector or an institution. But when it came to her portrait of Breonna Taylor — the 26-year-old medical worker who was shot and killed by police officers in Louisville, Ky. — Sherald herself wanted to see that particular painting all the way home.

"I felt like it should live out in the world," Sherald said. "I started to think about her hometown and how maybe this painting could be a Balm of Gilead for Louisville."

Sherald believed the painting should be seen by people where Taylor died as well as by a broader audience. And she intended the proceeds from her sale of the painting to advance the cause of social justice.

In an unusual arrangement that has unified two museums and two foundations, Sherald has managed to achieve those goals for the work, which was originally commissioned for the cover of Vanity Fair last September by Ta-Nehisi Coates, who was a guest editor for a special edition on activism.

CONTINUED ON PAGE C5

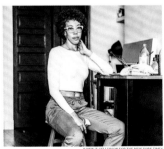

JUSTIN T. GELLERSON FOR THE NEW YORK TIMES

Amy Sherald, above, and her portrait of Breonna Taylor, right, who was killed by the police.

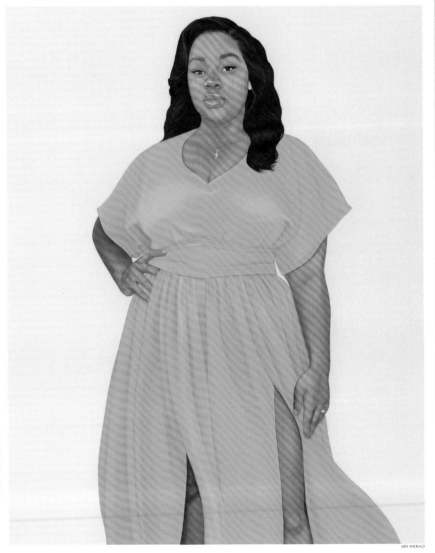

AMY SHERALD

Picturing Breonna Taylor, and Justice

CONTINUED FROM PAGE C1

The painting — 54 inches tall by 43 inches wide — will be jointly owned by the Smithsonian's National Museum of African American History and Culture in Washington and by the Speed Museum in Louisville, assuming the artwork passes through both museums' acquisition process.

The institutions purchased the painting with $1 million donated by the Ford Foundation and the Hearthland Foundation, a new philanthropy that supports social justice initiatives and is run by the actress Kate Capshaw and her husband, the director Steven Spielberg.

Sherald plans to direct the funds from the painting's sale toward a program she is forming with the guidance of both foundations that will support students pursuing higher education who have an interest in social justice.

The artwork is expected to be included in the Speed Museum's Taylor-inspired exhibition "Promise, Witness, Remembrance," which opens on April 7 and has been organized by Allison Glenn, an associate curator at the Crystal Bridges Museum of American Art in Bentonville, Ark., in consultation with Taylor's family.

Sherald, along with the artists Theaster Gates and Hank Willis Thomas, serves on the Speed's advisory panel for the exhibition, which will feature prominent Black artists including Sam Gilliam, Lorna Simpson, Kerry James Marshall and Glenn Ligon. "The killing of Breonna Taylor and a year of protests have really changed the course of Louisville, and we're struggling," said Stephen Reily, the Speed's director. "Our goal and ambition is to use the work of great artists to help process what we've been through and collectively find a way forward."

Lonnie G. Bunch III, the founding director of the National Museum of African American History and Culture, who is now the Smithsonian's secretary, said Sherald's painting of Taylor "captured both the joy and the pain of this moment."

"This is a story that needs to be told and needs to be retold," Bunch added. "If it went into a private collection, it might get a little attention and then disappear. This way, generations are going to understand the story of this woman and the story of this period."

When Coates asked Sherald to paint Taylor, the artist said she "saw it as an opportunity to codify the moment." Sherald, 48, who had a heart transplant in 2012, had been unable to participate in last summer's protests amid the pandemic. The painting gave her the chance "to have a voice and to give Breonna Taylor a voice."

The commission was only Sherald's second — the first, which catapulted her to national prominence, was Michelle Obama's official portrait, which has been drawing crowds at the National Portrait Gallery

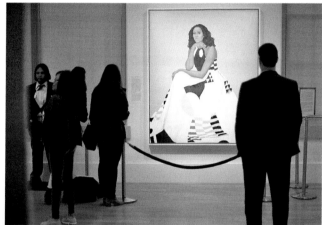

MARK MAKELA FOR THE NEW YORK TIMES

(and is set to go on a five-city tour with the Kehinde Wiley portrait of Barack Obama, beginning in June).

It was also the first time Sherald had painted someone who was no longer living. So she embarked on an immersive process of research, studying photos of Taylor, and speaking with Taylor's mother, Tamika Palmer, "so I could get a feel for who she was as a person," Sherald said, "her sense of style and how she felt beautiful."

"Her mom shared with me that she loved to get dressed up," Sherald added. "So I thought it was fitting that she have on a beautiful dress."

Palmer said her daughter was "definitely a diva."

"You wouldn't catch her not together," she continued. "She definitely took pride in what she looked like and how she carried herself."

Sherald wanted to find a Black female designer for the dress — she settled on Jasmine Elder of the Atlanta-based JIBRI — believing that "a Black woman painting a portrait of a Black woman should be dressed by a Black woman."

The artist photographed an acquaintance who shared Taylor's body type and considered what color to make the dress. "I decided to go with turquoise, and then with a background that was the same color, be-

cause it really allowed you to focus on her face and look in her eyes," said Sherald, whose subjects gaze directly at the viewer. "She has this kind of otherworldly feel, kind of ethereal, very peaceful."

The artist's connection to Taylor was aided by a video Coates sent of Taylor double-Dutch jump-roping. "I got to hear her giggle," Sherald said, "and hear her voice."

The artist LaToya Ruby Frazier shared with Sherald photographs she had taken of the Taylor family for the Vanity Fair issue, including one of the engagement ring with which Taylor's boyfriend, Kenneth Walker, had planned to propose.

"I realized this was a love story, too," Sherald said. "I asked permission to paint that ring onto her finger. She didn't know he had the ring."

Upon seeing the finished painting, Palmer was overwhelmed. "I could not believe it," she said. "It definitely showed her character and who she was."

Sherald could have sold the painting through her gallery, Hauser & Wirth, which on March 20 will open a show of the artist's latest work at its Los Angeles location, her first West Coast solo exhibition. But she wanted to more directly control the fate of her Breonna canvas, so reached out to her friend Capshaw.

Capshaw had felt a kinship with Sherald

from afar since reading a 2017 interview with her in The New York Times and finding they had passions in common, including the poet David Whyte and the public radio host Krista Tippett.

"I am feeling this is someone I already know," Capshaw said of that moment. She has since become Sherald's friend, and said she wanted to help the artist realize her goals for the Taylor painting. "What is it that is needed to make sure that she gets to be the author of the story of this portrait?" Capshaw said. "Whatever it costs to make that happen, I was in."

"She's been the architect," Capshaw added of Sherald. "It will be what it will be because of her. She is serving Breonna as a symbol, as a person, as a story that needs to be told, as a representation of something that is happening in this nation that needs to stop."

Capshaw called Darren Walker, president of the Ford Foundation, who agreed to share the purchase price and to make an additional $1.2 million grant to fund the Speed's Taylor exhibition as well as free admission and community programs there.

"This painting and exhibition embody the idea of art for justice and demonstrate the potential power of art to heal," said Walker, who in 2017 played a similar role in helping the art collector Agnes Gund sell a 1962 Roy Lichtenstein painting to start a fund that supports criminal justice reform. The Breonna Taylor work "indicates how an artist can play a transformative role in bringing more equity to a community," he said.

In the 2017 interview in The Times, when she was just gaining fame for painting the first lady, Sherald expressed the hope that she would someday be able to give back to struggling youth, after paying off her school loans and affording her heart medication.

"When I look at those people," Sherald said at the time, "I see myself."

Talking now, Sherald became emotional realizing that four years later — having skyrocketed in the art world, with one work reaching $4.3 million at auction over an estimate of $150,000 to $200,000 — she is finally able to do that.

"I specifically thought about a young woman I mentor now who wants to go to nursing school but doesn't have the means to do it," Sherald said. "I really want the money to give someone an opportunity to do something they might not have been able to do without it."

Palmer said that she was moved by the idea that Sherald's poignant image would live on in major art institutions for the world to look at and learn from. "Never in a million years would I have thought she'd end up in a museum," Palmer said of her daughter. "I still can't even find the words. It's such a blessing, because people will come from everywhere to see her."

Viewers in 2018 looking at Michelle Obama's official portrait by Amy Sherald, unveiled at the National Portrait Gallery in Washington.

The opportunity is to show what it means to listen. I don't think museums are going to get everything right. Cultural workers aren't going to get everything right. But when you listen, you provide opportunities for accessibility, for inroads, for connection. And I hope the end result provides a platform for people to feel heard, and perhaps to process the past year.[157]

— ALLISON GLENN

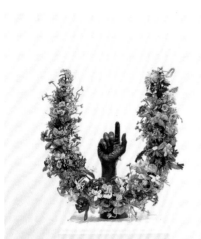

NICK CAVE

AMY SHERALD AND HAUSER & WIRTH

The exhibition "Promise, Witness, Remembrance" will include, clockwise from far left: "Unarmed" (2018), by Nick Cave; a portrait of Breonna Taylor (2020) by Amy Sherald; and a photograph by Jon P. Cherry taken at a protest in Louisville, Ky., in September.

JON P. CHERRY AND GETTY IMAGES

How a Museum Show Tries to 'Get It Right'

Honoring Breonna Taylor and her legacy challenges the curator Allison Glenn, who lost a brother to gun violence.

By SIDDHARTHA MITTER

"Promise, Witness, Remembrance" — an exhibition opening on April 7 at the Speed Art Museum in Louisville, Ky., in honor of Breonna Taylor, the 26-year-old medical worker killed by police there nearly a year ago — came together fast, yet in a manner "tempered by conversations," said its curator Allison Glenn.

These involved, centrally, Tamika Palmer, Taylor's mother, whose input yielded the show title; and the painter Amy Sherald, whose portrait of Taylor will anchor the exhibition. Two advisory committees — one national, one in Louisville — have guided the show's making, in part to avoid the shoals on which museums have foundered in their efforts to address trauma and inequity in their communities, and in their own practices.

But "Promise, Witness, Remembrance" — whose list of about two dozen artists mixes big names (for instance Kerry James Marshall and Lorna Simpson) with others who are lesser known (Bethany Collins, Noel Anderson, Jon-Sesrie Goff), several with Louisville ties, and local photographers who documented the protests last year — has both greater and simpler ambitions. The hope, Glenn said, is to show "museums can get it right" through consultation that improves, not diminishes, curatorial quality. It is also to help stitch community in a midsize city by listening to those excluded by art institutions in the past.

During a phone conversation, Glenn, who is from Detroit and is an associate curator at the Crystal Bridges Museum of American Art in Bentonville, Ark., shared insights gleaned in making the exhibition, which will run through June 6. The following excerpts have been edited and condensed.

This exhibition is the result of intense consultation, notably with Tamika Palmer, but many others as well. Whose advice, artist and nonartist, did you seek out?

First, I spoke with Breonna's mother, and asked how we might think of her daughter's legacy, and translated that into the three ideas: promise, witness, remembrance. Then I convened a national panel. I was very intentional in developing the panel because of my particular position: I lost my brother to gun violence, about a year and a half ago. It doesn't need to overshadow this story, but it's important to mention, because it informs a lot. I wanted a cabinet of advisers who could relate on a personal level.

[Advisers to the show also include] Theaster Gates, who has been successful in his work with the Tamir Rice Foundation. Jon-Sesrie Goff has a film in the exhibition; his father took over the Mother Emanuel AME congregation in Charleston after the murders there, and the Rev. Clementa Pinckney was a mentor to him. Hank Willis Thomas 20 years ago lost his cousin, and has made work about that. I enlisted a friend, La Keisha Leek, who was in grad school when her cousin Trayvon Martin was killed; I had helped her in some projects to work through that, including an exhibition she curated. Raymond Green, who lives here in Arkansas, is a cousin of Alton Sterling [who was fatally shot by white police officers in Baton Rouge, La.]. That experience of loss from gun violence or policy brutality — or both — brings a level of care.

As a guest curator, without prior experience in Louisville, how did you develop an exhibition that made sense for the city?

I wanted to create a conversation between the local community and the national community — whether in the art world or among private citizens. Toya Northington, the community engagement strategist at the Speed Art Museum, developed a Louisville advisory committee. They gave me great feedback and suggestions. It was a different kind of curatorial process: I wasn't necessarily trying to drive a thesis based on research into an idea or an artist. It was really built on conversations about how a museum can get it right, how the art world can respond, what does it mean to collaborate in this space.

What sense of the city did you form personally as you went about the work?

I spent time in Louisville. I read everything I could. I listened to podcasts. And there's a relationship I can't exactly put my finger on, but I grew up in Detroit, I've worked in New Orleans, and Louisville is another port city with a French connection. It's the border of the North and the South. It's where Lewis and Clark started their expedition, and I'm fascinated with the ideology of Western expansion. Some loops closed for me when I visited. For example, that horrible phrase: "Being sold down the river." Down the river is New Orleans; the origin of the phrase is in Louisville.

How did community input alter the show's shape?

To tell this story, I didn't necessarily think that every artist had to be a Black artist.

But after listening, I understood the importance of visibility, to the Louisville community, of presenting a show of only Black artists in this space. (Tyler Gerth, a local photographer shot and killed while documenting the protests on June 27, is the sole exception.) That was an "aha!" moment: This is the community's desire, and I can be flexible, I can be nimble in this way, without having to compromise any curatorial framework. And then it became deeper. The site of the exhibition is galleries that usually hold the Dutch and Flemish collections. We've got 22-foot ceilings, terrazzo floors, marble doorways. It became clear that an effect would be a kind of decolonizing of that museum space.

A lot of people feel that museums aren't accessible, aren't reflective of who they are. This exhibition is about a woman who lived in Louisville, whose family lived in Louisville; it's about what happened to her, and in response to these things. There will be people who may come to the museum for the first time.

Amy Sherald's portrait of Breonna Taylor will be a big draw, appropriately. Does it risk posthumous hero-izing of someone who did not ask for it? And how do you build a show around it that brings both care and insight in the wake of trauma?

That is *the* question. In layout and design, when you walk into the gallery, in your sightline will be the portrait. If that is all you are here for, you can go right there.

The first section, called "Promise," is a bit more conceptual, a conversation about ideologies of the United States through symbols that uphold them. Bethany Collins's work addresses "The Star Spangled Banner," for example.

In the "Witness" section are protest photographs from 2020, as well as work that connects to a century of movements for Black lives. And there is Sam Gilliam, who grew up and studied in Louisville, protesting against the expectation that his work as a Black male painter was to carry the weight of representation, as part of a movement toward positive imagery. His resisting that becomes a protest in itself. And it sets the stage for someone like Rashid Johnson to work within conceptual art and abstraction, but more freely.

I made the decision that I wasn't going to show any work that was traumatizing in the exhibition. But I also had to be clear that I couldn't edit the archive when it came to the protest photographs.

Can the exhibition benefit the Louisville arts scene beyond the museum?

I think of Alisha Wormsley's work "There Are Black People in the Future," which will be installed like ticker-tape in the second gallery. As part of Alisha's practice, she requires that the museum give honorariums to three local artists to respond to that idea. The Louisville steering committee will decide how to carry that out.

What is the opportunity this project offers?

The opportunity is to show what it means to listen. I don't think museums are going to get everything right. Cultural workers aren't going to get everything right. But when you listen, you provide opportunities for accessibility, for inroads, for connection. And I hope the end result provides a platform for people to feel heard, and perhaps to process the past year.

MARIANA SOUTHALL?

Allison Glenn, the show's curator, said consultation improved curatorial quality. "It was really built on conversations about how a museum can get it right, how the art world can respond, what does it mean to collaborate in this space."

2 FILM

Chloé Zhao takes Directors
Guild honor. BY KYLE BUCHANAN

3 BOOKS

A focus on a family and the
opioid crisis. BY MJ FRANKLIN

6 ART

Turkey is suing
Christie's over a
marble work.

BY COLIN MOYNIHAN

NEWS | CRITICISM

Arts
The New York Times

MONDAY, APRIL 12, 2021 C1
N

HOLLAND COTTER | CRITIC'S NOTEBOOK

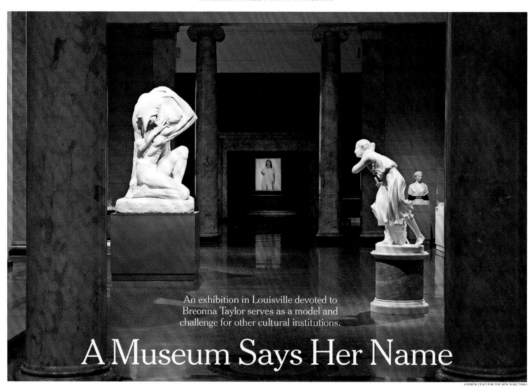

An exhibition in Louisville devoted to
Breonna Taylor serves as a model and
challenge for other cultural institutions.

A Museum Says Her Name

ANDREW CENCI FOR THE NEW YORK TIMES

LOUISVILLE, KY. — People talk a lot about getting back to pre-Covid normal. But our traditional art museums can forget about that. After a year of intense racial justice reckoning, a paralyzing pandemic and crippling economic shortfalls, aging hidebound institutions are scrambling just to stay afloat. And the only way for them to do so is to change. Strategies for forward motion are needed.

One is in play here at the Speed Art Museum, in the form of a quietly passionate show called "Promise, Witness, Remembrance," which might, with profit, be studied by other institutions in survivalist mode.

Conventional encyclopedic museums like the Speed, the largest and oldest art museum in Kentucky, are glacial machines. Their major exhibitions are usually years in the planning. Borrowing objects from other museums can be a red-tape tangle. "Historical" shows, by definition, are usually confined to events and cultures of the past. "Promise, Witness, Remembrance" revises all of that. It speeds up exhibition production, focuses on the present, and in doing so

reaches out to new audiences vital to the institutional future.

Combining works from the Speed's permanent collection with loans in several cases directly from artists and galleries, the show was assembled and installed (beautifully) in a mere four months. And it was conceived as a direct response to a contemporary news event: the killing, by Louisville police, of Breonna Taylor, a Black 26-year-old medical worker, in March 2020. A posthumous painting of Taylor by the artist Amy

CONTINUED ON PAGE C6

Amy Sherald's painting of
Breonna Taylor is the
centerpiece of a show at the
Speed Art Museum in
Louisville, Ky. It can be seen far
in the distance from the
moment you enter.

C6 N THE NEW YORK TIMES, MONDAY, APRIL 12, 2021

HOLLAND COTTER | CRITIC'S NOTEBOOK

A Museum Says Breonna's Name

CONTINUED FROM PAGE C1

Sherald is the exhibition's centerpiece, accompanied by photographs of local street protests sparked by her death and by the lenient treatment of the white officers involved.

The availability of the painting by Sherald, who is widely known for her earlier portrait of Michelle Obama, was the impetus for the show. Originally commissioned by Vanity Fair, it appeared on the cover of the magazine's September 2020 issue. Sherald herself expressed interest in having the painting shown at the Speed, and in November the museum hired Allison Glenn, an associate curator of contemporary art at Crystal Bridges Museum of American Art in Bentonville, Ark., who, with astonishing speed and acuity, built an exhibition around it in Louisville, consisting entirely of Black artists, with funding found to keep the admission free.

Accessibility, cultural and financial, is a crucial feature of the show. Until now, museums have generally ignored the country's changing population demographics. The history that our big, general-interest art museums promote, through their preservation and display of objects, is primarily white history, with views of all other histories filtered through it. But that slanted perspective is no longer representative of audiences that museums will — speaking purely pragmatically — need to attract to survive.

Museums also tend to underestimate radical shifts in awareness of, and interest in, the past. In a social media century, attention

Right: "Carousel Form II" by Sam Gilliam, left; "Same" by Lorna Simpson, center; and wall text, "There are black people in the future," by Alisha B. Wormsley, right. Below, from top: "Unarmed" by Nick Cave; a visitor views "Open Up the Cells," a photo of a Louisville protest, by Jon P. Cherry; "We the People" by Nari Ward and a banner titled "15,433 (2019)" by Hank Willis Thomas, a name that refers to statistics regarding gun-related violence.

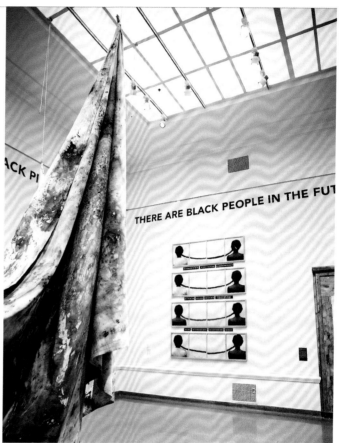

PHOTOGRAPHS BY ANDREW CENCI FOR THE NEW YORK TIMES

seems increasingly focused on the 24-hour news cycle. How can that new consciousness be reflected in classical museums, which pride themselves on being slow-reacting monoliths? Only by staying limber, being ready and able to adjust, absorb and adapt can our art institutions thrive.

In "Promise, Witness, Remembrance," the Speed offers an example of this dynamic. Working closely with Taylor's family, and with the Speed's community relations strategist Toya Northington, Glenn quickly mustered advisory committees of artists and activists from the city itself and from across the country. In the Speed's permanent collection, she found solid material to build on, including works by several artists associated with the city. Pieces included a magnificent, warm-as-an-embrace draped painting from 1969 by Sam Gilliam, who grew up in Louisville; a sculptured bronze head of a Black Union soldier by Ed Hamilton, who still lives there; and a suite of strategically altered Ebony magazine pages by Noel W Anderson, who is now based in New York City.

Glenn then began making requests for loans. Within a time frame most museums would consider impossibly tight, agreements were signed, and pieces began to come in. The last to to be installed, shortly before the opening, was the Sherald portrait, which had by then been purchased jointly by the Speed and the Smithsonian's National Museum of African American History and Culture in Washington, D.C., with the help of a $1 million donation by two philanthropies, the Ford Foundation and the Hearthland Foundation (run by the actress Kate Capshaw and her husband, the director Steven Spielberg).

The resulting show isn't huge — around 30 pieces — but the museum has given it prime space, clearing out three permanent collection galleries on either side of its sculp-

ture-filled central atrium to accommodate it. This guarantees that individual works have room to breathe. It also symbolically offers a gesture of welcome on the part of a traditional museum to a display of Black contemporary art. (By contrast, two years ago, the Metropolitan Museum of Art installed a truly regal Kerry James Marshall retrospective, not where it really belonged in special exhibition galleries in the museum's Fifth Avenue headquarters, but in what was then its Breuer annex on Madison Avenue.)

Glenn mapped out the show in three parts keyed to the themes in the title, all proposed by Taylor's mother, Tamika Palmer. The work in the first section, "Promise," suggests a nation's vaunted humanist ideals and abuse of those ideals. A 2011 wall piece by Nari Ward spells out the opening words of the Constitution, "We the People," in letters made from multicolored shoelaces. In Bethany Collins's "The Star Spangled Banner: A Hymnal" (2020), militantly nationalist songs are seared, as if written with acid, into the pages of a book.

The second gallery, "Witness," focuses loosely on the theme of cultural and political resistance, recent in images by Louisville photographers — Erik Branch, Xavier Burrell, Jon P. Cherry, Tyler Gerth (1992-2020) and T. A. Yero — documenting the city's 2020 Black Lives Matter demonstrations; and historical in the case of Terry Adkins's sculptural column of stacked-up drums referring to a march organized by the N.A.A.C.P. in 1917 in New York City to protest a national plague of lynchings.

The third section, "Remembrance," is dimly lighted and sparsely hung. Here what look like commemorative floral tributes — a sculptural one by Nick Cave and a painted one by the Cuban-born Maria Magdalena Campos-Pons — flank a wall-filling projection of Jon-Sesrie Goff's video "A Site of Reckoning: Battlefield," a brief, moving

meditation on the 2016 mass shooting at the Emanuel African Methodist Episcopal Church in Charleston, S.C.

Sherald's portrait of Taylor, whom she depicts in a breeze-blown turquoise dress against a turquoise ground, hangs just beyond, in a chapel-like space, otherwise empty except for a wall text in the form of a biographical timeline composed by her mother. The entire show is basically designed to lead to and enshrine this image. You can see it far in the distance, an eye-catching blur of color, from the minute you enter three galleries away, and approach it by a processional route.

I find myself resisting such enshrinements, whether of people, or art, or history. So I was glad the show didn't quite end there, but with a two-channel video by the artist and filmmaker Kahlil Joseph called "BLKNWS" in a bright room, with an outdoor view, one flight down. Raucous and nervy, the video is a careening jump-cut alternative view of what the media leave out, or misrepresent, in reporting on Black life and experience.

In the context of the Speed exhibition, its mock newscast is a reminder of what museums, too, leave out. As far as I know, "Promise, Witness, Remembrance" is the only large-scale institutional show to date that addresses the important episode in our contemporary national history that Taylor's violent death, and the communal reaction to it, represent.

And it's worth considering that the Speed show coincides with the trial in Minneapolis of the white police officer accused of killing George Floyd, another epoch-shaping event that — again, as far as I know — no major institution has yet even glancingly touched on. If you're wondering why our museums are looking too often these days like dated artifacts with shaky futures, Covid-19 can't take all the blame.

Community Engagement Programs

"Photovoice is an art-based intervention and method of community participatory research developed by health promotion researchers." By utilizing photographs taken and selected by participants, respondents can reflect upon and explore the reasons, emotions, and experiences that have guided their chosen image.

— DR. LESLIE HARRIS

(SPEED RESEARCH COMMITTEE MEMBER - QUOTING FROM *PHOTOVOICE: CONCEPT, METHODOLOGY, & USE FOR PARTICIPATORY NEEDS ASSESSMENT* BY CAROLINE WANG, DRPH & MARY ANN BURRIS, PHD)

COMMUNITY-ENGAGED RESEARCH
COMMUNITY ENGAGEMENT SURVEY & "IT COULD HAVE BEEN ME"

"IT COULD HAVE BEEN ME EXHIBITION," CURATED BY TOYA NORTHINGTON
SPEED ART MUSEUM, JUNE 2021

"It Could Have Been Me" is a Photovoice project that aimed to more fully understand the lived experiences of the Black community in Louisville in the wake of Breonna Taylor's murder through picture taking and group conversation. This study is a community engagement project for *Promise, Witness, Remembrance* led by Community Engagement Strategist Toya Northington, created in partnership with the Speed Art Museum, the University of Louisville's Kent School of Social Work and the School of Public Health and Information Sciences, and Virginia Commonwealth University's School of Social Work.

Photovoice is a way to hear about people's thoughts and experiences through their eyes and their words. People who were part of the project took pictures with a camera and then discussed them to determine the meaning embedded in the composition and subject matter. Their work was exhibited in the Speed Art Museum. The themes for this Photovoice project were developed from conversations with Tamika Palmer, Breonna Taylor's mother.

The purpose of the project is to explore and describe experiences, perspectives, and feelings through photography and words. The title came from conversations with community members. People said over and over that "Breonna Taylor could have been me." There is a sense of vulnerability that this could happen at any time to any Black person living in Louisville, especially those living closest to the West End. There is also a connection to Breonna Taylor as a person and with her family. Many see themselves in her story with her hopes, dreams, and untimely tragedy, thinking "it could have been me" or "it could be me in the future."

TOYA NORTHINGTON: First, there's surveys. Really collecting ideas and perspective from the Black community—capital "B" community. So how do we get people that are not affiliated with organizations, how do we get people that you might know from around the way, that have good ideas, good perspectives, but, you know, people don't really hear them? They may not have an avenue for telling their thoughts, or they just might not be connected to the movers and shakers. We want to hear from them. We want to hear from the people you see at the dollar store or the beauty shop, or up the street that might be outside the corner store. Those are the people we really want to connect with this survey, and we're really looking for a wide range of perspectives there. And really asking them, "Hey, this is what we're doing. There's an exhibition coming up, how do you feel about that? How do you feel about museums taking on social change or social impact projects? What are your ideas? What do you want to do? What are you interested in? What do you want to talk about?"[158]

—

This conversation is needed. This has been someone else's moment that was unknown. There are so many of these moments. The protests made these moments and pain heard. I realized so many of us responded, "It could have been me." It could be me tomorrow. The bar is so low, no matter who you talk to says that. It's the inherent fear for our safety. We see ourselves as Breonna.[159]

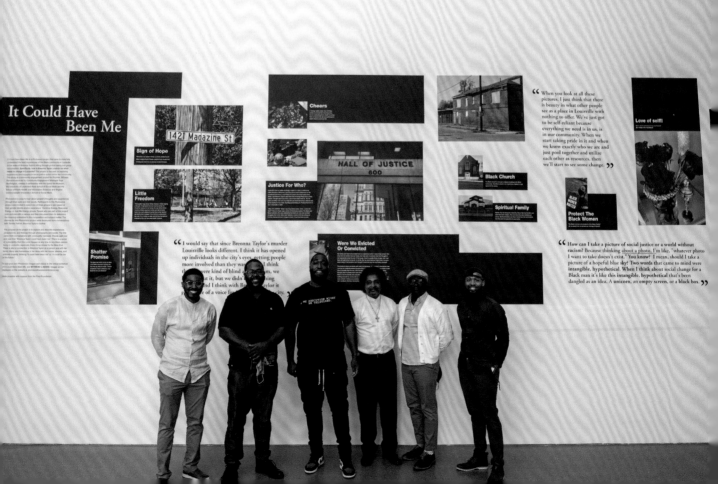

The research also gathered feedback from other BIPOC people in Greater Louisville asking for their feelings about the work that we are doing, and what they would like to see in the programming around the exhibition.[160]

— TOYA NORTHINGTON

That's kind of what this project is trying to add, is a little healing. It's like a step forward for us. Just collecting our thoughts and holding space for each other and trying to see what our community needs out of a moment where we're all so vulnerable.
– PHOTOVOICE FACILITATOR

I've been looking forward to this. And part of the reason I'm looking forward to this is that I do want to have what my brother said. I want to hear the perspective of other brothers.
– PHOTOVOICE PARTICIPANT

One thing that I think you said, this is really powerful. That applies to me, at least to a broader context is the idea of there being a caveat to Black joy and black happiness, almost perpetually, right. There's always a little caveat to being like, ah, I can't quite, I can't quite exhale.
– PHOTOVOICE PARTICIPANT

ABOVE
Reception photos by Jon Cherry

It Could Have Been Me

Cheers
A strength really arises when birthday parties are turned into mourning sites. Are we celebrating life or death? Amazing that we deserve life, but are sentenced to death. Breonna deserved life.

Sign of Hope
This photo was taken in West Louisville, predominantly Black neighborhood. These neighborhoods usually lack funding and resources, on account of discrimination.

Little Freedom
This beautiful image shows African American children playing in the park. It represents innocence and how simple life should be, however it is not always the case. Many African American children experience racism and discrimination before they reach adulthood, causing them to feel depleted and leaving them in dispair. It is our job, as a community, to take care of our children, to make sure that they feel safe and protected, so they can have more simpler moments.

Justice for Who?
Louisville's Hall of Justice is fittingly created in a style of architecture called Brutalism. Whenever I see those three words emblazoned on the courthouse downtown, I can't help but to think about their gross irony. When I saw Breonna Taylor's story (and that of George Floyd and so many others), I thought about how lucky I am to have made it this far. But the police brutality I had seen my whole life and heard about from relatives was at the forefront of my mind, haunting and terrifying me. Feeling that level of fear is traumatic in itself.

"HALL OF JUSTICE." When I see those three words, I think, "Justice for who?!" Breonna Taylor was a victim of that broken system. The Black and Brown activists who were protesting her death and who were arrested alongside their white allies were failed by a system that was doling out harsher, disproportionate charges to them. It was business as usual.

Shatter Promise
This glass was broken during the Black Lives Matter movement. It represents the lives they say that do not matter. "Dreams are shattered, Hope is shattered, Lives are shattered, and Love is shattered."

"I would say that since Breonna Taylor's murder, Louisville looks different. I think it has opened up individuals in the city's eyes, getting people more involved than they was before. I think that we were kind of blind about racism, we knew about it, but we didn't say anything about it, and I think with Breonna Taylor, it gave more of a voice for individuals in the city."

"When you look at these pictures, I just think that there is beauty in what other people see as a place in Louisville with nothing to offer. We've just got to be self-reliant because everything we need is in us, is in our community. When we start taking pride in it, and when we know exactly who we are, and just pool together and utilize each other as resources, then we'll start to see some change."

Black Church

The Black church is not just a religious building in the Black community. The Black church is an experience, family, and a rest haven for the weary.

Love of Self!!

Don't wait for someone to buy you flowers! BUY THEM FOR YOURSELF!

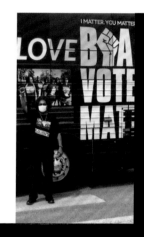

Spiritual Family

Family may not always be related by blood. Spiritual families can share the same religion, they can share the same beliefs and values. Spiritual families can share mutual love for one another, and they can be supportive to each other.

Blackness Now

"I think that some people are more empowered, they're more outspoken. It's like they feel their blackness now. I think it's how the community has changed."

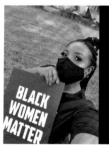

Protect The Black Women

The Black woman is the bedrock of the Black family!! As we protect her, we protect our heritage & future!

"How can I take a picture of social justice or a world without racism? Because thinking about a photo, I'm like, 'whatever photo I want to take doesn't exist.' You know? I mean, should I take a picture of a hopeful blue sky? Two words that came to mind were intangible, hypothetical. When I think about social change for a Black man, it's like this intangible hypothetical that's been dangled as an idea. A unicorn, an empty screen, or a black box."

Were We Evicted Or Convicted

My family and I had to be evicted from our apartment when I was in high school. Not only were we evicted from our home, but I was also convinced from the thought of me supposedly being the man of the house, that I had to quickly think of ways that I could help with gathering money for my family. But my mom told me I didn't have to worry about being in that position, but I thought I could do more for my family anyway.

This photo is where my family and I were evicted from. You will see in the picture that I am not on a solid foundation because they have cracks in them. These cracks in the street resemble that it is not a firm foundation that my family and I were walking through when my family and I were evicted. These cracks resemble hardships, no father in the household, and unsustainable income flowing in our family. As I am walking towards the camera, this is where I felt like we were convicted more than we were evicted. I believe, as a community, we must restore the foundation together. We can't condemn. But love one another!

1. BLM Sign at Waterfront

We saw it, it was like a lantern, with the black fist symbolizing BLM. And I looked at it and it made me think of just how powerful something like that could be, like a lantern. Have y'all seen like Batman or something like that? Like y'all know that whenever there's a bat symbol or whatever, it's most likely that they want Batman or a superhero to show up and go out and get justice. It made me think like, wow. Know what I'm saying? Like, we are really being called to action to get justice for Breonna Taylor, and we are really showing up, trying to get that. We're going to try to get that by any means necessary. That was just powerful.

2. Black Lives Matter

This photo represents taking a stand against injustice on account of racism and violence against African Americans.

3. My Life Matters

When I look at this picture, it reminds me of 1965, a long struggle for Brown / Black people.

4. This is Black Love

We talked about Black joy, Black celebration, and Black love. And for me, this is Black love. My mother is in the middle, my nephew is to the side, and I'm there to the left. And what's so powerful about this... I got a chance to go home and see my mom and we went to church. My mom is so much of a warrior. She had an accident when she was an undergraduate at Deleware State University, which had her in a coma for six months. They said my mom would never have children. She had to learn how to read, write, walk, and talk again. And then she birthed me and it's such a blessing.

5. Black Kids Matter

This was taken during the early part of all of the protesting. We were teaching him to stand up for what is right, however also be respectful that he has voice and his life matters.

6. Hands, Fist & Heart

What Does Black Love Mean To Me?
Open Black Hands, Power Fists, and Open Heart.

7. Family Reunion

This has been a family tradition on Christmas day & the Fourth of July. This picture was taken in 1986, off of Murphy Lane, at a Fourth of July family reunion. It was on a family property. Out of 74 years, we missed only one, due to COVID-19 in 2020. At this time, there are only two living siblings left, one brother and the only sister.

8. Youth to Senior

This is Black Excellence. This is Black accomplishments. This is Black success. WE ARE BLACK MEN!!

9. Black Love in the Midst of Fear

Black men like myself die at the hands of police more than often. Everyday I'm grateful that I made it home without facing a negligent, fearful, public servant that wouldn't mind taking my life under the umbrella of justice. When these tragic police encounters happen, our plans for our children never get carried out, holes are created that can't be filled, and that's one less positive role model for future Black adults. Picture submitted in memory of loving Black unarmed fathers that will never get the chance to feel and fuel this joyful Love.

10. Uncle Joe

This picture was taken at the nursing home, we were celebrating my father-in-law's birthday. He was born on June 25, 1945. He passed on August 21, 2019. He talked about the racism that he had to endure during his upbringing. He really didn't trust the white man. When listening to those stories, we understand why, and we are still having the same issues and concern today.

11. Food For The Soul

Even while grabbing some of the best Soul Food in West Louisville, Breonna reminds us there's still work to do!

"I think the contribution to the society, or to Black people, or to the community, is we love soul food. It's just, that's what we do. It's our heritage, and I love Big Momma's. I know this has just been here forever, and Sheryl and their family, big mama, they just do so much for the community. Giving out food when the pandemic started, and the kids were home from school, they could go there and get a free meal. I just like the work that they do in the community. It was really cool that the Breonna Taylor billboard was right there, because as I write, it still shows us that we have work to do."

12. Black Joy

The joy of BBQ SMOKE.
Grilling brings all types of Black joy! Salute to the grill masters!

13. A Fairytale

Happily ever after does exist!!

This is the brain child of my matchmaking abilities. I am a matchmaker, if you need some love, then let me know. I grew up with both of them in two different areas of Kentucky, so they didn't know each other. Patrice, she will tell you too that she felt like she was breaking a generational curse because the women in her family just had, not real positive relationships with men. So, she found love and she was opening herself up and wanted something different to show her daughters. And for Ron, he symbolizes that you can find love again. The first time don't always work honey, so you can definitely find love again and have your fairytale.

14. Family Wedding Photo

This photo depicts a wedding from two community members, showcasing Black Joy & Love. In early times, slaves were seperated from those they loved, even after marriage. So, to be able to love and remain with the ones that you love is not only Black Joy & Love, but our God Given right. When two or three are gathered God said, " I will be in the midst."

15. Ubunto - Been Equal

This photo shows the love that two married couples have for each other. Despite that there was a chance to have thier own drinks, my love decided to grab a straw and drink out of the cup, our cup. The concept it to have love for each other even when it may be unexpected. We are one, We are equal, We are together.

These photos represent intimate moments captured as personal photographs. Just as memories fade and become fuzzy over time, so have some of these prints, yet they remain an important memory to those involved. They also serve as a way to observe and honor Black existence in Louisville, KY, such as the spark of the Black liberation movements, the Black contribution, Black family, Black Joy, and Black Love.

"I just think that she [Breonna Taylor] has brought a great sense of pride to Louisville and just togetherness, and really opened our eyes that we got to stick together and to make changes, otherwise, it could have been any of us."

LOUISVILLE ARTIST RESPONSES TO ALISHA WORMSLEY'S "THERE ARE BLACK PEOPLE IN THE FUTURE"

The Community Engagement Steering Committee organized an open call for local artists to respond to Alisha Wormsley's work. They added funds from their own budget to increase the number of local artists and selected five, each of whom was paid an honorarium and a fee to present their work as part of the Speed's virtual programming.

——

They are able to do whatever they want as far as I'm concerned, there's no constraints, just create work that's in response to the idea that there are Black people in the future.[161]

— ALLISON GLENN

——

There Are Black People In The Future is an Afrofuturist piece
in the exhibition by artist Alisha Wormsley that invites us to
reimagine life for Black people. My role during this project as the
Community Engagement Strategist is like an Afrofuturistic story
for how to reimage the role that community activism, research,
art creation, curating, diversity, equity and inclusion (DEAI)
and community engagement could inform how institutions
function internally and how we can engage and co-create with
other, external communities. The work added a depth to the
discussions around the art and the exhibition itself that would
not have been as powerful without our collective feedback.
This project asked "what if we do things differently?" What new
methods or approached could we incorporate from people
outside the institution? By people, I mean the people that have
been excluded from those decisions or overlooked in the past.
What I found is that we were more efficient, more collaborative,
more vulnerable, yet more successful in our outcomes.[162]

— TOYA NORTHINGTON

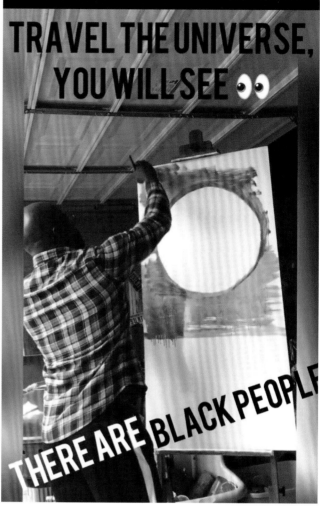

Kofi Darku is a painter working with text layered video clips presented with music. Several Darku paintings focus on space, the extraterrestrial as is the focus in this piece, "2020s Black Culture time capsule for Black People of the Future." Darku's focus on space offers figurative and abstract options for Black people to expand the culture. Video and soundtracks of his performance of the creative process and encouragement for "the struggle" of Black people accompany his focus on abstract expressionism and surrealism.

Kofi Darku

*2020s Black Culture time capsule
for Black People of the Future,* 2021

The first thing that reached out to me was the idea that we would no longer be tethered by things that have caused us trauma, things that have caused us pain—either mentally or physically . . . The idea of weightlessness, of floating, of being released into this weird, expansive, sky. And kinda being . . . limitless.[163]

— KALA LEWIS

Kala Lewis is a digital illustrator based in Louisville, KY. Her work mostly showcases portraiture and character design with themes ranging from the deeply personal to the narratively fantastical. She graduated from Northern Kentucky University with a Bachelor's degree in Fine Arts and is currently working as a freelance illustrator.

Kala Lewis

We Fly In the Future, 2021

ABOVE
Courtesy of the artist

RIGHT
Photo by Russ Sweeney

Dre Dawson, aka Dre DaSon, is the flagship artist and entertainer of the Global Inspiration Ent. brand. Dre describes his art as an entheogen for the social educated, spiritually elevated, and politically inundated. With heavy influences from Lauryn Hill, Jay-Z, Outkast, and others, Dre's bled of soulful yet uplifting and diverse beat selections sprinkled with poetically witty yet socially-relevant lyrics, then soused with an impeccably versatile delivery, once cooked, can only possibly be categorized as True Hip hop, Trap-Soul, or Ghetto-Gospel at the least.

Dre Dawson, aka Dre DaSon

BLUE SOLES

by Dre Dawson, aka Dre DaSon

I'm seeing visions of greatness,
I'm working digits with agents
I'm indigenous and favored,
I work this block with my natives
Turn a spot to cicada's, we could
turn up, debaters
Sack & seizing these Raiders,
leave em deceased in Decatur
Never ceasing on haters, we walk
in peace and our vapors
Applying pressure to paper, we
buying black wit our neighbors
Attacking facts that degrade us,
we action packed and we Avis
Move in PAC's with the bangers,
To clap political angus,
We strapped and we anxious,
at a MINIMUM dangerous
No cynical anguish, I'm only
numb to be painless
I'm steel, StainLeSS, I was built
from the ancients
I'm avenging defendants and
doing battle with plaintiffs
Holdin court on the judges that
imprisoned my cousins
All black jury convict you, you
gon get more than the dozens
Did this for the dozens that
never ceased and that wasn't..

..At peace with just nothin
This is our piece of that
something (Ase)

I'm seeing visions of greatness,
I'm working digits with agents
I'm indigenous and favored,
I work this block with my natives
Turn a spot to cicada's, so we
could turn up, debaters
Sack & seizing these Raiders,
leave em deceased in Decatur

We piecing out acres, we got
these spots wit no neighbors
We leave these keys to our kids,
we leave Deez Nuts to our haters
We keep our wealth in our
Fam we keep our health,
that's behaviour
We keep the world in our hands,
we stay in Now and not Later
They kept our piece of the pie
we stole the dough from
the baker
We kept that Pac in our eye,
we kept that Nipsey behavior
Out-Hussled the takers, 50-1
to they wagers
*We aint into minor deals we

making plays in the majors
Resort to picking them locks to
make our way out them cages
We could all really flourish if we
could find different spaces
Roses in concrete but this
garden is dangerous
Surrounded by thorns but
still destined for greatness

Tonnea (Nea) Green is a 33-year-old mother, acrylic portrait artist, Enrollment Professional at Humana, and Executive Director of a startup non-profit, Thomas Gales Art Gallery, Inc. Her happy place is making art, especially seeing it through the eyes of her son. Art has brought a peace to her life she didn't know could exist, and she is passionate about extending what she has found great about making art by hosting paint parties for kids and adults.

Tonnea (Nea) Green

we don't give af about these kids, 2021

BLACK GIRL INFERNO

by Rheonna Nicole

Rheonna Nicole is a slam poet and spoken word artist from Louisville, KY. Her poetry is an authentic reflection of what she embodies as a person. It is raw, bold, black and unapologetic about its existence. Her work speaks to struggle in urban communities, fat bodies and women / girls of Color. Noticing the lack of women poets in Louisville, Rheonna created her own poetry competition called Lipstick Wars Poetry Slam. Lipstick Wars is a platform created to give opportunity to the voices of women and girls through the art of slam poetry.

64,000 black women and girls disappear in front of an audience and no one around
even ask for an encore.
I guess a magician never reveals their secrets so what a girl to do with all this power.
How am I too much but never enough in the same sentence.

They've been burning us at the stake for years but this time, this time we will
resurrect from the ashes filled with combustion.
Ready to set you ablaze and watch us dance in the fire!

A white woman asked me once if I was a magical feminist?
Was I not made to be one?
I be on the front lines for everyone else's protest and war but where are your
battle scars from my fight?

We break bread over the forgotten and drink their blood at the last supper. Do this
in remembrance of them. In remembrance of Sandra, Taneisha, Miriam, Korryn,
Attiyana, Breonna and the countless women whose names we will never know!
Lock arms sisters and cover ourselves in the last words of Fannie Lou Hamer
and Assata.

But if they kill us...
Turn this shit into a disco inferno and Light the roof! The roof! The roof on fire,
cuz we don't need no water let this mothafucker burn baby, burn!

Teal Table Talks

WITH CHANDRA IRVIN AND THE CENTER FOR PEACE AND SPIRITUAL RENEWAL AT SPALDING UNIVERSITY

Inspired by Jada Pinkett Smith's "Red Table Talk," "Teal Table Talks" brought strangers together to have candid conversations about their experiences and issues that have affected the Louisville community over the past year. Its goal was to create a space for community members to have organic conversations after experiencing *Promise, Witness, Remembrance*. In partnership with the Spalding University Center for Peace and Spiritual Renewal, "Teal Table Talks" were led by Chandra Irvin, MEd, MDiv (Executive Director) and Dr. Steven Kniffley, with additional facilitators from Spalding University and a spoken word performance from local poet Rheonna Thornton.

"TEAL TABLE TALKS" QUESTIONS:

1. How did you get your name? How long have you lived in your neighborhood?
 What do you hope to get out of the discussion and what will you bring?
 Do you agree to the guidelines?

2. What came up for you through the *Promise, Witness, Remembrance* exhibition?
 In what way does your personal experience impact how you reflect on the exhibit?

3. What I have **witnessed** over the past year is . . .
 What I must **remember** is . . .
 I have the power to . . .
 I will commit / **promise** to . . .
 I will maintain this comitment to myself, and my community by . . .

ABOVE
Photos by Toya Northington

COMMUNITY ENGAGEMENT EVENTS:

—

COMMUNITY LEADER PANEL DISCUSSION ABOUT JUDAS AND THE BLACK MESSIAH | MARCH 25, 2021 /

Nicole Hayden, *Moderator*, Charles Booker, Councilwoman Keisha Dorsey, Shauntrice Martin, Dr. Brandon McCormack

—

FAITH & JUSTICE WEEKEND | MAY 29-30, 2021 /

Tiffany Farmer, Dr. Brandon McCormack, Rev. Tim Findley, Representative Keturah Herron, Sweet Potato Pie Kitchen, Gore's BBQ, Seafood Moe, JuJu's treats

—

CELEBRATING COMMUNITY | JUNE 5-6, 2021 /

Garden Girl Foods, Brittany Thurman, Jaylin Stewart, DJ John Q, Louisville Metro Dept. of Public Health and Wellness, Tyreson Lancaster / Ty Taking Photos, Anthony Northington

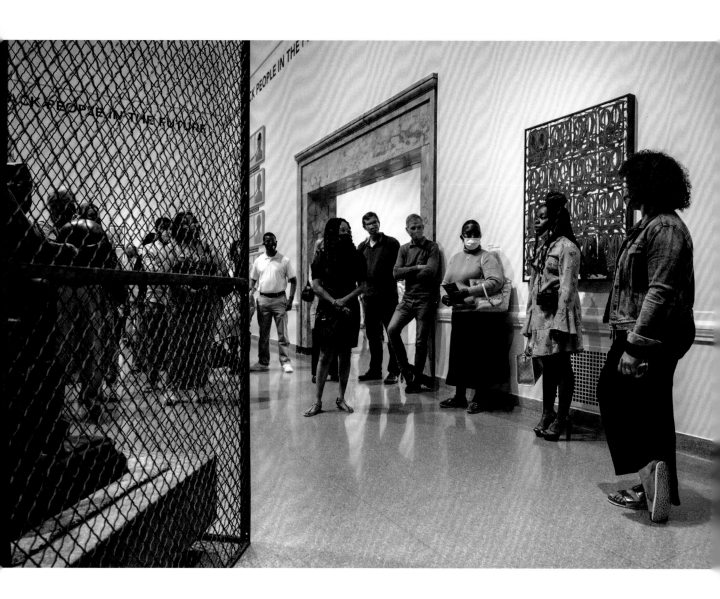

LEFT, ABOVE & BELOW
Photos by Jon Cherry

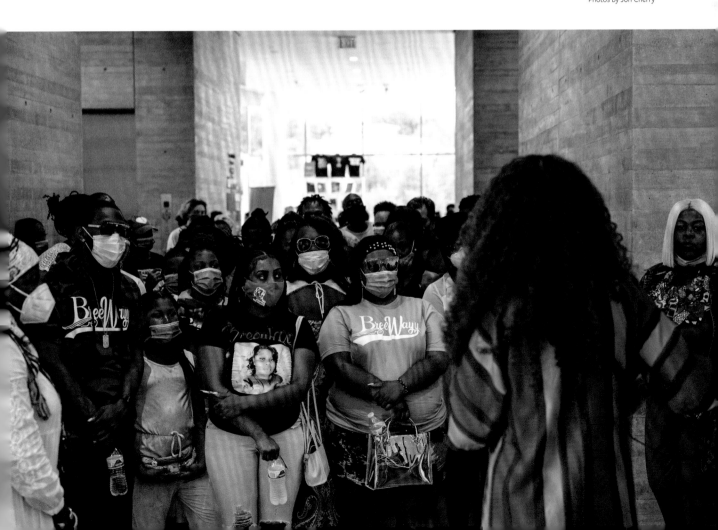

Collaboration:
UNIVERSITY OF LOUISVILLE

"SAY HER NAME: BREONNA TAYLOR"
BY ARON CONAWAY AND THE UNIVERSITY OF LOUISVILLE'S
ART & ACTIVISM INSTALLATION

STEPHEN REILY: In February 2020, Tamika Palmer asked the Speed if it could find a way to present the portrait of Breonna Taylor that had served as the centerpiece of protests from May-November 2020. *Say her Name: BREONNA TAYLOR* is a large-scale work by Louisville artist Aron Conaway, who had promised the portrait to Ms. Palmer.

Because the exhibition was devoted to works by Black artists (with one exception – a photograph by Tyler Gerth, who himself was killed during the protests), and Conaway is white, the Museum explored alternate ways to exhibit it, ultimately partnering with the University of Louisville on what became an interpretive installation near the entrance to the exhibition. Art History Professor Chris Reitz and the students in his "Art and Activism" class took this on as a final project and contextualized Conaway's iconic work in a long history of art as activism. The work later returned to its role as an iconic feature of Louisville's protest movement.

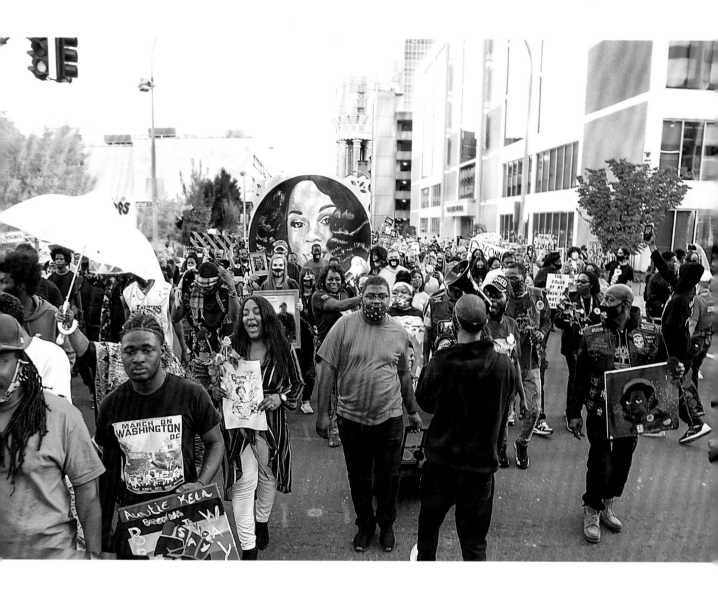

During the summer 2020 protests calling for justice for Breonna Taylor, a portrait of Taylor created by local mural artist Aron Conaway became a focalizing point at Louisville's Jefferson Square park, dubbed "Breonna's Square" and "Injustice Square" by the local protest movement. This image of Taylor was widely shared on social media and became a visual rallying point for the local Justice for Breonna movement, serving to expand awareness and to create solidarity with Louisville Standing up for Racial Justice (LSURJ) and with Black Lives Matter movements both in Louisville and beyond.

Aron Conaway

Say Her Name: BREONNA TAYLOR, 2020

ABOVE
Photo by Tyreson Andre

ART AND ACTIVISM

Art and activist politics have been in close conversation throughout the modern era. In the last half century, that relationship has become more nuanced, and today it is commonplace to find "political" art hanging on the walls of museums. Indeed, little contemporary art of note can be described as entirely apolitical. Yet "political art" as it exists on a museum's wall does not always include the kind of creative making that so often accompanies activist politics—that is, the posters, graffiti, and performances that go hand-in-hand with social justice movements. What distinguishes a work of political art from a creative work of activism? Is the distinction meaningful? And, if so, what happens when a work of creative activism or "activist art" enters the art museum, such as the installation of Aron Conaway's *Say Her Name: BREONNA TAYLOR* (2020) in the Speed Art Museum?

The adjacent timeline includes selected works of political art and creative activism in the United States from 1972 to the present day. Although many artistic modes can be encompassed by the term creative activism, there are specific underlying qualities that inform activist art. Activist art seeks to engage social, political, and economic realities through direct action. Rather than call attention to a given issue through a political aesthetic, activist art uses tactics of organization, occupation, and visual communication to mobilize groups and to effect measurable change. In one such example of creative activism, AIDS Coalition to Unleash Power (ACT UP) staged a "die-in" at the Wall Street Stock Exchange (1989) in which coalition members theatrically "died" on the floor of the Exchange in protest against corporate profiteering by the sole drug manufacturer of the antiretroviral treatment AZT, Burroughs-Wellcome. After this and other actions, including ACT UP's now-iconic poster campaigns, Burroughs-Wellcome reduced the price of AZT by twenty percent. Furthermore, ACT UP's coalition effectively broke the silence surrounding AIDS.

Activist art is often created using collaborative methods that prioritize the creative gesture's ability to effect change over individual artistic vision. This practice often results in artworks that are anonymous or collectivist in character. Signs created for the Occupy Wall Street Movement (2011) bearing messages such as "We Are the 99%" express a collective spirit of resistance to corporate greed rather than singular gestures by individual artists. Some banners of the Occupy movement also concealed extendable ladders that were used by Occupy protesters to breach barriers and gain access to contested spaces. These creatively designed objects of resistance exemplify the pragmatism that Lucy Lippard cited as a hallmark of activist art in her well-known essay, "Trojan Horses, Activist Art and Power," (1984). Lippard calls activist art an "art of contact" that abandons frames and pedestals and that makes use of a variety of artistic forms, practices, and strategies to infiltrate the mainstream and to effect real change.

Art that becomes symbolically linked to a protest movement functions as activism by uniting individuals around a common goal. During the summer 2020 protests calling for justice for Breonna Taylor, a portrait of Taylor created by local mural artist Aron Conaway became a focalizing point at Louisville's Jefferson Square park, dubbed "Breonna's Square" and "Injustice Square" by the local protest movement. This image of Taylor was widely shared on social media and became a visual rallying point for the local Justice for Breonna movement, serving to expand awareness and to create solidarity with Louisville Standing up for Racial Justice (LSURJ) and with Black Lives Matter movements both in Louisville and beyond.

For Lippard, works of creative activism are often characterized by their organic connection to the community for which they speak. "It is impossible just to drop into a 'community' and make good activist art. The task is specialized (though not in the same ways 'high art' is) and it demands discipline and dedication (as high-art does)." These criteria apply to Conaway's painting that was created collaboratively with artists Lydia Corner and Toussha "Howlin'" Summers and that was originally conceived as a platform or stage to hold memorial items from Taylor's supporters. Once completed and brought to its intended display site at Sixth and Jefferson, however, supporters encouraged Conaway to display the painting vertically to make it more visible from the street. The painting then became another kind of stage, or backdrop, for supporters and those in mourning—including Taylor's mother Tamika Palmer—to be photographed with the portrait, thus adding themselves to the narrative of the Justice for Breonna movement.

In this sense, *Say Her Name: BREONNA TAYLOR* is very much art of the movement rather than art about the movement. Like other examples of activist art, Conaway's portrait was conceived as a vehicle for making change rather than as an object to be admired in and of itself or an object that comments on a social justice issue in a generalized manner. The Speed Art Museum installation of this work of creative activism from the local context of the 2020 Louisville protest movement pays tribute to the grassroots involvement of the many activists who asserted the value of Black lives and who gathered over the summer of 2020 in resistance to aggressive policing and racial violence. Like the other works of activist art on the timeline, Conaway's portrait engages issues of social justice through direct and collaborative creative action. *Say Her Name: BREONNA TAYLOR* is indeed an "art of contact" that is a part of both the local and national narrative of reckoning with racial injustice and violence.

WOMANHOUSE
1972

THE DEATH OF MICHAEL STEWART
1983

ACT UP
1987

GUERRILLA GIRLS
1989

SILENCE = DEATH

This text and the research underlying it was created by students in the University of Louisville spring 2021 class "Art & Activism" taught by Professor Chris Reitz. They are:

Abigail Birney · Hannah DeWitt
Ashley Bittner · Nicole Clay
Cathy Shannon · Olivia Bechel
Allie Blankenship · Rasheed Adedoyin Ismaila
Flora K. Schildknecht · Shachaf Polakow

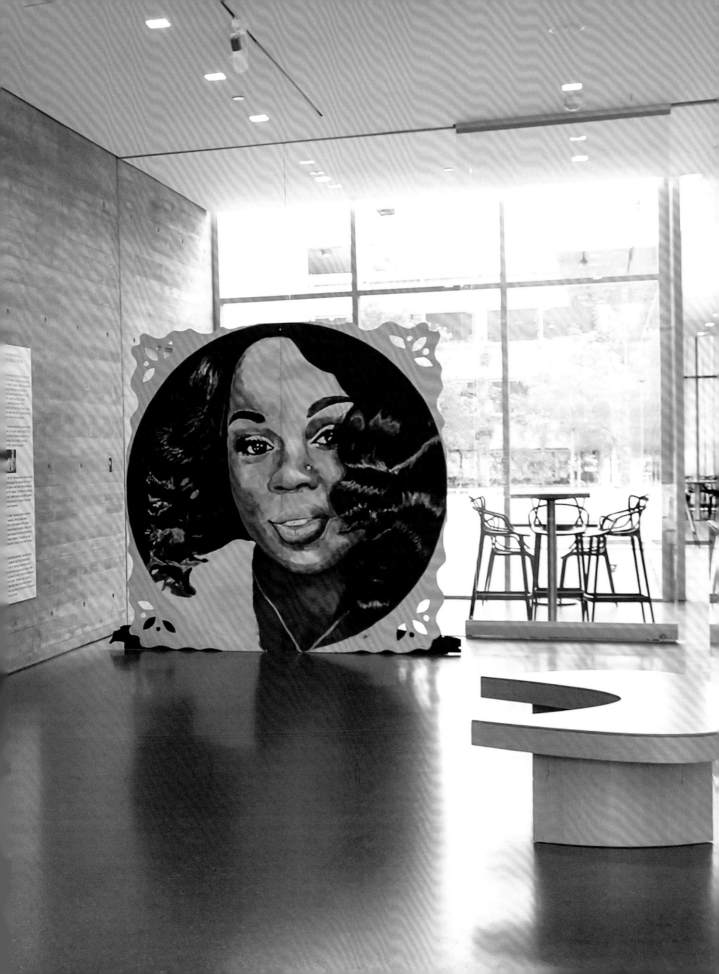

ART & ACTIVISM

Art and activist politics have been in close conversation throughout the modern era. In the last half century, that relationship has become more nuanced, and today it is commonplace to find "political" art hanging on the walls of museums. Indeed, little contemporary art of note can be described as entirely apolitical. Yet "political art" as it exists on a museum's wall does not always include the kind of creative making that so often accompanies activist politics—that is, the posters, graffiti, and performances that go hand-in-hand with social justice movements. What distinguishes a work of political art from a creative work of activism? Is the distinction meaningful? And, if so, what happens when a work of creative activism or "activist art" enters the art museum, such as the installation of Aron Conaway's *Say Her Name: BREONNA TAYLOR* (2020) in the Speed Art Museum?

The timeline within the following pages includes selected works of political art and creative activism in the United States from 1972 to the present day. Although many artistic modes can be encompassed by the term creative activism, there are specific underlying qualities that inform activist art: activist art seeks to engage social, political, and economic realities through direct action. Rather than call attention to a given issue through a political aesthetic, activist art uses tactics of organization, occupation, and visual communication to mobilize groups and to effect measurable change. In one such example of creative activism, AIDS Coalition to Unleash Power (ACT UP) staged a "die-in" at the Wall Street Stock Exchange (1989) in which coalition members theatrically "died" on the floor of the Exchange in protest against corporate profiteering by the sole drug manufacturer of the antiretroviral treatment AZT, Burroughs-Wellcome. After this and other actions, including ACT UP's now-iconic poster campaigns, Burroughs-Wellcome reduced the price of AZT by twenty percent. Furthermore, ACT UP's coalition effectively broke the silence surrounding AIDS.

Activist art is often created using collaborative methods that prioritize the creative gesture's ability to effect change over individual artistic vision. This practice often results in artworks that are anonymous or collectivist in character. Signs created for the Occupy Wall Street Movement (2011) bearing messages such as "We Are the 99%" express a collective spirit of resistance to corporate greed rather than singular gestures by individual artists. Some banners of the Occupy movement also concealed extendable ladders that were used by Occupy protesters to breach barriers and gain access to contested spaces. These creatively designed objects of resistance exemplify the pragmaticism that Lucy Lippard cited as a hallmark of activist art in her well-known essay, "Trojan Horses, Activist Art and Power," (1984). Lippard calls activist art an "art of contact" that abandons frames and pedestals and that makes use of a variety of artistic forms, practices, and strategies to infiltrate the mainstream and to effect real change.

Art that becomes symbolically linked to a protest movement functions as activism by uniting individuals around a common goal. During the summer 2020 protests calling for justice for Breonna Taylor, a portrait of Taylor created by local mural artist Aron Conaway became a focalizing point at Louisville's Jefferson Square park, dubbed "Breonna's Square"

What distinguishes a work of political art from a creative work of activism?

and "Injustice Square" by the local protest movement. This image of Taylor was widely shared on social media and became a visual rallying point for the local Justice for Breonna movement, serving to expand awareness and to create solidarity with Louisville Standing up for Racial Justice (LSURJ) and with Black Lives Matter movements both in Louisville and beyond.

For Lippard, works of creative activism are often characterized by their organic connection to the community for which they speak: "It is impossible just to drop into a 'community' and make good activist art. The task is specialized (though not in the same ways high art is) and it demands discipline and dedication (as high art does)." These criteria apply to Conaway's painting that was created collaboratively with artists Lydia Comer and Suzette "Hawkfire" Summers and that was originally conceived as a platform or stage to hold memorial items from Taylor's supporters. Once completed and brought to its intended display site at Sixth and Jefferson, however, supporters encouraged Conaway to display the painting vertically to make it more visible from the street. The painting then became another kind of stage, or backdrop, for supporters and those in mourning—including Taylor's mother Tamika Palmer—to be photographed with the portrait, thus adding themselves to the narrative of the Justice for Breonna movement.

In this sense, *Say Her Name: BREONNA TAYLOR* is very much art of the movement rather than art about the movement. Like other examples of activist art, Conaway's portrait was conceived as a vehicle for making change rather than as an object to be admired in and of itself or an object that comments on a social justice issue in a generalized manner. The Speed Art Museum's installation of this work of creative activism from the local context of the 2020 Louisville protest movement pays tribute to the grassroots involvement of the many activists who asserted the value of Black lives and who gathered over the summer of 2020 in resistance to aggressive policing and racial violence. Like the other works of activist art on the timeline, Conaway's portrait engages issues of social justice through direct and collaborative creative action. *Say Her Name: BREONNA TAYLOR* is indeed an "art of contact" that is a part of both the local and national narrative of reckoning with racial injustice and violence.

—

This text and the research underlying it was created by students in the University of Louisville spring 2021 class "Art & Activism" taught by Professor Chris Reitz. The students were: Abigail Briney, Ashley Bittner, Cathy Shannon, Allie Blankenship, Flora Schildknecht, Hannah DeWitt, Nicole Clay, Olivia Beutel, Rasheed Adedoyin Ismaila, and Shachaf Polakow.

WOMAN HOUSE
1972

Womanhouse (1972) was a massive collection of installations and performances housed within an abandoned 17-room mansion in Hollywood, California. Led by Judy Chicago and Miriam Shapiro for CalArts' budding Feminist Art Program, a team of 30 women artists painstakingly renovated and transformed the dilapidated building, knowing that it was scheduled for demolition soon after the exhibition closed. The installations and performances, which were recorded in the accompanying documentary film, consisted of parodies and exaggerations of domestic scenes and tropes that entice the viewer with laughter and play, only to leave them with an overwhelming sense of dread at the bitter realization of how these societal roles consume the waking hours of women each day.

A few especially memorable installations included laborious and repetitive performances of household chores, the meticulous application, removal, and re-application of makeup, and a bridal staircase featuring a mannequin in a bridal gown with an exaggeratedly long train that ominously descends the stairs as if creating a silky slide into the pits of eternity.

Robin Weltsch (Kitchen) **& Vicki Hodgetts** (Eggs to Breasts)
Woman House, 1972

THE DEATH OF MICHAEL STEWART
1983

On September 15, 1983, Michael J. Stewart, a 25-year-old Black graffiti artist, was arrested for spraying graffiti on a New York City subway station. Stewart died 13 days after being brought to Bellevue Hospital in a coma within an hour of his arrest. The three white arresting officers were charged with criminally negligent homicide, assault, and perjury. Protesters took to the streets of New York as the news of Stewart's death spread. Soon after Stewart's death, the renowned painter and graffiti artist Jean-Michel Basquiat, using acrylic paint and marker, made *The Death of Michael Stewart* on a wall of Keith Haring's studio. After Basquiat's death, Haring cut the painting out of the wall, had it placed in an ornate frame, and hung it over his bed, where it remained until he died from AIDS complications in 1990. In 2019, The Guggenheim held an exhibition featuring the Basquiat original, as well as an original created by Keith Haring.

Spike Lee cites Stewart's murder as the inspiration for the ending of his movie, *Do The Right Thing* (1989), where the character Radio Raheem is strangled by police. The artist and the community rallied behind these images, determined to speak out against the injustice.

ACT UP
1987

The first meeting of the AIDS Coalition to Unleash Power, more commonly known as ACT UP, took place in New York City on March 12, 1987. The most iconic image associated with ACT UP is their *Silence = Death* poster, pictured here. Although this poster is almost synonymous with ACT UP, it was created prior to the coalition's conception by three gay men in an attempt to push the gay community into action. The pink triangle is a symbol easily recognized by LGBTQ communities, as it has signified violent homophobia since the Nazis employed it to mark queer prisoners in concentration camps. The use of this identifying symbol also serves as a commentary on the 1986 call by William F. Buckley to tattoo HIV-positive individuals.

The Silence = Death Project
(Avram Finkelstein, Brian Howard, Oliver Johnston, Charles Kreloff, Chris Lione, and Jorge Soccarás)
ACT UP, 1987
Courtesy of actupny.com

GUERRILLA GIRLS
1989

Branding themselves as the "conscience of the art world," the Guerrilla Girls have been active in calling out institutional misdeeds since 1985. Their focus is primarily on critiquing the New York-centered art world for ignoring the contributions of women and people of color. Their activism began as wheat pasting bombastic flyers close to institutions and putting stickers on gallery doors. Now the group has been able to expand and use the institutions they have critiqued to continue their feminist goal of furthering inclusion in the art world. Using the tactics of humor, data, and anonymity in their works, the Guerrilla Girls have been influential in the art world for almost forty years. The Guerrilla Girl's anonymity may be their most striking feature, as the group members adopt the names of dead women artists and don expressive gorilla masks when representing the group.

Guerilla Girls
Do Women Have To Be Naked To Get Into The Met. Museum?, 1989
Courtesy of the artist and guerrillagirls.com
3 White Women, 1 Woman of Color and No Men of Color – Out of 71 Artists?, 1997
Courtesy of the artist and guerrillagirls.com

THE WHITNEY BIENNIAL
1993

The mid-1980s were a time of rapid economic shifts in Europe and the Americas. Increased international trade compacts, the movement of industrial labor to developing nations, and the rise of finance capitalism inaugurated a new era for global economic policy, what many critics call the neoliberal era. The fall of the Soviet Union in 1989 helped to cement this new form of global capitalism, both in the U.S. and globally. Under neoliberalism, public and private life changed. As theorist Michel Foucault argued, it increasingly came to feel like all forms of human interaction had been financialized—we now imagined we were "investing" in ourselves when we continued our education or "invested" in our children when we enriched their play. Simultaneously, the commercial world rapidly adapted to incorporate not only counter cultural forms but also criticism—by the 1990s, punk music and activist aesthetics became marketable. What were politically conscious artists to do?

One response came from within art institutions. Artists adapted the feminist mantra "the personal is political" to mount a critique of "identity," demanding not only greater representation of diverse American populations in the museum, but also demanding greater forms of identification with underrepresented, subjective American experiences. One response to these calls came in the form of the 1993 Whitney Biennial. The exhibition included not only a more diverse group of artists, but also an expanded definition of art. One the most provocative projects in the show was Daniel Martinez's museum admission tags, which were composed of words forming the phrase "I can't imagine ever wanting to be white." The project not only served to decenter whiteness in the exhibition, but since visitors were required to wear the tags in order to enter the show, it also destabilized the fixed racial positions of the majority-white museum audience.

Daniel Joseph Martinez
Museum Tags: Second Movement (overture); or, Overture con Claque (Overture with Hired Audience Members), 1993
Courtesy of the artist

Michael Rakowitz
Joe Heywood's paraSITE shelter, 2000
Courtesy of the artist

THE INTERVENTIONISTS: ART IN THE SOCIAL SPHERE
1997

Outside of the museum another political turn was underway. In the streets, corporate board rooms, and even on fashion runways, artists and activists were developing techniques for disrupting or intervening into social power structures. In 2004, to capture this new 90s political art, Nata Thompson curated the exhibition "The Interventionists: Art in the Social Sphere" at Mass MoCA. Many artists took part in the exhibition and he organized them into four categories:

"Nomads" included artworks that require mobility and circulate in the public sphere. *ParaSITE*, for example, by Michael Rakowitz consists of a tent for the homeless that is inflated by existing apartment HVAC system discharges.

"Reclaim the City" features artists' actions that are usually aimed against the corporate take over of the public sphere, many times directly influenced by radical DIV tradition. The Street Rec collective, for example, created posters and graffiti against the American wars and in support of the global south social movements.

"Ready to Wear" includes projects or artworks that are wearable, offering social justice statements or even solutions for the lives of underserved community members. Ruben Ortiz Torres made ball caps that were modifications of famous teams' apparel, for example one cap transformed the LA Kings' logo to read "Rodney King."

"The Experimental University" describes when artists, academics and other professionals create a hub for learning, discussion and art creation and theory around social issues. Often these hubs lead not only to new art and literature but also to action. 16 Beaver was a space in Lower Manhattan were many artists, activists, academics, and others participated in discussions, organizing and more.

IRAQ

2004

iRaq (2004) is a striking example of anti-war art created by two anonymous artists under the name Forkscrew Graphics. The work imitates the design of a popular 2004 Apple ad campaign, which depicted silhouettes dancing to music playing through their thin white head-phones. Instead of these dancing Figures, however, *iRaq* shows a black silhouette standing on a box with a thin white wire attached to each hand, arms outstretched to mimic the crucifixion. In a jarring moment of realization, one recognizes this as an image of inhuman torture from the Abu Ghraib prison, specifically that of a hooded Iraqi man told that he would be electrocuted if he fell off the narrow box. The work, which is one of four in a larger series, seizes on the arresting combination of eye-catching commercialism and sickening atrocity to force a reconciliation between ideas of freedom and justice and the crimes presented.

Forkscrew Graphics
iRaq, 2004

THE YES MEN

2004

During a televised appearance on BBC4 in 2004, in a dramatic reversal of their previously declared position, Dow Chemical publicly accepted responsibility for the Bhopal industrial disaster, a toxic gas leak that killed nearly 3,800 people and sickened tens of thousands more. Dow Chemical, now the owner of the Bhopal plant, promised on-air to spend billions to make right the human and material costs of the community. But this announcement came as a surprise to the real Dow Chemical, which had no intention to make any restitution for the damage, and they watched in horror as their stock value plummeted on the news. The announcement was later revealed to be a hoax by the artis / activist group, The Yes Men. For a brief moment, the group made it seem possible that a major corporation could invest in social responsibility over profit.

The work of The Yes Men mimics the shape and form of corporate capitalism. By exploiting the same media culture as major corporations, including websites and news interviews, they disrupt the image of their target organizations. These disruptions sometimes include posing as spokespeople for existing companies and non-governmental organizations in order to make uncharacteristically humane announcements. More often, however, the interventions come in the form of a parody corporate website or promotion that grapples with honesty and accountability—qualities that are all too lacking in real corporate branding.

The Yes Men
Dow Does the Right Thing, 2004

FORENSIC ARCHITECTURE
"TRIPLE-CHASER"
2019

Museum galleries have long regarded themselves as neutral, if sacred, repositories of culture. But after the 1970's turn to institutionally critical art, that status has been called into question. Today, artist groups often demand that cultural institutions answer for ethical shortcomings regarding their board members and sponsors. The Whitney Museum, and in particular the Whitney Biennial, has been a frequent site of artist protest over the years. In 2019, the Biennial faced perhaps its biggest act of reckoning thus far.

During the exhibition, eight artists withdrew their works to take part in a months-long protest calling for the removal of the trustee Warren Kanders, president of the tear-gas and military equipment company Safariland. For their contribution to the exhibition, the group Forensic Architecture showed *Triple-Chaser*, an exposition on Safariland in which gas canisters were used on civilians. Groups such as Forensic Architecture and Occupy Museums work to hold cultural institutions to the values they claim to promote. No longer can museums pretend to be bastions of progressive art when they partner with people and companies that cause harm.

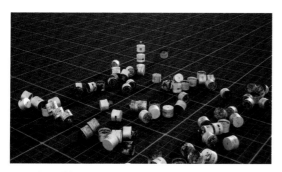

Forensic Architecture
Triple-Chaser, 2019

It is impossible just to drop into a 'community' and make good activist art. The task is specialized (though not in the same ways high art is) and it demands discipline and dedication (as high art does).

— LUCY LIPPARD

Checklist

——

TERRY ADKINS /

American, 1953 - 2014

Muffled Drums (from "Darkwater"), 2003

Bass drums, mufflers

Tate: Purchased using funds provided by the 2013 Outset / Frieze Art Fair Fund to benefit the Tate Collection 2014 L2021.15

—

NOEL W ANDERSON /

American, born 1981

Sly Wink, 2012-2018

Erased Ebony Magazine

Courtesy of the artist, from his private collection

Check the skin, 2012-2018

Erased Ebony Magazine

Courtesy of the artist, from his private collection

he's Mean!, 2012-2018

Erased Ebony Magazine

Courtesy of the artist, from his private collection

Woman there is..., 2012-2018

Erased Ebony Magazine

Courtesy of the artist, from his private collection

Rinse, 2012-2018

Erased Ebony Magazine

Courtesy of the artist, from his private collection

—

ERIK BRANCH /

American, born 1979

We Honor Breonna, August 23, 2020 (printed 2021)

Giclée print on Hahnemuhle rag paper

Collection of the Speed Art Museum, Louisville, Kentucky. Purchased with funds from the Alice Speed Stoll Endowed Art Acquisition Fund 2021.11.1

Say Her Name, 6th Street, Downtown Louisville, Kentucky, June 6, 2020 (printed 2021)

Giclée print on Hahnemuhle rag paper

Collection of the Speed Art Museum, Louisville, Kentucky. Purchased with funds from the Alice Speed Stoll Endowed Art Acquisition Fund 2021.11.2

XAVIER BURRELL /
American, born Germany, 1979

SAY HER NAME!!, September 18, 2020 (printed 2021)
Giclée print on Hahnemuhle rag paper

Collection of the Speed Art Museum, Louisville, Kentucky. Purchased with funds from the Alice Speed Stoll Endowed
Art Acquisition Fund 2021.10.1

The Frontlines, Daniel Cameron's Louisville office, Shelbyville Road, September 23, 2020 (printed 2021)
Giclée print on Hahnemuhle rag paper

Collection of the Speed Art Museum, Louisville, Kentucky. Purchased with funds from the Alice Speed Stoll Endowed
Art Acquisition Fund 2021.10.2

MARÍA MAGDALENA CAMPOS-PONS /
American, born Cuba, 1959

Butterfly Eyes, (for Breonna Taylor) from the series In the year of the pandemic, in the month of the awakening, 2021
Mixed medium, watercolor, ink, gouache, digital print on Arches archival paper

Collection of the Speed Art Museum, Louisville, Kentucky. Purchased with funds from the Alice Speed Stoll Endowed
Art Acquisition Fund and the generous donations of Jeffrey and Susan Callen, Sally and Stanley Macdonald, Dr. Rebecca
Terry and Mr. Pete Thompson, Victoria and Paul Diaz, Juliet Gray and Mathias Kolehmainen, Lopa and Rishabh Mehrotra,
Sarah and Chuck O'Koon, Ruth Simons, and Linda and Chris Valentine 2021.7

NICK CAVE /
American, born 1959

Unarmed, 2018
Sculpture, cast bronze, metal and vintage beaded flowers

Courtesy of the artist L2021.3

JON P. CHERRY /
American, born 1989

Open Up the Cells, September 24, 2020 (printed 2021)
Giclée print on Hahnemuhle rag paper

Collection of the Speed Art Museum, Louisville, Kentucky. Purchased with funds from the Alice Speed Stoll Endowed
Art Acquisition Fund 2021.9

BETHANY COLLINS /
American, born 1984

The Star Spangled Banner: A Hymnal, 2020
100 laser cut leaves

Collection of the Speed Art Museum, Louisville, Kentucky. Purchased with funds from the Alice Speed Stoll Endowed
Art Acquisition Fund 2021.1

The Star Spangled Banner, 2021
One channel sound recording, two wall-mounted speakers

Collection of the Speed Art Museum, Louisville, Kentucky. Purchased with funds from the Alice Speed Stoll Endowed Art Acquisition Fund 2021.6

—

THEASTER GATES /
American, born 1973

Alls my life I has to fight, 2019
Metal, bronze, Cerulean granite and carpet

Gray, Chicago / New York and Tia Collection, Santa Fe L2021.17

—

TYLER GERTH /
American, 1992 - 2020

Untitled, June 11, 2020 (printed 2021)
Giclée print on Hahnemuhle rag paper

Collection of the Speed Art Museum, Louisville, Kentucky. Purchased with funds from the Alice Speed Stoll Endowed Art Acquisition Fund 2021.8

—

SAM GILLIAM /
American, born 1933

Carousel Form II, 1969
Acrylic on canvas

Collection of the Speed Art Museum, Gift of the artist 2013.6

—

JON-SESRIE GOFF /
American, born 1983

A Site of Reckoning: Battlefield, 2016
High-definition video, with sound Duration: 4 minutes 47 seconds, looped

Courtesy of the artist L2021.5

—

ED HAMILTON /
American, born 1947

Untitled, 2000
Bronze, limestone

Gift of Dr. and Mrs. S. Pearson Auerbach 2000.17

—

KERRY JAMES MARSHALL /
American, born 1955

Lost Boys: AKA BB, 1993
Acrylic and collage on canvas mounted on board

Art Bridges Collection L2019.9

—

RASHID JOHNSON /
American, born 1977

Anxious Red Painting, November 3, 2020, 2020
Oil on linen

Courtesy of the artist L2021.6

—

KAHLIL JOSEPH /
American, born 1981

BLKNWS®, (2018-ongoing)
Two-channel fugitive newscast

Courtesy the artist L2021.7

—

GLENN LIGON /
American, born 1960

Aftermath, 2020
Neon

Courtesy of the artist and Hauser & Wirth L2021.8

—

AMY SHERALD /
American, born 1973

Breonna Taylor, 2020
Oil on canvas

The Speed Art Museum, Louisville, Kentucky, Museum purchase made possible by a grant from the Ford Foundation; and the Smithsonian National Museum of African American History and Culture, purchase made possible by a gift from Kate Capshaw and Steven Spielberg/The Hearthland Foundation 2021.2

—

LORNA SIMPSON /
American, born 1960

Same, 1991
16 color Polaroids in four frames with 11 plastic plaques

Collection of the Speed Art Museum, Gifts of the New Art Collectors 1991.22.2 a-e

—

NARI WARD /
American, born Jamaica, 1963

We the People, 2011
Shoelaces

Collection of the Speed Art Museum, Gift of Speed Contemporary 2016.1

—

HANK WILLIS THOMAS /
American, born 1976

Remember Me, 2014
Neon

Courtesy of the artist and Jack Shainman Gallery, New York L2021.12.1

15,433 (2019), 2021
Embroidered stars on polyester fabric

Courtesy of the artist and Jack Shainman Gallery, New York L2021.12.2

19,281 (2020), 2021
Embroidered stars on polyester fabric

Courtesy of the artist and Jack Shainman Gallery, New York L2021.12.3

—

ALISHA B. WORMSLEY /
American, born 1978

There Are Black People in the Future, 2011-present
Vinyl letters

Courtesy of Alisha B Wormsley L2021.13

—

T.A. YERO /
American, born 1986

Healing, June 15, 2020, 7:41pm, Breonna Taylor Memorial at Jefferson Square Park, Louisville, KY (printed 2021)
Giclée print on Hahnemuhle rag paper

Collection of the Speed Art Museum, Louisville, Kentucky. Purchased with funds from the Alice Speed Stoll Endowed Art Acquisition Fund 2021.12.1

Who has the power?, June 15, 2020, 8:04 pm, Breonna Taylor Memorial at Jefferson Square Park, Louisville, KY (printed 2021)
Giclée print on Hahnemuhle rag paper

Collection of the Speed Art Museum, Louisville, Kentucky. Purchased with funds from the Alice Speed Stoll Endowed Art Acquisition Fund 2021.12.2

Program Listing

—

Visit www.PromiseWitnessRemembrance.org for more information or to watch recordings of these programs.

—

CINEMA+ LOOKING AT THE PAST TO INSPIRE THE FUTURE: COMMUNITY LEADER PANEL DISCUSSION ABOUT JUDAS AND THE BLACK MESSIAH (MARCH 25, 2021) /

Nicole Hayden - *Moderator,* Charles Booker, Councilwoman Keisha Dorsey, Shauntrice Martin, Dr. Brandon McCormack

—

NATIONAL ADVISORY PANEL CONVERSATION WITH ALLISON GLENN (APRIL 8, 2021) /

Allison Glenn - *Moderator*, Mecca Brooks, Jon-Sesrie Goff, Amy Sherald, Allison K. Young

—

VIRTUAL AFTER HOURS (APRIL 16, 2021) /

Director's Cut with Speed Art Museum Director Stephen Reily and Community Engagement Strategist Toya Northington

"VIRGIL"

Created by Davóne Tines. "Virgil" Written By: Igee Dieudonné, Davóne Tines, Matthew Aucoin. Performed By: Davóne Tines and Conor Hanick. Sound Engineered By: Jake Vicious.

Jermaine Fowler: Art's Power of "Promise," "Witness," and "Remembrance"

Tricia Hersey: Creating a Guided Meditation for *Promise, Witness, Remembrance*

The Afrophysicists

—

VIRTUAL AFTER HOURS (MAY 21, 2021) /

Director's Cut with Speed Art Museum Director Stephen Reily and artist Amy Sherald

"THERE ARE BLACK PEOPLE IN THE FUTURE" ARTIST RESPONSES:

Kofi Darku, Dre Dawson (aka Dre DaSon), Tonnea (Nea) Green, Kala Lewis, Roman Lane, Rheonna Nicole

ART + ACTIVISM WITH THE UNIVERSITY OF LOUISVILLE DISCUSSION:

Chris Reitz - *Professor,* Hannah DeWitt, Flora K. Schildknecht, Cathy Shannon

TEAL TABLE TALKS:

Dr. Steven Kniffley, Chandra Irvin, Spalding University, Jessie Halladay, Dr. Dede Wohlfarth, Al Klein, Janelle Rae

—

PHOTOGRAPHING THE PROTESTS: THROUGH THE LENS OF TYLER GERTH (MAY 27, 2021) /

Allison Glenn - *Moderator*, Tiffany Hensley, Jon P. Cherry, Brittany Loewen

—

FAITH & JUSTICE WEEKEND (MAY 29-30, 2021) /

Tiffany Farmer, Dr. Brandon McCormack, Rev. Tim Findley, Representative Keturah Herron, Sweet Potato Pie Kitchen, Gore's BBQ, Seafood Moe, JuJu's Treats

—

CELEBRATING COMMUNITY (JUNE 5-6, 2021) /

Garden Girl Foods, Brittany Thurman, Jaylin Stewart, DJ John Q, Louisville Metro Dept. of Public Health and Wellness, Tyreson Lancaster / Ty Taking Photos, Anthony Northington

Biographies

—

Contributors /

—

STEPHEN REILY /

Stephen Reily is an attorney, entrepreneur, and civic leader in Louisville, Kentucky. After clerking for the U.S. Supreme Court and practicing law, he founded IMC Licensing, a global leader in brand licensing that has generated over $6 billion in consumer product sales for the Fortune 500 brands it represents. He is also the co-founder of Curated Media and its fast-growing app ClickHer, which shares content by and for women, and the founder of Seed Capital Kentucky, a non-profit focused on building a more sustainable future for Kentucky family farmers and farm communities.

A collector and arts patron, he answered a call in 2017 to serve as Director of the Speed Art Museum in Louisville, and for more than four years he led the institution under a new mission to "invite everyone to celebrate art forever." Under Reily's leadership, the Speed introduced a new "Speed for All" free family membership for anyone for whom cost is a barrier to entry; initiated its first paid internships; issued its first annual Racial Equity Report, specifying the museum's standing and commitments on staffing, acquisitions and exhibitions, programming, and more; presented over 20 exhibits, expanding the museum's commitment to presenting both the work of artists historically underrepresented in museums and all of the arts of Kentucky; increased contributed revenue by nearly 50%; offered an "After Hours" event welcoming on average over 1,000 visitors monthly; and created "The Art of Bourbon," the premier national nonprofit bourbon auction.

In 2017 he created the Reily Reentry Project in partnership with the Louisville Urban League to support expungement programs for citizens of Kentucky. He serves on the Boards of Creative Capital, a leading grantmaker in the arts, the Greater Louisville Project, the Louisville Urban League, the James Graham Brown Foundation, and LHOME. He is married to Emily Bingham, an author and historian, and they have three children.

—

ALLISON GLENN /

Allison Glenn is a curator and writer deeply invested in working closely with artists to develop ideas, artworks, and exhibitions that respond to and transform our understanding of the world. Glenn's curatorial work focuses on the intersection of art and publics, through public art, biennials, special projects, and major new commissions by leading contemporary artists.

She is one of the curators of Counterpublic 2023, a St. Louis-based triennial. Previous curatorial roles include senior curator and director of public art at the Contemporary Arts Museum Houston; associate curator, contemporary art at Crystal Bridges Museum of American Art; curatorial associate and publications manager for Prospect New Orleans international art triennial *Prospect.4: The Lotus in Spite of the Swamp*; and a curatorial fellowship with the City of Chicago Department of Cultural Affairs and Special Events.

Her writing has been featured in catalogs published by Crystal Bridges Museum of American Art, The Los Angeles County Museum of Art, Prospect New Orleans, Princeton Architectural Press, California African American Museum, Kemper Art Museum, Studio Museum in Harlem, and she has contributed to Artforum, ART PAPERS, Hyperallergic, Fresh Art International, ART21 Magazine, Gulf Coast Quarterly, and Pelican Bomb, amongst others.

Recognition includes the 2022 ArtNews Deciders list and the 2021 Observer Arts Power 50 List. Glenn is a member of Madison Square Park Conservancy's Public Art Consortium Collaboration Committee, and sits on the Board of Directors for ARCAthens, a curatorial and artist residency program based in Athens, Greece and the Bronx, New York. She received dual master's degrees from the School of the Art Institute of Chicago in Modern Art History, Theory and Criticism and Arts Administration and Policy, and a Bachelor of Fine Art Photography with a co-major in Urban Studies from Wayne State University in Detroit.

—

TOYA NORTHINGTON /

Toya Northington, MSSW is an artist, researcher and social entrepreneur. She holds a Bachelor of Fine Arts degree from Georgia State University and also holds a Masters in Social Work from the University of Louisville. Working in mixed media and across disciplines, Toya's works are an act of resistance, pushing back against societal expectations. Northington engages in multiple strategies to promote social change and further her commitment to social justice. Among these strategies are her engagement in research that seeks to improve conditions for highly marginalized populations (i.e., formerly incarcerated African American men and women living with HIV; incarcerated older adults) and the empowerment of sexual minority youth.

Her work is an acknowledgement of traumas too often experienced by women, and provides a means to foster healing and resilience from them. Northington brings a unique and important feminist perspective to her work and life as an African American working class woman. She combines her personal, lived experience with her professional training and education as both an artist and a master's level social worker to produce work that is simultaneously transformative, empowering and socially conscious. Toya is the recipient of *Art Meets Activism, Artist Enrichment*, and *The Special* grants from the Kentucky Foundation for Women.

In 2012, Toya founded an art-based, mental health and social justice organization, artThrust. This was the first non-profit organization employing art-based, trauma-informed programming to address the psychosocial needs of Black girls and LGBTQ+ youth in Louisville, KY. She is also currently the Executive Director of artThrust and the Community Engagement Strategist at the Speed Museum.

Artists /

——

TERRY ADKINS /

Terry Adkins (b. 1953, Washington, D.C.; d. 2014, Brooklyn, NY) established an interdisciplinary and frequently collaborative practice that encompassed sculpture, music, printmaking, and video. Engaging with the improvisatory spirit of free jazz, he sought to "find a way to make music as physical as sculpture might be and sculpture as ethereal as music is."

Adkins grew up in a musical household. He played guitar, saxophone, and other instruments and counted John Coltrane, Nina Simone, and Jimi Hendrix among his influences. His early affinity for drawing was nourished at Fisk University in Nashville, where he studied with such luminaries as David Driskell and Martin Puryear. In 1975 Adkins completed his B.S. in printmaking and then pursued an MS in the field from Illinois State University. In 1979, he received an MFA in sculpture from the University of Kentucky. Adkins returned to D.C., where he joined a free jazz band led by Yahya Abdul-Majid of the Sun Ra Arkestra.

It was Adkins's residencies at the Studio Museum in Harlem and, subsequently, P.S. 1 Contemporary Art Center which prompted the artist's experimentation with sculpture, installation and performative practice. In 1986, Adkins was

awarded a residency in Zürich, where he founded the Lone Wolf Recital Corps, a performance collaborative featuring a rotating ensemble of artists, musicians, and friends, such as Charles Gaines, Kamau Patton, Jacolby Satterwhite, and Jamaaladeen Tacuma. He termed the group's multimedia happenings "recitals."

Adkins's recitals were often dedicated to recovering the narratives of historical figures important to the cultures of the African diaspora, including botanist and inventor George Washington Carver, musician Jimi Hendrix, intellectual W. E. B. Du Bois, composer Ludwig van Beethoven, and blues singer Bessie Smith. Adkins reached beyond conventional interpretations of the past in his "abstract portraiture," coming to understand his subjects through site-specific research, engaging relevant contemporary communities, and employing historically potent materials for his installations and recitals.

In 1995, Thelma Golden curated an exhibition of Adkins's work at the Whitney Museum of American Art at Phillip Morris, including his Akrhaphones: giant horns which are both sculptures and invented instruments. In 1999, Adkins mounted a solo exhibition at the Institute of Contemporary Art in Philadelphia and in 2000 he joined the faculty at the University of Pennsylvania School of Design in the departments of Fine Arts and Africana Studies. In 2009, he received the Jesse Howard, Jr. / Jacob H. Lazarus—Metropolitan Museum of Art Rome Prize. A retrospective of his work, Terry Adkins Recital, was organized in 2012 by the Frances Young Tang Teaching Museum and Art Gallery at Skidmore College, Saratoga Springs, New York.

On February 8, 2014, Adkins passed away at the age of 59. His work has posthumously been included in significant international exhibitions including the 2014 Whitney Biennial, the 56th Venice Biennale in 2015, and the 2015–16 traveling exhibition The Freedom Principle: Experiments in Art and Music, 1965 to Now. In 2017, the Museum of Modern Art in New York hosted the first exhibition and performance series to reunite the Lone Wolf Recital Corps since Adkins's death. Important solo exhibitions of his work include Terry Adkins: Infinity Is Always Less Than One at the Institute of Contemporary Art, Miami (2018); Our Sons and Daughter Ever on The Altar co-presented by Frist Museum and Fisk University, Nashville (2020); and Resounding at the Pulitzer Art Foundation, St. Louis (2020).

Work by Adkins can be found in the collections of major public institutions, including Museum of Modern Art, New York; Metropolitan Museum of Art, New York; Whitney Museum of American Art, New York; Tate Modern, London; Hirshhorn Museum and Sculpture Garden, Smithsonian Institution, Washington, DC; Museum of Contemporary Art Chicago; San Francisco Museum of Modern Art; de Young, Fine Arts Museums of San Francisco; Museum of Contemporary Art Los Angeles; Art Bridges Foundation, Bentonville, Arkansas; Studio Museum in Harlem, New York; Pennsylvania Academy of the Fine Arts, Philadelphia; and Pérez Art Museum Miami. (via Lévy Gorvy)

—

NOEL W ANDERSON /

Noel W Anderson (b. 1981, Louisville, KY) received an MFA from Indiana University in Printmaking, and an MFA from Yale University in Sculpture. He is also Area Head of Printmaking in NYU's Steinhardt Department of Art and Art Professions.

Anderson utilizes print-media and arts-based-research to explore philosophical inquiry methodologies. He primarily focuses on the mediation of socially constructed images on identity formation as it relates to Black masculinity and celebrity. In 2018, Noel was awarded the NYFA Artist Fellowship grant and the prestigious Jerome Prize. His solo exhibition "Blak Origin Moment" debuted at the Contemporary Arts Center (Cincinnati) in February 2017 and travelled to the Hunter Museum of American Art in October 2019. His first monograph, Blak Origin Moment, was also recently published. (via artist website)

—

ERIK BRANCH /

Erik Branch is a photographer living in Louisville, KY.

—

XAVIER BURRELL /

Xavier Burrell is a native of Huntsville, Alabama and is currently pursuing an MBA Degree at the University of Louisville College of Business. He is a former student-athlete at UofL, where he was a player on the UofL football team. He earned a BS Degree in Communications in 2008 from UofL, as well as a BS Degree in Sports Administration in 2018 when he returned back to school after he was medically retired from the U.S. Army as a Captain after serving 8 years on active duty. He was deployed twice to Afghanistan during Operation Enduring Freedom and during his military career he was awarded the Bronze Star Medal, Meritorious Service Medal (2), Army Commendation Medal (2), Army Achievement Medal, Combat Action Badge, Meritorious Unit Commendation (2), National Defense Service Medal, Global War on Terrorism Service Medal, Army Service Ribbon, Overseas Service Ribbon (2), NATO Service Medal, and a Combat Action Badge. After his military career was cut short, Xavier picked up a camera as a hobby and since then he has worked on creative projects with the UofL Athletics Department, Revolt, as well as a freelancer for the New York Times. Xavier works with various mediums to produce videos and photographs that always capture the essence of his subjects through an emphatic lens. (via the artist)

—

MARÍA MAGDALENA CAMPOS-PONS /

María Magdalena Campos-Pons (b. 1959, La Vega, Cuba) combines and crosses diverse artistic practices, including photography, painting, sculpture, film, video, and performance. Her work addresses issues of history, memory, gender, and religion; it investigates how each one of these themes informs identity formation.

Born in 1959 in La Vega, a town in the province of Matanzas, Cuba, Campos-Pons is a descendant of Nigerians who were brought to the island as slaves in the 19th century. She grew up learning firsthand about the legacy of slavery along with the beliefs of Santeria, a Yoruba-derived religion. Directly informed by the traditions, rituals, and practices of her ancestors, her work is deeply autobiographical. Often using herself and her Afro-Cuban relatives as subjects, she creates historical narratives that illuminate the spirit of people and places, past and present, and renders universal relevance from personal history and persona. Her imagery and performances recall dark narratives of the Middle Passage and the Trans-Atlantic slave trade. They honor the labor of black bodies on indigo and sugar plantations, renew Catholic and Santeria religious practices, and celebrate revolutionary uprisings in the Americas. As she writes, "I...collect and tell stories of forgotten people in order to foster a dialogue to better understand and propose a poetic, compassionate reading of our time."

Campos-Pons has had solo exhibitions at the Museum of Modern Art, the Indianapolis Museum of Art, the Peabody Essex Museum, and the National Gallery of Canada, among other distinguished institutions. She has participated in the Venice Biennale (twice), the Dakar Biennale, the Johannesburg Biennial, Documenta 14, the Guangzhou Triennial, three editions of the Havana Biennial, and the Pacific Standard Time: LA/LA and Prospect.4 Triennial. She has presented over 30 solo performances commissioned by institutions including the Guggenheim Museum and the Smithsonian's National Portrait Gallery.

Every element that appears in María Magdalena Campos-Pons' performance work is something that the artist herself has created. She designs her own costumes. She writes the texts that she or her collaborators will speak or chant. She fabricates the physical items that she will deploy and constructs the sonic features by which she will be accompanied. The power of her performances—unprecedented actions that immerse contemporary viewers in ancient practices and unremembered narratives—is derived precisely from her commitment to and investment in every aspect of her work.

Campos-Pons' performances tend to unfold as processions. They are ritualistic spectacles that physically and spiritually embody the spaces in which they take place while asserting themselves outward and beyond the boundaries of those spaces. They are simultaneously immanent and transcendent. Operating within the museum institution, they kick open

its doors and reinscribe within its halls identities that have been institutionally excluded, thereby transforming both the institution and the visitor. Incorporating incantations, religious rituals, and celebrations, Campos-Pons' performances challenge viewers to participate by virtue of their presence while providing opportunities for all present to reflect, to call forth energies, and to heal.

In the late 1980s, Campos-Pons taught at the prestigious Instituto Superior de Arte in Havana and gained an international reputation as an exponent of the New Cuban Art movement that arose in opposition to Communist repression on the island. In 1991, she immigrated to Boston and taught at the School of the Museum of Fine Arts at Tufts University, where she received numerous prizes and honors for both her teaching and her artistic practice. In 2017, she was awarded the Vanderbilt Chair at Vanderbilt University and moved to Nashville, TN., where she currently resides.

Campos-Pons' works are in over 30 museum collections, including the Smithsonian Institution; the Whitney Museum of American Art; the Art Institute of Chicago; the National Gallery of Canada; the Victoria and Albert Museum; the Museum of Modern Art; the Museum of Fine Arts, Boston; the Perez Art Museum, Miami; and the Fogg Art Museum. (via Gallery Wendi Norris)

—

NICK CAVE /

Nick Cave (b. 1959, Fulton, MO) is an artist, educator and foremost a messenger, working between the visual and performing arts through a wide range of mediums including sculpture, installation, video, sound and performance. Cave is well known for his Soundsuits, sculptural forms based on the scale of his body, initially created in direct response to the police beating of Rodney King in 1991. Soundsuits camouflage the body, masking and creating a second skin that conceals race, gender and class, forcing the viewer to look without judgment. They serve as a visual embodiment of social justice that represent both brutality and empowerment.

Throughout his practice, Cave has created spaces of memorial through combining found historical objects with contemporary dialogues on gun violence and death, underscoring the anxiety of severe trauma brought on by catastrophic loss. The figure remains central as Cave casts his own body in bronze, an extension of the performative work so critical to his oeuvre. Cave reminds us, however, that while there may be despair, there remains space for hope and renewal. From dismembered body parts stem delicate metal flowers, affirming the potential of new growth. Cave encourages a profound and compassionate analysis of violence and its effects as the path towards an ultimate metamorphosis. While Cave's works are rooted in our current societal moment, when progress on issues of global warming, racism and gun violence (both at the hands of citizens and law enforcement) seem maddeningly stalled, he asks how we may reposition ourselves to recognize the issues, come together on a global scale, instigate change, and ultimately, heal. (via Jack Shainman Gallery)

—

JON P. CHERRY /

Jon Cherry (he/him) is a widely published multi-specialty photographer whose work spans a wide range of photographic disciplines. His work has been described as deeply romantic, yet joyful.

Currently, Jon is committed to documenting the community uprising, the COVID-19 pandemic, and cultural occurrences in Louisville, Kentucky. He is dedicated to capturing moments that spark action without words and convey emotions that may be otherwise foreign to the viewer.

Jon has worked as a stringer for Getty Images, and has been published when shooting independently by *TIME* Magazine, *Vanity Fair, The Guardian, The New York Time*s, and others.

—

BETHANY COLLINS /

Bethany Collins (b. 1984, Montgomery, AL lives and works in Chicago, IL) is a multidisciplinary artist whose conceptually driven work is fueled by a critical exploration of how race and language interact. As Holland Cotter noted in *The New York Times*, "language itself, viewed as intrinsically racialized, is Bethany Collins' primary material." Her works have been exhibited in solo and group exhibitions nationwide, including the Studio Museum in Harlem, The Drawing Center, Wexner Center for the Arts, Museum of Contemporary Art Detroit, Atlanta Contemporary Art Center, and the Birmingham Museum of Art. Collins has been recognized as an Artist-in-Residence at the Studio Museum in Harlem, the MacDowell Colony, the Bemis Center, and the Hyde Park Art Center among others. In 2015, she was awarded the Hudgens Prize. She received her MFA from Georgia State University, and her BA from the University of Alabama. (via gallery)

—

THEASTER GATES /

Theaster Gates (b. 1973) lives and works in Chicago. Gates creates works that engage with space theory and land development, sculpture and performance. Drawing on his interest and training in urban planning and preservation, Gates redeems spaces that have been left behind. Known for his recirculation of art world capital, Gates creates work that focuses on the possibility of the "life within things." His work contends with the notion of Black space as a formal exercise—one defined by collective desire, artistic agency, and the tactics of a pragmatist.

In 2010, Gates created the Rebuild Foundation, a nonprofit platform for art, cultural development, and neighborhood transformation that supports artists and strengthens communities through free arts programming and innovative cultural amenities on Chicago's South Side. In 2016, at the request of Samaria Rice, Tamir Rice's mother, Rebuild Foundation received the gazebo where Tamir was playing when he was killed. Ms. Rice sought to preserve the structure as a community space for care, dialogue, and public engagement. The gazebo, which had once been on display in a deconstructed state inside the Stony Island Arts Bank, now stands tall in a reflection garden on the Arts Bank lawn where it serves as a site and object of care.

Gates has exhibited and performed at Tate Liverpool, UK (2020); Haus der Kunst, Munich (2020); Walker Art Centre, Minneapolis (2019); Palais de Tokyo Paris, France (2019); Sprengel Museum Hannover, Germany (2018); Kunstmuseum Basel, Switzerland (2018); National Gallery of Art, Washington D.C., USA (2017); Art Gallery of Ontario, Canada (2016); Fondazione Prada, Milan, Italy (2016); Whitechapel Gallery, London, UK (2013); Punta della Dogana, Venice, Italy (2013) and dOCUMENTA (13), Kassel, Germany (2012), Serpentine Pavilion, London, UK (2022). He was the winner of the Artes Mundi 6 prize and a recipient of the Légion d'Honneur in 2017. In 2018, he was awarded the Nasher Prize for Sculpture, and the Urban Land Institute, J.C. Nichols Prize for Visionaries in Urban Development. Gates received the 2020 Crystal Award for his leadership in creating sustainable communities.

Gates is a professor at the University of Chicago in the Department of Visual Arts and the Harris School of Public Policy, and is Distinguished Visiting Artist and Director of Artist Initiatives at the Lunder Institute for American Art at Colby College. (via the artist)

—

TYLER GERTH /

Tyler Gerth (b. 1992; d. 2020, Louisville, KY) was incredibly kind, warm-hearted and generous, holding deep convictions and faith. It was this sense of justice that drove Tyler to be part of the peaceful demonstrations advocating for the destruction of the systemic racism within our society. This, combined with his passion for photography led to a strong need within him to be there, documenting the movement, capturing and communicating the messages of peace, justice and change.

Tyler Gerth was a beloved son, cherished little brother, adored uncle and a trusted friend. A graduate of Trinity High School (2011) and the University of Kentucky (2016), Tyler was a lifelong learner and held many passions in addition to his corporate career in quality assurance with Papa John's. Tyler loved watching movies; listening to his vast and diverse record collection, traveling and exploring new places; learning about history through both genealogy research as well as biographies & documentaries; playing and watching a variety of sports; and spending time with family and friends. Tyler was creative, inquisitive, gentle, tenacious, and so very brave. He played the ukulele, had a thriving garden, loved to play with his nieces and nephews, constantly wore some sort of silly socks (tie-dye was his favorite) and is still missed terribly by his precious rescue dog, Jordan.

Tyler desired a world in which the future generation could have equal and equitable access to rights and opportunities and he truly believed as he often quoted Sam Cooke, "change is gonna come." We at Building Equal Bridges, The Tyler Gerth Memorial Foundation are determined to continue Tyler's legacy of fighting social and racial injustice and are committed to seeing that change he gave his life advocating for. (via the artist's family)

—

SAM GILLIAM /

Sam Gilliam (b. 1933, Tupelo, MS) is one of the great innovators in postwar American painting. He emerged from the Washington, D.C. scene in the mid 1960s with works that elaborated upon and disrupted the ethos of Color School painting.

A series of formal breakthroughs would soon result in his canonical Drape paintings, which expanded upon the tenets of Abstract Expressionism in entirely new ways. Suspending stretcherless lengths of painted canvas from the walls or ceilings of exhibition spaces, Gilliam transformed his medium and the contexts in which it was viewed. As an African-American artist in the nation's capital at the height of the Civil Rights Movement, this was not merely an aesthetic proposition; it was a way of defining art's role in a society undergoing dramatic change. Gilliam has subsequently pursued a pioneering course in which experimentation has been the only constant. Inspired by the improvisatory ethos of jazz, his lyrical abstractions continue to take on an increasing variety of forms, moods, and materials.

In addition to a traveling retrospective organized by the Corcoran Gallery of Art, Washington, D.C. in 2005, Sam Gilliam has been the subject of solo exhibitions at the Museum of Modern Art (1971); The Studio Museum in Harlem (1982); Whitney Museum of American Art, Philip Morris Branch (1993); J.B. Speed Memorial Museum (1996); Phillips Collection (2011); and Kunstmuseum Basel, Switzerland (2018), among many other institutions. A semi-permanent installation of Gilliam's paintings will opened at Dia:Beacon in August 2019. His work is included in over fifty public collections, including those of the Musée d'Art Moderne de la Ville de Paris; Tate Modern, London; the Museum of Modern Art; the Metropolitan Museum of Ar; and the Art Institute of Chicago. He lives and works in Washington, D.C. (via Pace)

—

JON-SESRIE GOFF /

Jon-Sesrie Goff (b. 1983, Hartford, CT) is a multidisciplinary artist, curator, and arts administrator. With extensive experience in media and film production, Jon has offered his lens to a variety of projects spanning many genres including the recently released and award-winning documentaries, including *Out in the Night* (POV, Logo 2015), *Evolution of a Criminal* (Independent Lens 2015) and *Spit on the Broom* (2019), among several other projects. He is in production for his feature-length documentary, *After Sherman*, which has received support from JustFilms, Firelight Media, International Documentary Association, Black Public Media, Jerome Foundation, Gucci / Tribeca Film Institute, and the Sundance Institute.

Previously, he has served as Executive Director of the Flaherty Film Seminar and the Museum Specialist for Film at the Smithsonian's National Museum of African American History & Culture where he was responsible for developing

the museum's public film program. His personal practice has involved extensive institutional, community, and personal archival research, photo, and film documentation, and oral history interviews in the coastal South on the legacy of Black land ownership and Gullah Geechee heritage preservation. Jon engages with his work from the paradigm of a social change instigator. This is evidenced in his participation in the dimensionality of discourse in multicultural communities both within the United States and overseas. He has taught courses in photography, social justice documentary, and film production—at Duke University, Villanova University, and Westchester University.

Jon has served on grant-making panels and juries for the National Endowment for the Arts, Open Society Foundation, Tribeca Film Institute, Lower Manhattan Cultural Council, International Film Festival Rotterdam, Black Star Film Festival, International Documentary Association, Oberhausen Seminar, and CinemAfrica Film Festival (Stockholm, Sweden), among others. He has an MFA in Experimental and Documentary Arts from Duke University. (via the artist)

—

ED HAMILTON /

Ed Hamilton was born in 1947 in Cincinnati, Ohio and is a resident of Louisville, Kentucky. He has been married to Bernadette for 55 years. He has a daughter, Kendra Hamilton Wynn of McKinney, Texas. Ed is a graduate of the Shawnee High School class of 1965 and a graduate of the Louisville School of Art class of 1969.

Active in his community, Ed spends time teaching workshops and lectures for public schools, colleges, and conferences. He has created opportunities for other artists to work and hone their crafts and skills. He has taught sculpture at Jefferson Community College, and is a Morgan Professor of Public Art at University of Louisville. He is a member of Alpha Phi Alpha Fraternity, and a longtime member of St. George's Episcopal Church.

In 2005, Ed was part of the design team of Mahan Rykiel and Associates that won the commission to create the Martin Luther King Jr. Memorial Park in downtown Newport News, Virginia, which was dedicated on May 17, 2014. In 2009, Ed created the Lincoln Memorial at Waterfront Park, a 12 ft. Lincoln and four bas-reliefs that tell Lincoln's story.

Ed also created the Lincoln Memorial for Centre College in Danville, Kentucky, which was dedicated on October 19, 2012. The heroic 12 ft. bronze statue stands in front of the library on campus. Ed Hamilton received an Honorary Degree from Centre College on May 19, 2013.

—

KERRY JAMES MARSHALL /

Through its formal acuity, Kerry James Marshall's (b. 1955, Birmingham, AL) work reveals and questions the social constructs of beauty, taste, and power. As the artist has written, "I gave up on the idea of making Art a long time ago, because I wanted to know how to make paintings; but once I came to know that, reconsidering the question of what Art is returned as a critical issue." Engaged in an ongoing dialogue with six centuries of representational painting, Marshall has deftly reinterpreted and updated its tropes, compositions, and styles, even pulling talismans from the canvases of his forbearers and recontextualizing them within a modern setting. At the center of his prodigious oeuvre, which also includes drawings and sculpture, is the critical recognition of the conditions of invisibility so long ascribed to black bodies in the Western pictorial tradition, and the creation of what he calls a 'counter-archive' that reinscribes these figures within its narrative arc.

Marshall was born in 1955 in Birmingham, Alabama. He received his BFA from the Otis Art Institute in Los Angeles in 1978, where he was later awarded an honorary doctorate in 1999. In 2014, Marshall joined David Zwirner. "Kerry James Marshall: Look See," an exhibition of new paintings by the artist, marked his first gallery solo show at David Zwirner in London that same year. "Kerry James Marshall: History of Painting," the artist's second solo presentation with the gallery, was on view in London in 2018.

Marshall has exhibited widely throughout Europe and the United States since the late 1970s and early 1980s. In 2018, "Kerry James Marshall: Collected Works" was presented at the Rennie Museum in Vancouver and "Kerry James Marshall: Works on Paper" at The Cleveland Museum of Art. His site-specific outdoor sculpture, *A Monumental Journey* was also permanently installed in Hansen Triangle Park in downtown Des Moines, Iowa. From 2016 to 2017, "Kerry James Marshall: Mastry," the first major museum survey of the artist's work, was on view at the Museum of Contemporary Art Chicago, followed by The Met Breuer, New York, and the Museum of Contemporary Art, Los Angeles. In 2015, he created a large-scale mural specifically for the High Line, marking the artist's first public commission in New York. In 2013, his work was the subject of a major survey entitled "Kerry James Marshall: Painting and Other Stuff." The exhibition was first on view at the Museum van Hedendaagse Kunst Antwerpen in Antwerp. In 2014, it traveled to the Kunsthal Charlottenborg in Copenhagen and was co-hosted by two venues in Spain, the Fundació Antoni Tàpies in Barcelona and the Museo Nacional Centro de Arte Reina Sofía in Madrid.

Other prominent institutions which have presented solo shows include the National Gallery of Art, Washington, D.C. (2013); Secession, Vienna (2012); Vancouver Art Gallery (2010); San Francisco Museum of Modern Art (2009); and the Wexner Center for the Arts, Columbus, Ohio (2008). Previous traveling solo exhibitions include those organized by the Camden Arts Centre, London (2005), Museum of Contemporary Art Chicago (2003), and The Renaissance Society at the University of Chicago (1998).

Marshall received the 2019 W. E. B. Du Bois Medal, which is considered Harvard University's highest honor in the field of African and African American studies. In 2016, the artist was the recipient of the Rosenberger Medal given by The University of Chicago for outstanding achievement in the creative and performing arts. In 2014, he received the Wolfgang Hahn Prize, an award given annually by the Gesellschaft für Moderne Kunst at the Museum Ludwig in Cologne. In 2013, he was one of seven new appointees named to former President Barack Obama's Committee on the Arts and the Humanities. Other prestigious awards include a 1997 grant from the MacArthur Foundation and a 1991 fellowship from the National Endowment for the Arts.

Museum collections which hold works by the artist include the Art Institute of Chicago; Los Angeles County Museum of Art; The Metropolitan Museum of Art; Museum of Contemporary Art Chicago; The Museum of Modern Art; National Gallery of Art, Washington, DC; San Francisco Museum of Modern Art; The Studio Museum in Harlem; Walker Art Center, Minneapolis; and the Whitney Museum of American Art, New York. Marshall lives and works in Chicago. (via David Zwirner)

—

RASHID JOHNSON /

Rashid Johnson (b. 1977, Chicago, IL) is among an influential cadre of contemporary American artists whose work employs a wide range of media to explore themes of art history, individual and shared cultural identities, personal narratives, literature, philosophy, materiality, and critical history. After studying in the photography department of the Art Institute of Chicago, Johnson's practice quickly expanded to embrace a wide range of media – including sculpture, painting, drawing, filmmaking, and installation – yielding a complex multidisciplinary practice that incorporates diverse materials rich with symbolism and personal history.

Johnson's work is known for its narrative embedding of a pointed range of everyday materials and objects, often associated with his childhood and frequently referencing collective aspects of African American intellectual history and cultural identity. To date, Johnson has incorporated elements / materials / items as diverse as CB radios, shea butter, literature, record covers, gilded rocks, black soap and tropical plants. Many of Johnson's works convey rhythms of the occult and mystic: evoking his desire to transform and expand each included object's field of association in the process of reception. (via Hauser & Wirth)

—

KAHLIL JOSEPH /

Kahlil Joseph (b. 1981, Seattle, WA) earned his spurs early on working for the photographer Melodie McDaniel and the movie director Terrence Malick. Joseph creates films and video installations that disrupt linear narratives with a particular treatment of music, used both as a material and as a model of lyricism and complexity. Joseph's practice scrambles the conventional approach to and understanding of video: his films quote the likes of Andrei Tarkovsky and Chris Marker and feature pop culture icons and underground heroes alike. Joseph's current focus is the ongoing project *BLKNWS®*, an artwork and functioning business established as a way to redefine how Black culture is experienced, viewed, and communicated. *BLKNWS®* starts from the postulate that anything can be "news" that is new to someone. Originally conceived as a television program, it presents an uninterrupted—though highly edited—stream of images focusing on African American life, including YouTube videos, amateur film footage, internet memes, Instagram stories, and actual news clips. The work operates through a network of highly skilled editors and fugitive journalists—constantly updating the stream—whom Joseph hires and supports, forming a sort of *BLKNWS®* academy that reflects his interest in community-driven process. Joseph's work with *BLKNWS®* was included in "May You Live in Interesting Times" at the 58th Venice Biennale (2019) and in the "Biennale de l'Image en Mouvement," Geneva (2018). His short film *Fly Paper* debuted as part of his 2017 solo exhibition at the New Museum, New York. Other exhibitions include those at Bonnefantenmuseum, Maastricht, Netherlands (2017); Frye Art Museum, Seattle (2016); and Museum of Contemporary Art, Los Angeles (2015). Joseph currently serves as the creative director of the Underground Museum alongside his family, carrying out the vision of his brother, the late Noah Davis. (via the Hammer Museum)

—

GLENN LIGON /

Glenn Ligon (b. 1960, Bronx, NY) received a BA from Wesleyan University in 1982. His early practice was grounded in painting, and his canvases of this period built upon the legacies of such Abstract Expressionist artists as Philip Guston, Cy Twombly, Robert Rauschenberg, and Jasper Johns. In 1984 – 1985, Ligon spent an academic year in the Whitney Museum of American Art's Independent Study Program, developing a series of representational drawings of iconic sculptures by European artists such as Alberto Giacometti and Constantin Brâncuși, juxtaposed against images of African American hair products rendered in acrylic and ink.

This early deployment of objects as signifiers did not fully meet Ligon's desire for expression: "I had a crisis of sorts when I realized there was too much of a gap between what I wanted to say and the means I had to say it with." Nevertheless, these works crystallized Ligon's commitment to using signifiers within formalist procedures as a means to explore the complexities of deep cultural tensions.

Soon Ligon began incorporating text into his paintings, using the stenciled words that would become a hallmark of his oeuvre, in order to say more. Just as Guston returned to figuration after a long exploration in Abstract Expressionist painting as a response to the Vietnam War, Ligon pursued language as a means of commentary on the cultural milieu of the 1980s and '90s, and more specifically on African American identity within a turbulent landscape. Among key works from this period is '*Untitled (I Am a Man)*' (1988), an oil and enamel painting derived from a black-and-white photograph by Ernest C. Withers, depicting black sanitation workers striking in Memphis and carrying identical signs printed with the text 'I AM A MAN.' These words still carry the force of a heavy assertion: a demand for visibility and humanity in response not only to the injustices thrust upon African Americans in the present time, but also to the history of slavery, the effects of which continue to permeate the entire American experience.

Ligon's 1991 work '*Untitled (I Am an Invisible Man)*' borrows lines from the 1955 Ralph Ellison novel 'Invisible Man.' Ligon strategically blends, muddles, and merges written words in oil stick and graphite, thereby juxtaposing presence and absence, comprehension and illegibility; by claiming these words in a new context, he points to the possibility of how meaning can slip or evolve. Works such as 'Untitled (I Feel Most Colored When I Am thrown Against a Sharp

White Background)' (1990), which draws text from Zora Neale Hurston's 1928 essay 'How It Feels to Be Colored Me,' or 'Untitled (There is a consciousness we all have...)' (1988), in which Ligon uses a comment made in the *New York Times* about African American artist Martin Puryear, engage not only the language itself but the visual expression of that language to comment on the subject matter. Painted language becomes the construct of the self, and the stencil is a mechanism of reconstruction, with both pop and expressionist qualities, allowing for a complication of Ligon's address. In the moments of blurred illegibility, Ligon alludes to the systemic exclusion and erasure of African Americans— including the ways in which black artists have been situated in the margins of canonical art history.

Over the past two and a half decades, Ligon has expanded his practice radically to incorporate new media and structures in large-scale installations, prints, photographs, and sculptures. While sweepingly broad in style and composition, these works engage not only with text-based resources but found images, reworked by the artist in order to amplify the conversation: from the re-appropriation of Robert Mapplethorpe's photographs of black male nudes, to silkscreen paintings from the Nation of Islam's Million Man March in Washington D.C., to his seminal *'Untitled'* (2008), a neon work that spells out the word 'AMERICA.' Expressed through this broader range of mediums, Ligon's engagement with words takes on greater physicality. In *'Self- Portrait Exaggerating My Black Features and Self-Portrait Exaggerating My White Features'* (1998), Ligon riffs upon Adrian Piper's seminal work *'Self-Portrait Exaggerating My Negroid Features'* (1981) to address the complexities in our perceptions of race using two towering images made from the exact same silkscreen, with the title of the work printed clearly at the bottom of each image. The artist appears here in a rare instance of self-portraiture, provoking questions about the gaze and racist stereotyping.

In 2004, Ligon wrote a major essay for Artforum titled 'Black Light: David Hammons and the Poetics of Emptiness.' Shortly after, inspired by the notion of working with light, he presented his first neon relief: *'Warm Broad Glow'* (2005) outlining the words 'negro sunshine' in neon letters. Ligon has continued to question the relationship between light and dark in his work, most recently using neon in the handwriting of his friends and colleagues in a work titled *'Some Black Parisians'* (2019), included in the exhibition "Black Models: From Géricault to Matisse" at the Musée d'Orsay in Paris. This sculptural work displays the names of black models whose identities are the focus of the exhibition. While centering and celebrating the individuals whose likenesses are rendered in these works, Ligon also uses the phrase 'nom inconnu' (name unknown) to remind viewers that many of these subjects still remain lost to history.

Ligon engages the state of the world—and urges us to do the same—by posing questions rather than proposing answers. His art demonstrates the ways in which a given subject has permeated culture over time, magnetizing our attention to the mutability of images and our perceptions of them. His questions concern not only the identity of his subject; he interrogates the viewer, the history, the institution, and the cultural context by rendering a portrait of America as a concept, a place, and a nation.

The artist's important recent exhibitions include "Glenn Ligon: Encounters and Collisions," a curatorial project organized with Nottingham Contemporary and Tate Liverpool (2015), and "Blue Black," an exhibition curated by the artist at the Pulitzer Arts Foundation in St. Louis (2017). A retrospective of Ligon's work, "Glenn Ligon: America," organized by Scott Rothkopf, opened at the Whitney Museum of American Art in March 2011 and traveled to the Los Angeles County Museum of Art (2011) and the Modern Art Museum of Fort Worth (2012).

Ligon's work has been included in major international exhibitions such as the Biennale di Venezia, Venice, Italy (1997, 2015); Berlin Biennale, Berlin, Germany (2014); Istanbul Biennale, Istanbul, Turkey (2011); Documenta XI, Kassel, Germany (2002); Gwangju Biennale, Gwangju, South Korea (2000); and the Whitney Biennial (1991, 1993). He has received numerous awards for his work, including the Joan Mitchell Foundation Grant (1997), the John Simon Guggenheim Memorial Foundation Fellowship (2003), the Skowhegan Medal for Painting (2006), and the Studio Museum's Joyce Alexander Wein Artist Prize (2009). (via Hauser & Wirth)

—

AMY SHERALD /

Born in Columbus, Georgia, and now based in the New York City area, Amy Sherald documents contemporary African American experience in the United States through arresting, otherworldly figurative paintings. Sherald engages with the history of photography and portraiture, inviting viewers to participate in a more complex debate about accepted notions of race and representation, and to situate Black heritage centrally in American art.

Sherald received her MFA in painting from Maryland Institute College of Art and BA in painting from Clark-Atlanta University. Sherald was the first woman and first African-American to ever receive the grand prize in the 2016 Outwin Boochever Portrait Competition from the National Portrait Gallery in Washington D.C.; she also received the 2017 Anonymous Was A Woman award and the 2019 Smithsonian Ingenuity Award. In 2018, Sherald was selected by First Lady Michelle Obama to paint her portrait as an official commission for the National Portrait Gallery. Sherald's work is held in public collections such as the Whitney Museum of American Art, New York, NY; the Los Angeles County Museum of Art, Los Angeles, CA; Museum of Fine Arts Boston, Boston, MA; the Crystal Bridges Museum of American Art, Bentonville, AR; Embassy of the United States, Dakar, Senegal; Smithsonian National Museum of African American History and Culture, Washington, DC; Smithsonian National Portrait Gallery, Washington, DC; and Nasher Museum of Art, Durham, NC.

—

LORNA SIMPSON /

Lorna Simpson (b. 1960, Brooklyn, NY) came to prominence in the 1980s with her pioneering approach to conceptual photography. Simpson's early work—particularly her striking juxtapositions of text and staged images—raised questions about the nature of representation, identity, gender, race and history that continue to drive the artist's expanding and multi-disciplinary practice today. She deftly explores the medium's umbilical relation to memory and history, both central themes within her work.

Studying on the West Coast in the mid-1980s, Simpson was part of a generation of artists who utilized conceptual approaches to undermine the credibility and apparent neutrality of language and images. Her most iconic works from this period depict African American figures as seen only from behind or in fragments. Photographed in a neutral studio space, the figures are tied neither to a specific place nor time. Drawing upon a long standing interest in poetry and literature, the artist accompanies these images with her own fragmented text, which is at times infused with the suggestion of violence or trauma. The incredibly powerful works entangle viewers into an equivocal web of meaning, with what is unseen and left unsaid as important as that which the artist does disclose. Seemingly straightforward, these works are in fact near-enigmas, as complex as the subject matter they take on.

Over the past 30 years, Simpson has continued to probe these questions while expanding her practice to encompass various media including film and video, painting, drawing and sculpture. Her recent works incorporate appropriated imagery from vintage Jet and Ebony magazines, found photo booth images, and discarded Associated Press photos of natural elements – particularly ice, a motif that appears in her sculptural work in the form of glistening 'ice' blocks made of glass. The new work continues to immerse viewers in layers of bewitching paradoxes, threading dichotomies of figuration and abstraction, past and present, destruction and creation, and male and female. Layered and multivalent, Simpson's practice deploys metaphor, metonymy, and formal prowess to offer a potent response to American life today. (via Hauser & Wirth)

—

NARI WARD /

Nari Ward (b. 1963, St. Andrew, Jamaica; lives and works in NYC, NY) is known for his sculptural installations composed of discarded material found and collected in his neighborhood. He has repurposed objects such as baby strollers, shopping carts, bottles, doors, television sets, cash registers and shoelaces, among other materials. Ward re-contextualizes these found objects in thought- provoking juxtapositions that create complex, metaphorical meanings to confront social and political issues surrounding race, poverty, and consumer culture. He intentionally leaves the meaning of his work open, allowing the viewer to provide his or her own interpretation.

One of his most iconic works, *Amazing Grace*, was produced as part of his 1993 residency at The Studio Museum in Harlem in response to the AIDS crisis and drug epidemic of the early 1990s. For this large-scale installation, Ward gathered more than 365 discarded baby strollers—commonly used by the homeless population in Harlem to transport their belongings—which he bound with twisted fire hoses in an abandoned fire station in Harlem. Echoing through the space was an audio recording of gospel singer Mahalia Jackson's Amazing Grace on repeat. The lyrics speak about redemption and change, generating optimism and a sense of hope. As with most of his work, this installation explored themes informed by the materials, community, and location in which Ward was working. The work has since been recreated at the New Museum Studio in 2019, the New Museum's Studio 231 series in 2013, and in several locations across Europe. With each change of context, the significance of the work changes as each community associates differently with these found objects.

Nari Ward received a BA from City University of New York, Hunter College in 1989, and an MFA from City University of New York, Brooklyn College in 1992. Solo exhibitions of his work have been organized at the Contemporary Arts Museum Houston (2019); New Museum (2019); Institute of Contemporary Art (2017); Socrates Sculpture Park (2017); The Barnes Foundation (2016); Pérez Art Museum Miami (2015); Savannah College of Art and Design Museum of Art (2015); Louisiana State University Museum of Art (2014); The Fabric Workshop and Museum (2011); Massachusetts Museum of Contemporary Art (2011); Isabella Stewart Gardner Museum (2002); and Walker Art Center (2001, 2000). Select group exhibitions featuring his work include Objects Like Us, The Aldrich Contemporary Art Museum (2018-19); UPTOWN: nastywomen/badhombres, El Museo del Barrio (2017); Black: Color, Material, Concept, The Studio Museum in Harlem, New York (2015); The Great Mother, the Fondazione Nicola Trussardi, Palazzo Reale, Milan (2015); The Freedom Principle: Experiments in Art and Music, 1965 to Now, the Museum of Contemporary Art Chicago (2015); NYC 1993: Experimental Jet Set, Trash and No Star, New Museum (2013); Contemplating the Void: Interventions in the Guggenheim Rotunda, Solomon R. Guggenheim Museum (2010); the Whitney Biennial (2006); Landings, Documenta XI, Kassel, Germany (2002); Passages: Contemporary Art in Transition, The Studio Museum in Harlem; Projects: How to Build and Maintain the Virgin Fertility of Our Soul, MoMA PS1, Long Island City; The Listening Sky, Studio Museum in Harlem; the Whitney Biennial (1995); and Cardinal Points of the Arts, 45th Venice Biennale, Venice, Italy.

Ward's work is in numerous international public and private collections, including Albright-Knox Art Gallery; Baltimore Museum of Art; the Blanton Museum of Art; the Brooklyn Museum; Crystal Bridges Museum of American Art; GAM, Galleria Civica di arte, Torino, Italy; the Institute of Contemporary Art; Istanbul Modern, Istanbul, Turkey; the Museum of Contemporary Art; Musée d'Art Moderne Grand-Duc Jean, Luxembourg; the Museum of Modern Art; the Nasher Museum of Art at Duke University; National Gallery of Victoria, Southbank, Australia; the New York Public Library; Pérez Art Museum Miami; Smithsonian American Art Museum, Washington, D.C.; Speed Art Museum; the Studio Museum in Harlem; the Walker Art Center; and the Whitney Museum of American Art.

Ward has received numerous honors and distinctions including the Fellowship Award, The United States Artists, Chicago (2020); Vilcek Prize in Fine Arts, Vilcek Foundation, New York (2017); the Joyce Award, The Joyce Foundation, Chicago (2015), the Rome Prize, American Academy of Rome (2012), and awards from the American Academy of Arts and Letters (1998), the Pollock-Krasner Foundation (1996); and the National Endowment for the Arts (1994). Ward has also received commissions from the United Nations and the World Health Organization. (via Lehmann Maupin)

—

HANK WILLIS THOMAS /

Hank Willis Thomas (b. 1976, Plainfield, NJ; lives and works in Brooklyn, NY) is a conceptual artist working primarily with themes related to perspective, identity, commodity, media, and popular culture. His work has been exhibited throughout the United States and abroad including the International Center of Photography; Guggenheim Museum Bilbao, Spain; Musée du quai Branly, Paris; Hong Kong Arts Centre, Hong Kong, and the Witte de With Center for Contemporary Art, Netherlands.

Solo exhibitions of his work have been featured at Portland Art Museum; Crystal Bridges Museum of Art; SCAD Museum of Art; California African American Museum; Philadelphia Photo Arts Center; Cleveland Museum of Art; The Art Museum at the University of Kentucky; The Aldrich Contemporary Art Museum; Corcoran Gallery of Art; Brooklyn Museum; Baltimore Museum of Art; Nerman Museum of Contemporary Art; and the African American Museum; among others. Major group exhibitions of his work include the 2017 inaugural show at Zeitz Museum of Contemporary Art Africa, Cape Town, South Africa; P.S. 1 Contemporary Art Center; The Studio Museum in Harlem; Zacheta National Museum of Art, Poland; Yerba Buena Center for the Arts; and the 2006 California Biennial at the Orange County Museum of Art.

Thomas' work is included in numerous public collections including the Museum of Modern Art; Solomon R. Guggenheim Museum; Whitney Museum of American Art; Brooklyn Museum; High Museum of Art; and the National Gallery of Art. His collaborative projects include Question Bridge: Black Males, In Search Of The Truth (The Truth Booth), The Writing on the Wall, and For Freedoms. In 2017, For Freedoms was awarded the ICP Infinity Award for New Media and Online Platform. Thomas is a recipient of the Gordon Parks Foundation Fellowship (2019), The Guggenheim Fellowship (2018), AIMIA | AGO Photography Prize (2017), Soros Equality Fellowship (2017), Aperture West Book Prize (2008), Renew Media Arts Fellowship from the Rockefeller Foundation (2007), and the New York Foundation for the Arts Fellowship Award (2006).

Thomas holds a BFA. from New York University, New York, NY (1998) and an M.A. / M.F.A. from the California College of the Arts, San Francisco, CA (2004). He received honorary doctorates from the Maryland Institute of Art, Baltimore, MD and the Institute for Doctoral Studies in the Visual Arts, Portland, ME in 2017. In 2019, Thomas unveiled his permanent work "Unity" in Brooklyn, NY. In 2017, "Love Over Rules" permanent neon was unveiled in San Francisco, CA and "All Power to All People" in Opa Locka, FL. (via the artist)

—

ALISHA B. WORMSLEY /

Alisha B. Wormsley (b. 1978, Pittsburgh, PA) is an interdisciplinary artist and cultural producer. Her work is about collective memory and the synchronicity of time, specifically through the stories of women of color, more specifically Black Women in America. Wormsley is an artist who has worked in communities around the world, helping to develop artistic ideas, celebrate identities, and organize public art initiatives for national and international audiences. Wormsley's work has received a number of awards and grants to support programs namely the *Children of NAN* film series and archive, and *There Are Black People In The Future*. Her work has exhibited globally. Over the last few years, Wormsley has designed several public art initiatives including Streaming Space, a 24-foot pyramid with video and sound installed in Pittsburgh's downtown Market Square, and AWxAW, a multimedia interactive installation and film commission at the Andy Warhol Museum. Wormsley created a public program out of her work, "There Are Black People In the Future," which gives mini-grants to open up discourse around displacement and gentrification and was also awarded a fellowship with Monument Lab and the Goethe Institute. In 2020, Wormsley launched an art residency for Black creative mothers called Sibyls Shrine, which has received two years of support from the Heinz Endowments. Wormsley has an MFA in Film and Video from Bard College and currently is a Presidential Post Doctoral Research Fellow at Carnegie Mellon University to research and create work rooted in matriarchal leadership and mysticism in the African-American community. (via artist website)

—

T.A. YERO /

Growing up in Houston, Texas, Yero was always backstage in a theater following her mother's acting career, so she's seen *Black Magic* in person. She would always have her camera out for her scrapbook, taking shots of all the special moments. Then when she got older, she realized the "Magic" is not just in the theater. There is beauty in everything; you just have to find the right angle to capture it.

Her late father always said, "Photos were proof that we existed." So she took that to heart and kept a camera in her hand to capture every moment. When COVID shut down the world, it also shut down Yero's main source of income. However, it opened a door for her to follow her true passion. Yero started Two Hearts Media, a multimedia-production company, with her husband Aron Pryor. Their motto is, "Two Hearts, Two Cameras, One Story."

Yero was a contributing artist for *Land Is: Parks, Cultures, Stories*, an exhibit at KMAC Museum in Louisville, Kentucky. She is a published wedding photographer in *Tops* magazine in both Louisville and Lexington. Yero is also a photography instructor for the Urban Arts Academy with St. George Scholar Institute in Louisville, as well.

In describing her journey, Yero observes, "So here we are, taking headshots, pictures of protests, and everything in between. It's been long, it's been scary, but it's been worth it. Diamonds are formed under pressure, but never forget they are not formed overnight."

National Advisory Panel
—

MECCA BROOKS /

Mecca Brooks is a cultural producer and arts strategist committed to driving connectedness in collaborative spaces. She specializes in community partnerships, urban ecology and project management to provide a platform for awakened and transformative being. She is currently a team member at Hank Willis Thomas Studios. Previous roles and affiliations include Associate Consultant at TCC Group; Creative Consultants with Revival Arts Collective, Associate Director of ArtUP / School Partnerships at the Center for Community Partnerships/Columbia College Chicago, Lea Farmer at Bronzeville Rooftop Farm.

—

THEASTER GATES /

Theaster Gates lives and works in Chicago. Gates creates works that engage with space theory and land development, sculpture and performance. Drawing on his interest and training in urban planning and preservation, Gates redeems spaces that have been left behind. Known for his recirculation of art world capital, Gates creates work that focuses on the possibility of the "life within things." His work contends with the notion of Black space as a formal exercise – one defined by collective desire, artistic agency, and the tactics of a pragmatist. In 2010, Gates created the Rebuild Foundation, a nonprofit platform for art, cultural development, and neighborhood transformation that supports artists and strengthens communities through free arts programming and innovative cultural amenities on Chicago's South Side. In 2016, at the request of Samaria Rice, Tamir Rice's mother, Rebuild Foundation received the gazebo where Tamir was playing when he was killed. Ms. Rice sought to preserve the structure as a community space for care, dialogue, and public engagement. The gazebo, which had once been on display in a deconstructed state inside the Stony Island Arts Bank, now stands tall in a reflection garden on the Arts Bank lawn where it serves as a site and object of care.

Gates has exhibited and performed at Tate Liverpool, UK (2020); Haus der Kunst, Munich (2020); Walker Art Centre (2019); Palais de Tokyo Paris, France (2019); Sprengel Museum Hannover, Germany (2018); Kunstmuseum Basel, Switzerland (2018); National Gallery of Art (2017); Art Gallery of Ontario, Canada (2016); Fondazione Prada, Milan, Italy (2016); Whitechapel Gallery, London, UK (2013); Punta della Dogana, Venice, Italy (2013) and dOCUMENTA (13), Kassel, Germany (2012), Serpentine Pavilion, London, UK (2022). He was the winner of the Artes Mundi 6 prize and a recipient of the Légion d'Honneur in 2017. In 2018, he was awarded the Nasher Prize for Sculpture, and the Urban Land Institute, J.C. Nichols Prize for Visionaries in Urban Development. Gates received the 2020 Crystal Award for his leadership in creating sustainable communities. Gates is a professor at the University of Chicago in the Department of Visual Arts and the Harris School of Public Policy, and is Distinguished Visiting Artist and Director of Artist Initiatives at the Lunder Institute for American Art at Colby College.

—

JON-SESRIE GOFF /

Jon-Sesrie Goff is a multidisciplinary artist, curator, and arts administrator. With extensive experience in media and film production, Jon has offered his lens to a variety of projects spanning many genres including the recently released and award-winning documentaries, including *Out in the Night* (POV, Logo 2015), *Evolution of a Criminal* (Independent Lens 2015) and *Spit on the Broom* (2019), among several other projects. He is in production for his feature-length documentary, After Sherman, which has received support from JustFilms, Firelight Media, International Documentary Association, Black Public Media, Jerome Foundation, Gucci / Tribeca Film Institute, and the Sundance Institute.

Previously, he has served as Executive Director of the Flaherty Film Seminar and the Museum Specialist for Film at the Smithsonian's National Museum of African American History & Culture where he was responsible for developing the museum's public film program. His personal practice has involved extensive institutional, community, and personal archival research, photo, and film documentation, and oral history interviews in the coastal South on the legacy of Black land ownership and Gullah Geechee heritage preservation. Jon engages with his work from the paradigm of a social change instigator. This is evidenced in his participation in the dimensionality of discourse in multicultural communities both within the United States and overseas. He has taught courses in photography, social justice documentary, and film production at Duke University (Durham, NC), Villanova University (Villanova, PA), and Westchester University (Westchester, PA).

Jon has served on grant-making panels and juries for the National Endowment for the Arts, Open Society Foundation, Tribeca Film Institute, Lower Manhattan Cultural Council, International Film Festival Rotterdam, Black Star Film Festival, International Documentary Association, Oberhausen Seminar, and CinemAfrica Film Festival (Stockholm, Sweden) among others. He has an MFA in Experimental and Documentary Arts from Duke University.

—

RAYMOND GREEN /

Raymond Green was born in Baton Rouge, LA, and currently works and resides in Rogers, AR. He is a results driven leader who specializes in organizational leadership during peacetime and combat as a retired Army Officer. Ray graduated from the United States Military Academy at West Point with a Bachelor's Degree in Management (2007) then pursued his Master's Degree in Engineering Management from Missouri University of Science and Technology (2012). In 2019, he was a Guest Lecturer in the Department of Marketing at Clemson University. Green has over eleven years of military service and leadership in combat and non-combat arenas. As an Army officer Green led a platoon in Mosul, Iraq with a core mission of route clearance. He then deployed to Kandahar, Afghanistan where he served as a Company Executive Officer. After completion of his tour he served on the battalion staff as the Operations Officer.

Ray is currently retired from the Army and is Senior Account Executive for Procter and Gamble. He has two beautiful children, Ryan and Mia. He spends most of his time chasing them around. When not enjoying family time, Ray can be found on the lake, playing golf, or riding Harleys.

—

LA KEISHA LEEK /

La Keisha Leek is an administrator and artist advocate based in Chicago. With a love for operations, she currently serves as Administrator for Grants Management at the John D. and Catherine T. MacArthur Foundation. In previous roles she has worked within nonprofit arts, and higher education mission-driven organizations in Chicago and New York City. In 2019 she created L'Louise Arts to support the growth of early career Chicago-based artists and arts workers of color by providing thought partnership and economic resources. She is a founding member of Candor Collective, a group of like minded creative producers interested in changing how we think about arts economies, and co-founder of The Petty Biennial with collaborator Sadie Woods.

—

AMY SHERALD /

Born in Columbus, Georgia, and now based in the New York City area, Amy Sherald documents contemporary African American experience in the United States through arresting, otherworldly figurative paintings. Sherald engages with the history of photography and portraiture, inviting viewers to participate in a more complex debate about accepted notions of race and representation, and to situate Black heritage centrally in American art.

Sherald received her MFA in painting from Maryland Institute College of Art and BA in painting from Clark-Atlanta University. Sherald was the first woman and first African-American to ever receive the grand prize in the 2016 Outwin Boochever Portrait Competition from the National Portrait Gallery in Washington D.C.; she also received the 2017 Anonymous Was A Woman award and the 2019 Smithsonian Ingenuity Award. In 2018, Sherald was selected by First Lady Michelle Obama to paint her portrait as an official commission for the National Portrait Gallery. Sherald's work is held in public collections such as the Whitney Museum of American Art, New York, NY; the Los Angeles County Museum of Art, Los Angeles, CA; Museum of Fine Arts Boston, Boston, MA; the Crystal Bridges Museum of American Art, Bentonville, AR; Embassy of the United States, Dakar, Senegal; Smithsonian National Museum of African American History and Culture, Washington, DC; Smithsonian National Portrait Gallery, Washington, DC; and Nasher Museum of Art, Durham, NC.

—

HANK WILLIS THOMAS /

Hank Willis Thomas is a conceptual artist working primarily with themes related to perspective, identity, commodity, media, and popular culture. His work has been exhibited throughout the United States and abroad including the International Center of Photography, New York; Guggenheim Museum Bilbao, Spain; Musée du quai Branly, Paris; Hong Kong Arts Centre, Hong Kong, and the Witte de With Center for Contemporary Art, Netherlands. Thomas' work is included in numerous public collections including the Museum of Modern Art, New York; Solomon R. Guggenheim Museum, New York; Whitney Museum of American Art, New York; Brooklyn Museum, New York; High Museum of Art, Atlanta, and National Gallery of Art, Washington D.C. His collaborative projects include Question Bridge: Black Males, In Search Of The Truth (The Truth Booth), Writing on the Wall, and the artist-run initiative for art and civic engagement For Freedoms, which was awarded the 2017 ICP Infinity Award for New Media and Online Platform. Thomas is also the recipient of the Gordon Parks Foundation Fellowship (2019), the Guggenheim Foundation Fellowship (2018), Art for Justice Grant (2018), AIMIA | AGO Photography Prize (2017), Soros Equality Fellowship (2017), and is a former member of the New York City Public Design Commission. Thomas holds a B.F.A. from New York University (1998) and an M.A. / M.F.A. from the California College of the Arts (2004). He received honorary doctorates from the Maryland Institute of Art and the Institute for Doctoral Studies in the Visual Arts in 2017.

—

DR. ALLISON K. YOUNG /

Dr. Allison K. Young is Assistant Professor of Art History at Louisiana State University A&M in Baton Rouge. A specialist in postcolonial and contemporary art of the Global South, she received her Ph.D. from the Institute of Fine Arts, New York University in 2017. Young's research focuses on African and African-Diasporic artists and art histories, with emphasis on twentieth-century South African art, Black British art and visual culture, and questions surrounding migration, transnationalism and social justice in contemporary art.

Young's scholarship and arts criticism have been published in Art Journal, British Art Studies, the International Review of African American Art, Artforum, Apollo International, ART AFRICA Magazine, and the Photoworks Annual among other platforms. She has contributed to numerous books and exhibition catalogues, including *African Artists: From 1882 to Now* (2021), *Prospect.5: Yesterday We Said Tomorrow* (2021); *The Measurement of Presence, the Dutch Pavilion at the 58th Venice Biennale* (2019); *Queen: From the Collection of CCH Pounder* (2018); *Out of Easy Reach* (2018); and the *Short Guide for All the World's Futures, the 56th Venice Biennale* (2015).

Before joining LSU, Young was Andrew W. Mellon Foundation Fellow for Modern and Contemporary Art at the New Orleans Museum of Art, where she curated and published an exhibition catalogue for Lina Iris Viktor: "A Haven. A Hell. A Dream Deferred." (2018), and assisted with projects including Torkwase Dyson: "Black Compositional Thought | 15 Paintings for the Plantationocene" (2020), "Bodies of Knowledge" (2019) and "Changing Course: Reflections on New Orleans Histories" (2018).

Community Engagement Steering Committee

—

BIANCA AUSTIN /

Bianca Austin is the aunt of Breonna Taylor. She is passionate about fighting against police brutality and pushing for social equality in efforts to seek justice for my niece Breonna. Austin joined the steering committee to enlighten people on what a beautiful person Breonna Taylor was. She also joined to provide ongoing strategic direction for the initiative.

—

TAWANA BAIN /

As CEO at TBAIN & Co, Tawana Bain is a leading marketing strategist and visionary with a niche in streamlining their diverse portfolio of services. In addition, Bain is the Founder of the Global Economic Diversity Development Initiative, a Black founded and predominantly Black-led, a non-profit focused on building economic wealth for the black community. Aside from Bain's philanthropic and social justice work, she is also the proud owner of *Today's Woman* Magazine, Black Jockeys Lounge, and AFM Threads.

—

ASHLEY CATHEY /

Ashley Cathey is a multidisciplinary social change artist, curator, muralist and CEO. Her large, oil and acrylic portraits hope centralize the experiences of black bodies during and after the African Diaspora. Cathey's self-taught artistry started to emerge ideas of feminism through the lens of women of color; who have influenced her through the art of music, literature, and spoken word. These influences allowed her to display her emotions on canvas and in public spaces. Her vibrant artistic style defies convention and seeks to comment on the misrepresentation or under-representation of her subject matter.

Cathey's work has gained local and global recognition from the supporters of her movement. Recently, she curated the exhibit "Black Before I was Born: a meditation on identity" to speak on the lack of representation in the world of fine arts. She believes art is activism and often uses her pieces to bring a voice to social issues. Cathey's progression has also lead her to create opportunities for other emerging artist through her arts organization. Cathey is the Founder and CEO of The Healing Walls Project an arts organization revolutionizing the way we create public art, focusing on the amplification and healing of BIPOC artist through the creation of public art in their communities around the USA. Healing Walls Project was created and is run by a radical collective of fem artist and BIPOC art advocates. The Healing Walls Project is currently creating and healing in St. Louis, MO and started their Louisville, KY Mural Cycle in May 2021.

—

TIFFANY FARMER, LMFT /

Tiffany Farmer, LMFT works with multiple populations, but specializes in working with adults who experience patterns of relationship difficulties. Adult attachment, childhood trauma, and their effects on relationship stability are of particular interest. Tiffany owns a group private practice, Best Life Mental Health Services, which focuses on inclusive and accessible services for all, especially historically marginalized populations. Tiffany is also the Interim Clinical Director for the Couples and Family Therapy Program with the University of Louisville. She has been involved with Therapists for Protestor Wellness, activism in the community, and sits on the Kent School Alumni Council.

—

NICOLE HAYDEN /

Nicole Hayden is the Founder & President of Friends of Nicole 50/50 Mentoring Collaborative Inc. An accomplished teacher, motivational speaker, activist, and entrepreneur. Nicole has always kept Louisville at the center of her heart and was heartbroken by the murder of Breonna Taylor and subsequent mishandling of her case by local and state authorities. Nicole committed herself to protests & organizing throughout the Spring and Summer of 2020, collaborating with National Social Justice Organization Until Freedom and countless other organizations as a community liaison. This work saw Nicole labor tirelessly with many others and connecting protestors and organizers with community resources by leveraging her relationships both locally and nationally.

—

KETURAH J. HERRON /

Keturah J. Herron (she/they) is a policy strategist at the ACLU of Kentucky, an activist and social justice advocate with over 15 years of experience working with youth and families involved in social service and the criminal justice systems. Herron was instrumental in leading the charge in Louisville, Kentucky working alongside Metro Council members to institute Breonna's Law—effectively banning no-knock warrants within the city after the tragic death of Breonna Taylor. As an emerging and courageous thought leader, Herron is dedicated to the liberation of Black people and reimaging what our communities look like for all Black Kentuckians. Herron graduated from Eastern Kentucky University with a Masters in Corrections and Juvenile Justice Studies.

—

LANCE G. NEWMAN II /

Founding Director of SpreadLovEnterprise(c)2013. SpreadLove.life

—

LOPA MEHROTRA /

Lopa is a social entrepreneur who has worked on three continents to unlock the potential of individuals and communities through education, technology, entrepreneurship, and philanthropy. She currently serves as a Trustee to the Speed Museum, James Graham Brown Foundation, and Community Foundation of Louisville. Lopa fell in love with her first painting at the age of 10, and she is honored to support greater access to and equity in the visual arts.

—

SHARLIS N. MONTGOMERY /

A native of Lexington, KY, and a graduate of Eastern Kentucky University, Sharlis has called Louisville home for eight years. While living in Louisville, Sharlis has become acquainted with social and service organizations to continue fighting for social justice. Sharlis has a strong background in organizational and leadership efforts. In her current role at Hogan Lovells LLP, as a Senior Learning and Development Coordinator, she is responsible for program management and operational support for Business Services and lawyer learning. She is also the Community Engagement Manager at ANWA Louisville and serves as VP of Operations LULYP. In her own words, "I am everything you didn't realize you needed. I adapt and adjust, handling things in ways that will make you wonder how you managed without me and commit to never doing without again. I specialize in solutions. I offer no complaint without correction, and my goal is to improve outcomes."

MILLY MARTIN /

Milly Martin is a political activist and humanitarian from Louisville, KY. Although she has organized around issues related to the neighborhood safety and police contracts, she is best known as a protestor in the Breonna Taylor Movement.

RAMONA DALLUM LINDSEY /

Ramona Dallum Lindsey is a Senior Program Officer for the Community Foundation of Louisville's projects strengthening leaders, artists, and entrepreneurs as well as responding to community needs. As a visual artist, Ramona's artistic practice and background equip her to think outside traditional processes to develop, implement and manage Foundation programs.

JU'NIYAH PALMER /

Ju'Nyah Palmer joined the committee to bring awareness for her sister! Also because she loves to see a community come together to help each other.

MARK PENCE /

Mark Pence is a licensed barber and community advocate born in Louisville, KY. Pence lives and works in Louisville, KY and NYC, New York. Pence's work addresses the need for effective Black male leadership and positive examples of black youth excellence in the black community, while also creating opportunities and building economic foundation.

Mark Pence founded Gloves Not Guns Kentucky in 2018. Its mission is to create positive outlets and teach healthy non-violent coping methods to at risk children of color in high crime neighborhoods.

DR. BRANDY KELLY PRYOR /

A strategist and hope scholar, Dr. Brandy Kelly Pryor works at the intersection of health, hope, and equity. Currently she works in philanthropy strategizing participatory design approaches and often draws from her experience as the former Director of the Center for Health Equity. You can find her posting on Instagram daily @equityABCs

MICHAEL WADE SMITH, EDD, MBA /

As Chief of Staff and External Affairs at the University of Louisville, Michael Wade provides executive leadership across units to drive UofL closer to its vision to be an even greater place to learn, work and invest. He provides strategic direction, leadership and oversight of the people, projects, and operations of the Office of the President and serves as the senior external affairs administrator for the University of Louisville overseeing the Offices of Communications & Marketing and Government Relations. He is an experienced higher education administrator with a demonstrated history of success in organizational development and behavior, marketing and communications, strategy, and administration at large comprehensive research universities.

—

LINDA SARSOUR /

Linda Sarsour is the co-founder of Until Freedom alongside Tamika D. Mallory, Mysonne Linen and Angelo Pinto. Until Freedom is an intersectional social justice organization rooted in the leadership of diverse people of color to address systemic and racial injustice. At the request of the family, Until Freedom has played an integral part in the fight for justice for Breonna Taylor. They have organized major community service events across the West End and strategic direct actions garnering national media attention for Breonna's case.

—

ANTONIO TAYLOR /

Antonio M. Taylor is a Jefferson County Public Schools employee and Co-Owner of Wave FM Online a Black Owned Multi-Media Platform. He is also the co-founder of the Non-Profit Organization HHN2L, Inc. which mentors inner city youth.

—

STACEY WADE /

CEO / Executive Creative Director

Stacey Wade is the founder of NIMBUS, a fiercely independent strategic marketing and communications agency focused on the ideology of creating great work that is inclusive of today's multicultural marketplace.

By unifying and balancing creative energy with strategic thinking, Stacey and his team consistently deliver meaningful outcomes through fully-integrated communications strategies, experiential marketing platforms, and innovative brand design.

While you can see Stacey's style and personality reflected in each project, NIMBUS's approach is far from "cookie-cutter" and never "one size fits all." The NIMBUS team has dramatically helped brands pinpoint strategic brand opportunities by tapping into data and macro level cultural insights to create authentic connections in today's complex and multicultural marketplace.

Clients Stacey has worked with over the past 20+ years include leading brands such as Toyota, Vivendi (Universal Music Group), MTV Networks, Papa John's, Brown-Forman, Deutsche Lufthansa AG, and Swisher International, Inc.

Stacey serves on several boards including The Speed Art Museum, Leadership Louisville, and The Louisville Zoo.

Research Committee
—

DR. MAURICE N. GATTIS* /

Dr. Maurice N. Gattis is an Associate Professor at Virginia Commonwealth University School of Social Work and co-founder of Sweet Evening Breeze, Inc. located in Louisville, KY. Dr. Gattis has conducted research regarding LGBTQ+ youth of color experiencing homelessness in the United States and Canada. One of his research collaborations in Louisville resulted in the creation of www.embracethejourneylou.org.
Research liaison on the Steering Committee

—

DR. LESLEY HARRIS /

Dr. Lesley Harris has expertise is qualitative methodology, including Photovoice, Grounded Theory, and Ethnography. She is an investigator on five socially engaged research projects using artistically inspired methods in Louisville and abroad. The titles of these projects are *Our World Our Say* (*Photovoice*), *HIV Monologue Project* (Performing Art), *See Me* (*Photovoice*), *Project STAAR* (*Photovoice*), and *It Could Have Been Me* (*Photovoice*). The visual art derived from her research has been featured in art-advocacy exhibitions in South Korea, Vietnam, Arizona, and Louisville.

—

DR. JELANI KERR /

Dr. Jelani Kerr is an Associate Professor of Health Promotion and Behavioral Sciences at the University of Louisville. His work involves investigating factors that lead to higher HIV rates in African American communities. He also researches the impact of inequities in the criminal justice system and how this impacts health. His work extends beyond measuring health challenges to reducing them through multidisciplinary collaborations with various community-based organizations.

—

DR. EMMA STERETT HONG /

Dr. Emma Sterrett-Hong is the Associate Dean of Equity and Inclusion in the Kent School of Social Work at the University of Louisville. Her research focuses on the impact of interpersonal relationships on the well-being of underserved youth, as well as the dissemination of evidence-based psychosocial practices. In addition, she is a Licensed Psychologist and Licensed Marriage and Family Therapist.

Specialized Committees

—

MENTAL HEALTH /

STEVEN D. KNIFFLEY JR., PSYD MPA ABP /

Steven D. Kniffley Jr., PsyD MPA ABPP is Spalding University's Chief Diversity Officer and an Assistant Professor in Spalding University's School of Professional Psychology. Dr. Kniffley's area of expertise is research and clinical work with Black males and the treatment of race based stress and trauma. Dr. Kniffley also serves as an organizational diversity consultant and works with law enforcement departments on addressing conflicts between communities of color and police officers. Dr. Kniffley has written numerous books, book chapters, and articles on Black male mental health, Black males and the criminal justice system, and academic achievement. Additionally, Dr. Kniffley was recently selected as one of Louisville's "Top 40 Under 40" for 2020.

—

STRATEGIC PLANNING /

STEVON EDWARDS /

SteVon Edwards, Owner and Principal, Schenault Solutions, LLC. SteVon has 15+ years of proven experience in the public health and NGO sectors, ranging from volunteer to administrator. Through her consulting firm, Schenault Solutions, she guides teams along pathways that fulfill their mission and vision, improve internal infrastructure, identify work across sectors, and implement equitable practices to achieve true impact. Born and raised in Louisville, KY, she works to improve her hometown through each project and with each connection that she makes.

—

ARTS ACTIVISM & EDUCATION /

WILLIAM CORDOVA /

William Cordova is an interdisciplinary cultural practitioner born in Lima, Peru. Cordova lives and works in Lima, Miami, and New York City. Their work addresses the metaphysics of space and time and how objects change and perception changes when we move around in space. They received their BFA from The School of the Art Institute of Chicago; and an MFA, from Yale University. William Cordova founded the AIM BIENNIAL in Miami, Co-curates the Prism African Diaspora Art Fair and is co-organizer of the Greenwood Art Project as part of the 2021 Greenwood Centennial.

Speed Art Museum (during exhibition)

—

—

STAFF /

Rebecca Aldammad
Shelby Allen
Tina Allison
Evan Ames
Whitney Andrews
Cameron Austin
LaShana Avery
Melody Bailey
Emily Bailie
Abigail Bendock
Sheridan Bishoff
Fiona Blackburn
Anna Blake
Carmen Boston
Steven Bowling
Katie Bowling
MJ Boyd
Lucy Boyd
Jeremy Brightbill
Steve Burdsall
Megan Cantwell
Madelyn Carey
Toni Carver Smith
Kiley Cox
Kristin Darrow
Ron Davey
Brian Denny
Tim Dever
Hunter Dixon
Olivia Doyon
Scott Erbes
Ceirra Evans
Sterling Franklin
Renee Freville
Karen Gahafer-Buryn
Taleah Gipson
Ashley Giron
Allison Glenn
Grant Goodwine
Codi Goodwyn
Jae Grady
Rebecca Grider
Abigail Hamilton

Claire Harmon
Karen Harrell
Chelsea Harris
Ray Harrison
Caitlin Hogue
Erika Holmquist-Wall
Grace Hotkewicz
Angie Howard
Gabe Hughes
Ian Hughlett
Tiffany Huynh
Nakeia Joanisse
Mica Jochim
Chase Johnson
Shannon Karol
Mary Kirkman
Eska Koester
Kala Lewis
Emily Lincoln
Breck Lockett
Afua Martin
Nobie Martin
Ellen Massie
Shelby Mattingly
Hannah McAulay
Tiernan McClanahan
Kelsey McCracken
Terry Mcgill
Christian McKnight
Evan McMahon
Adrienne Miller
Destiny Minton
Shauntionne Mosley
Taylor Nord
Toya Northington
Dean Otto
Jackie Owens
Tory Parker
Steven Parrish
Cayla Pearman
Emma Pridham
Stephen Reily
Giselle Rhoden
Cheyenne Richardson
Chris Rightley

Bailey Roman
Brian Sachleben
Brandon Saxton
Eliza Sayers
Matthew Schuhmann
Giulia Setti
Beverly Short
Abby Shue
Sinclaire Smith
Andrew Smith
Dara Smith
Aris Spagnuolo
Kim Spence
Carlo Stallings
Mike Stauss
Shantel Stubbs
Karen Tate
Amber Thieneman
Brittany Thurman
Matt Thurman
Kevin Tierney
Max Valentine
Hannah VanHeuklon
Anne Vencel
Kolbie Vincent
Charlie Walsh
Martha Ward-Hendren
Amy Weeks
Shanda Wiley
Briana Williams
Darrick Wood
Jade Wright
Annika Yeske
Emily Yu

Acknowledgments

—

Amy Sherald
Tamika Palmer
Lonita Baker

NATIONAL ADVISORY PANEL / Mecca Brooks, Theaster Gates, Jon-Sesrie Goff, Raymond Green, La Keisha Leek, Amy Sherald, Hank Willis Thomas, Allison K. Young

COMMUNITY ENGAGEMENT STEERING COMMITTEE / Bianca Austin, Tawana Bain, Ashley Cathey, Tiffany Farmer, LMFT, Nicole Hayden, Keturah J. Herron, Lance G. Newman II, Lopa Mehrotra , Sharlis N. Montgomery, Milly Martin, Ramona Dallum Lindsey, Ju'Niyah Palmer, Mark Pence, Dr. Brandy Kelly Pryor, Michael Wade Smith, EdD, MBA, Linda Sarsour, Antonio Taylor, Stacey Wade

RESEARCH COMMITTEE / Dr. Maurice N. Gattis, Dr. Lesley Harris, Dr. Jelani Kerr, Dr. Emma Sterett Hong

RESEARCH TEAM / Stephanie Henry, BSW, Gaberiel Jones, Jr., PhD, MPH, Sirene Martin, Celes Smith, MSSW, LCSW

SPECIALIZED COMMITTEES /

MENTAL HEALTH / Steven D. Kniffley Jr., PsyD MPA ABPR
STRATEGIC PLANNING / SteVon Edwards
ARTS ACTIVISM AND EDUCATION COMMITTEE / William Cordova, Irene Karp, Alice Gray Stites, Thelma Golden

FORD FOUNDATION / Darren Walker, Noorain Khan

LENDERS / Noel W Anderson, Art Bridges Collection, Erik Branch, Building Equal Bridges (The Tyler Gerth Foundation), Xavier Burrell, María Magdalena Campos-Pons, Nick Cave, Jon Cherry, Gallery Wendi Norris (San Francisco), Theaster Gates, Jon-Sesrie Goff, GRAY Gallery (Chicago), Hauser & Wirth, Jack Shainman Gallery, Rashid Johnson, Kahlil Joseph, Patron Gallery (Chicago), Amy Sherald, Tate Museum, Hank Willis Thomas, Nari Ward, Alisha Wormsley, T.A. Yero

NATIONAL MUSEUM OF AFRICAN AMERICAN HISTORY AND CULTURE, SMITHSONIAN INSTITUTION / Kevin Young, Debra McDowell, Michèle Gates Moresi, Tuliza Fleming

CRYSTAL BRIDGES MUSEUM OF AMERICAN ART / Alice Walton - *Founder and Board Chair*, Rod Bigelow, Austen Barron Bailey, Beth Bobbitt, Lauren Haynes, Jason Overby, Stace Treat

ART BRIDGES FOUNDATION /

PULITZER ART FOUNDATION /

UNIVERSITY OF LOUISVILLE—ART AND ACTIVISM COURSE / Chris Reitz - *Professor,* Abigail Briney, Ashley Bittner, Cathy Shannon, Allie Blankenship, Flora Schildknecht, Hannah DeWitt, Nicole Clay, Olivia Beutel, Rasheed Adedoyin Ismaila, Shachaf Polakow, Tricia Hersey, Aron Conaway

"THERE ARE BLACK PEOPLE IN THE FUTURE" ARTIST RESPONSES / Kofi Darku, Dre Dawson (aka Dre DaSon), Tonnea (Nea) Green, Kala Lewis, Rheonna Nicole

IT COULD HAVE BEEN ME /

CULTURAL COUNCIL /
Ed Winstead, Marcella Zimmermann, Robert Grand, Emma Frohardt

TEAM / Amy Globus, John Clark, Samantha Kassay

KERTIS CREATIVE / Stephen Kertis, Christa Iwu, Chelsae Ketchem, Kaylee Everly

NIMBUS /

SPALDING UNIVERSITY / Chandra Irvin - *Director of the Center for Peace & Spiritual Renewal*

Wiltshire at the Speed
Xavier Burrell
Jon Cherry
Tiffany Hensley
Brittany Loewen
Bill Roughen

Content Credits

——

Grateful acknowledgement is made to the following for permission to reprint previously published material:

—

ARTFORUM / © Excerpted from Huey Copeland and Allison Glenn, "Taking Care," Artforum, Summer 2021

—

ART NET/THE ART ANGLE PODCAST / For permission to republish excerpts from The Art Angle Podcast "How Breonna Taylor's Life Inspired an Unforgettable Museum Exhibition" (May 14, 2021)

—

BURNAWAY / Excerpts from Jasmine Amussen's conversation with Toya Northington (published May 11, 2021). Reprinted by permission of *Burnaway*

—

DRE DAWSON, AKA DRE DASON / For permission to republish lyrics from "Blue Soles"

—

DR. KEVIN W. COSBY / For permission to republish excerpts from his speech at the Memorial Service of Muhammad Ali (June 10, 2016)

—

ELIZABETH HOWARD, HOST AND PRODUCER, THE SHORT FUSE PODCAST / For permission to republish excerpts from "Short Fuse Podcast #42: Promise Witness Remembrance"

—

GREGORY VOLK / HYPERALLERGIC / For permission to republish excerpts from "Bearing Witness to Breonna Taylor's Life and Death" (March 1, 2021)

—

HELEN HOLMES / OBSERVER / For permission to republish excerpts from "Allison Glenn, the Curator of a New Breonna Taylor Exhibition, On Responsibility in Art" in *Observer* (March 4, 2021)

—

HIZ.ART / Allison M. Glenn in conversation with Heidi Zuckerman excerpted from Episode 62 of the "Conversations About Art" podcast

—

MARÍA MAGDALENA CAMPOS-PONS / For permission to republish "The Rise of Butterfly Eyes," originally published in *Burnaway* (May 13, 2021)

—

NOEL W ANDERSON / For permission to republish "Beyond this point promise is DEMANDED!," originally published in *Burnaway* (May 11, 2021)

—

PENSKE MEDIA CORPORATION, COPYRIGHTED 2021 AND 1970 / For permission to republish masthead and excerpts from *Art in America* (September/October 1970 & June 1, 2021)

—

PHILBROOK MUSEUM OF ART AND PUBLIC RADIO TULSA / Excerpt from 'A Portrait of Breonna Taylor' in *Museum Confidential*, hosted by Jeff Martin (April 16, 2021). Reprinted by permission of Public Radio Tulsa

—

RAMONA DALLUM LINDSEY / For permission to republish excerpts from "Reflection on *Promise, Witness, Remembrance*," published in *Ruckus* (May 10, 2021)

—

RHEONNA NICOLE / For permission to republish her spoken word piece "Black Girl Inferno"

—

TRICIA HERSEY AND THE NAP MINISTRY / For permission to republish the Guided Meditation by Tricia Hersey, created for the exhibition

—

USA TODAY NETWORK / Excerpt from article written by Andre Toran / Louisville *Courier-Journal* (February 24, 2021). Reprinted by permission of USA TODAY NETWORK

—

VOICE LOUISVILLE / Excerpt from article written by Laura Ross (May 5, 2021)

Image Credits

—

Notes

—

1 / Huey Copeland, "Taking Care: Huey Copeland and Allison Glenn on *Promise, Witness, Remembrance*," *Artforum*, Vol. 50, No. 8 (Summer 2021).

2 / Robin Pogrebin, "Amy Sherald Directs Her Breonna Taylor Painting Toward Justice," *New York Times*, March 7, 2021.

3 / Robin Pogrebin, "Amy Sherald Directs Her Breonna Taylor Painting Toward Justice," *New York Times*, March 7, 2021.

4 / Elizabeth Howard, "Short Fuse Podcast #42: Promise Witness Remembrance," *The Arts Fuse*, July 13, 2021.

5 / Elizabeth Howard, "Short Fuse Podcast #42: Promise Witness Remembrance," *The Arts Fuse*, July 13, 2021.

6 / Speed Art Museum, "National Advisory Panel Conversation with Allison Glenn", YouTube video, April 8, 2021.

7 / Elizabeth Howard, "Short Fuse Podcast #42: Promise Witness Remembrance," *The Arts Fuse*, July 13, 2021.

8 / Elizabeth Howard, "Short Fuse Podcast #42: Promise Witness Remembrance," *The Arts Fuse*, July 13, 2021.

9 / Jeffrey Brown and Anne Azzi Davenport, *PBS Newshour*, Television broadcast, Public Broadcasting Service, May 4, 2021.

10 / Stephanie Wolf, *All Things Considered*, Radio broadcast, National Public Radio, April 11, 2021.

11 / Huey Copeland, "Taking Care: Huey Copeland and Allison Glenn on *Promise, Witness, Remembrance*," *Artforum*, Vol. 50, No. 8 (Summer 2021).

12 / Heidi Zuckerman,"62. Allison M. Glenn," *Conversations About Art*, April 6, 2021.

13 / Elizabeth Howard, "Short Fuse Podcast #42: Promise Witness Remembrance," *The Arts Fuse*, July 13, 2021.

14 / Huey Copeland, "Taking Care: Huey Copeland and Allison Glenn on *Promise, Witness, Remembrance*," *Artforum*, Vol. 50, No. 8 (Summer 2021).

15 / Heidi Zuckerman,"62. Allison M. Glenn", *Conversations About Art*, April 6, 2021.

16 / Laura Ross, *Promise, Witness, Remembrance, The Voice-Tribune*, May 5, 2021.

17 / Heidi Zuckerman,"62. Allison M. Glenn", *Conversations About Art*, April 6, 2021.

18 / Huey Copeland, "Taking Care: Huey Copeland and Allison Glenn on *Promise, Witness, Remembrance*," *Artforum*, Vol. 50, No. 8 (Summer 2021).

19 / Huey Copeland, "Taking Care: Huey Copeland and Allison Glenn on *Promise, Witness, Remembrance*," *Artforum*, Vol. 50, No. 8 (Summer 2021).

20 / Siddhartha Mitter, "How a Museum Show Honoring Breonna Taylor Is Trying to 'Get It Right,'" *New York Times*, March 11, 2021.

21 / Speed Art Museum, Speed Contemporary Event, March 10, 2021.

22 / Huey Copeland, "Taking Care: Huey Copeland and Allison Glenn on *Promise, Witness, Remembrance*," *Artforum*, Vol. 50, No. 8 (Summer 2021).

23 / Speed Art Museum, "National Advisory Panel Conversation with Allison Glenn," YouTube video, April 8, 2021.

24 / Speed Art Museum, All-Staff Meeting, January 22, 2021.

25 / Speed Art Museum, "National Advisory Panel Conversation with Allison Glenn," YouTube video, April 8, 2021.

26 / Heidi Zuckerman,"62. Allison M. Glenn", Conversations About Art, April 6, 2021.

27 / Speed Art Museum, Speed Contemporary Event, March 10, 2021.

28 / Speed Art Museum, "National Advisory Panel Conversation with Allison Glenn," YouTube video, April 8, 2021.

29 / Speed Art Museum, Speed Contemporary Event, March 10, 2021.

30 / Speed Art Museum, Speed Contemporary Event, March 10, 2021.

31 / Speed Art Museum, "National Advisory Panel Conversation with Allison Glenn," YouTube video, April 8, 2021.

32 / Speed Art Museum, "National Advisory Panel Conversation with Allison Glenn," YouTube video, April 8, 2021.

33 / Tyler Green, "No. 492: *Promise, Witness, Remembrance*, Magic Realism," *The Modern Art Notes Podcast*, April 8, 2021.

34 / Speed Art Museum, Speed Contemporary Event, March 10, 2021.

35 / Helen Holmes, "Allison Glenn, the Curator of a New Breonna Taylor Exhibition, On Responsibility in Art," *Observer*, March 4, 2021.

36 / Speed Art Museum, "National Advisory Panel Conversation with Allison Glenn," YouTube video, April 8, 2021.

37 / Jasmine Amussen, "In conversation with Toya Northington," *Burnaway*, May 11, 2021.

38 / Speed Art Museum, "Director's Cut with Community Engagement Strategist Toya Northington," YouTube video, April 16, 2021.

39 / Jasmine Amussen, "In conversation with Toya Northington," *Burnaway*, May 11, 2021.

40 / Laura Ross, *Promise, Witness, Remembrance, The Voice-Tribune*, May 5, 2021.

41 / Jasmine Amussen, "In conversation with Toya Northington," *Burnaway*, May 11, 2021.

42 / Speed Art Museum, "Director's Cut with Community Engagement Strategist Toya Northington," YouTube video, April 16, 2021.

43 / Speed Art Museum, "Director's Cut with Community Engagement Strategist Toya Northington," YouTube video, April 16, 2021.

44 / Jasmine Amussen, "In conversation with Toya Northington," *Burnaway*, May 11, 2021.

45 / Jeffrey Brown and Anne Azzi Davenport, PBS Newshour, Television broadcast, Public Broadcasting Service, May 4, 2021.

46 / Speed Art Museum, All-Staff Meeting, January 22, 2021.

47 / Ramona Dallum Lindsey, "Reflection on *Promise, Witness, Remembrance*," *Ruckus*, May 5, 2021.

48 / Jasmine Amussen, "In conversation with Toya Northington," *Burnaway*, May 11, 2021.

49 / Helen Holmes, "Allison Glenn, the Curator of a New Breonna Taylor Exhibition, On Responsibility in Art," *Observer*, March 4, 2021.

50 / Abby Schultz, "Speed Art Museum Features Legacy of Breonna Taylor," *Barron's*, March 12, 2021.

51 / Jeff Martin, "A Portrait of Breonna Taylor," *Museum Confidential*, April 2, 2021.

52 / Andre Toran, "Speed Art Museum announces new details for Breonna Taylor exhibit. Here's what to expect," *The Courier-Journal*, February 24, 2021.

53 / Nadja Sayej, "'It keeps her alive': remembering Breonna Taylor through art," *The Guardian*, April 1, 2021.

54 / Huey Copeland, "Taking Care: Huey Copeland and Allison Glenn on *Promise, Witness, Remembrance*," *Artforum*, Vol. 50, No. 8 (Summer 2021).

55 / Speed Art Museum, Speed Contemporary Event, March 10, 2021.

56 / Elizabeth Howard, "Short Fuse Podcast #42: Promise Witness Remembrance," *The Arts Fuse*, July 13, 2021.

57 / Speed Art Museum, "National Advisory Panel Conversation with Allison Glenn," YouTube video, April 8, 2021.

58 / Speed Art Museum, Speed Contemporary Event, March 10, 2021.

59 / Siddhartha Mitter, "How a Museum Show Honoring Breonna Taylor Is Trying to 'Get It Right,'" *New York Times*, March 11, 2021.

60 / Speed Art Museum, "Speed Art Museum Announces *Promise, Witness, Remembrance*," Press Release, February 23, 2021.

61 / Elizabeth Howard, "Short Fuse Podcast #42: Promise Witness Remembrance," The Arts Fuse, July 13, 2021.

62 / Speed Art Museum, "National Advisory Panel Conversation with Allison Glenn," YouTube video, April 8, 2021.

63 / Elizabeth Howard, "Short Fuse Podcast #42: Promise Witness Remembrance," *The Arts Fuse*, July 13, 2021.

64 / Tyler Green, "No. 492: *Promise, Witness, Remembrance*, Magic Realism", The Modern Art Notes Podcast, April 8, 2021.

65 / Speed Art Museum, Speed Contemporary Event, March 10, 2021.

66 / Tyler Green, "No. 492: *Promise, Witness, Remembrance*, Magic Realism", The Modern Art Notes Podcast, April 8, 2021.

67 / Speed Art Museum, Speed Contemporary Event, March 10, 2021.

68 / Kevin Cosby, "Muhammad Ali Memorial Service," June 10, 2016.

69 / Speed Art Museum, All-Staff Meeting, January 22, 2021.

70 / Siddhartha Mitter, "How a Museum Show Honoring Breonna Taylor Is Trying to 'Get It Right,'" *New York Times*, March 11, 2021.

71 / Speed Art Museum, "National Advisory Panel Conversation with Allison Glenn," YouTube video, April 8, 2021.

72 / Siddhartha Mitter, "How a Museum Show Honoring Breonna Taylor Is Trying to 'Get It Right,'" *New York Times*, March 11, 2021.

73 / Speed Art Museum, Speed Contemporary Event, March 10, 2021.

74 / Speed Art Museum, "National Advisory Panel Conversation with Allison Glenn," YouTube video, April 8, 2021.

75 / Speed Art Museum, "National Advisory Panel Conversation with Allison Glenn," YouTube video, April 8, 2021.

76 / Siddhartha Mitter, "How a Museum Show Honoring Breonna Taylor Is Trying to 'Get It Right,'" *New York Times*, March 11, 2021.

77 / Speed Art Museum, "Director's Cut with Community Engagement Strategist Toya Northington," YouTube video, April 16, 2021.

78 / Siddhartha Mitter, "How a Museum Show Honoring Breonna Taylor Is Trying to 'Get It Right,'" New York Times, March 11, 2021.

79 / Speed Art Museum, Speed Contemporary Event, March 10, 2021.

80 / Speed Art Museum, "Director's Cut with Community Engagement Strategist Toya Northington," YouTube video, April 16, 2021.

81 / Speed Art Museum, "Director's Cut with Community Engagement Strategist Toya Northington," YouTube video, April 16, 2021.

82 / Speed Art Museum, "National Advisory Panel Conversation with Allison Glenn," YouTube video, April 8, 2021.

83 / Huey Copeland, "Taking Care: Huey Copeland and Allison Glenn on *Promise, Witness, Remembrance*," *Artforum*, Vol. 50, No. 8 (Summer 2021).

84 / Artnet News, "The Art Angle Podcast: How Breonna Taylor's Life Inspired an Unforgettable Museum Exhibition," *The Art Angle*, May 14, 2021.

85 / Speed Art Museum, "Director's Cut with Community Engagement Strategist Toya Northington," YouTube video, April 16, 2021.

86 / Speed Art Museum, "Director's Cut with Community Engagement Strategist Toya Northington," YouTube video, April 16, 2021.

87 / Speed Art Museum, Speed Contemporary Event, March 10, 2021.

88 / Speed Art Museum (2021, April 14). 'Introducing *Promise, Witness, Remembrance*' [Video]. YouTube.

89 / Huey Copeland, "Taking Care: Huey Copeland and Allison Glenn on *Promise, Witness, Remembrance*," *Artforum*, Vol. 50, No. 8 (Summer 2021).

90 / Tyler Green, "No. 492: *Promise, Witness, Remembrance*, Magic Realism", The Modern Art Notes Podcast, April 8, 2021.

91 / Artnet News, "The Art Angle Podcast: How Breonna Taylor's Life Inspired an Unforgettable Museum Exhibition," *The Art Angle*, May 14, 2021.

92 / Huey Copeland, "Taking Care: Huey Copeland and Allison Glenn on *Promise, Witness, Remembrance*," *Artforum*, Vol. 50, No. 8 (Summer 2021).

93 / Ramona Dallum Lindsey, "Reflection on *Promise, Witness, Remembrance*," *Ruckus*, May 5, 2021.

94 / Jeffrey Brown and Anne Azzi Davenport, PBS Newshour, Television broadcast, Public Broadcasting Service, May 4, 2021.

95 / Ramona Dallum Lindsey, "Reflection on *Promise, Witness, Remembrance*," *Ruckus*, May 5, 2021.

96 / Nadja Sayej, "'It keeps her alive': remembering Breonna Taylor through art," *The Guardian,* April 1, 2021.

97 / Speed Art Museum, "Introducing *Promise, Witness, Remembrance*," YouTube video, April 14, 2021.

98 / Huey Copeland, "Taking Care: Huey Copeland and Allison Glenn on *Promise, Witness, Remembrance*," *Artforum*, Vol. 50, No. 8 (Summer 2021).

99 / Tyler Green, "No. 492: *Promise, Witness, Remembrance*, Magic Realism", The Modern Art Notes Podcast, April 8, 2021.

100 / Huey Copeland, "Taking Care: Huey Copeland and Allison Glenn on *Promise, Witness, Remembrance*," *Artforum*, Vol. 50, No. 8 (Summer 2021).

101 / Stephanie Wolf, All Things Considered, Radio broadcast, National Public Radio, April 11, 2021.

102 / Speed Art Museum, Speed Contemporary Event, March 10, 2021.

103 / Speed Art Museum, All-Staff Meeting, January 22, 2021.

104 / Speed Art Museum, All-Staff Meeting, January 22, 2021.

105 / Noel W Anderson, "Beyond this point promise is DEMANDED!," *Burnaway*, May 11, 2021.

106 / Speed Art Museum, "National Advisory Panel Conversation with Allison Glenn," YouTube video, April 8, 2021.

107 / Huey Copeland, "Taking Care: Huey Copeland and Allison Glenn on *Promise, Witness, Remembrance*," *Artforum*, Vol. 50, No. 8 (Summer 2021).

108 / Huey Copeland, "Taking Care: Huey Copeland and Allison Glenn on *Promise, Witness, Remembrance*," *Artforum*, Vol. 50, No. 8 (Summer 2021).

109 / WLKY, "Speed Art Museum exhibition honoring Breonna Taylor opens to public," Video of television broadcast, April 7, 2021.

110 / Nadja Sayej, "'It keeps her alive': remembering Breonna Taylor through art," *The Guardian*, April 1, 2021.

111 / Jon Cherry, "Walk Through The Breonna Taylor Art Exhibit with Louisville Protestors," *WFPL*, April 12, 2021.

112 / Artnet News, "The Art Angle Podcast: How Breonna Taylor's Life Inspired an Unforgettable Museum Exhibition," *The Art Angle*, May 14, 2021.

113 / Jon Cherry, "Walk Through The Breonna Taylor Art Exhibit with Louisville Protestors," *WFPL*, April 12, 2021.

114 / Nadja Sayej, "'It keeps her alive': remembering Breonna Taylor through art," *The Guardian*, April 1, 2021.

115 / Speed Art Museum, Speed Contemporary Event, March 10, 2021.

116 / Siddhartha Mitter, "How a Museum Show Honoring Breonna Taylor Is Trying to 'Get It Right,'" *New York Times*, March 11, 2021.

117 / Barbara Rose, "Black Art in America," *Art in America*, Vol. 58, No. 5. (September-October 1970): 57.

118 / Brianna Harlan, "Confronting Erasure: *Promise, Witness, Remembrance* at the Speed Art Museum," *Art in America*, June 1, 2021.

119 / Tyler Green, "No. 492: *Promise, Witness, Remembrance*, Magic Realism", The Modern Art Notes Podcast, April 8, 2021.

120 / Speed Art Museum, Speed Contemporary Event, March 10, 2021.

121 / Tyler Green, "No. 492: *Promise, Witness, Remembrance*, Magic Realism", The Modern Art Notes Podcast, April 8, 2021.

122 / Ramona Dallum Lindsey, "Reflection on *Promise, Witness, Remembrance*," *Ruckus*, May 5, 2021.

123 / Speed Art Museum, Speed Contemporary Event, March 10, 2021.

124 / Tyler Green, "No. 492: *Promise, Witness, Remembrance*, Magic Realism", The Modern Art Notes Podcast, April 8, 2021.

125 / Speed Art Museum, Speed Contemporary Event, March 10, 2021.

126 / Tyler Green, "No. 492: *Promise, Witness, Remembrance*, Magic Realism", The Modern Art Notes Podcast, April 8, 2021.

127 / Speed Art Museum, Speed Contemporary Event, March 10, 2021.

128 / Speed Art Museum, "Introducing *Promise, Witness, Remembrance*," YouTube video, April 14, 2021.

129 / Tyler Green, "No. 492: *Promise, Witness, Remembrance*, Magic Realism", The Modern Art Notes Podcast, April 8, 2021.

130 / Speed Art Museum, "National Advisory Panel Conversation with Allison Glenn," YouTube video, April 8, 2021.

131 / Speed Art Museum, Speed Contemporary Event, March 10, 2021.

132 / María Magdalena Campos-Pons, "The Rise of Butterfly Eyes," *Burnaway*, May 13, 2021.

133 / Tyler Green, "No. 492: *Promise, Witness, Remembrance*, Magic Realism", The Modern Art Notes Podcast, April 8, 2021.

134 / Nadja Sayej, "'It keeps her alive': remembering Breonna Taylor through art," *The Guardian*, April 1, 2021.

135 / Miles Pope, "Amy Sherald on Making Breonna Taylor's Portrait," *Vanity Fair,* August 24, 2020.

136 / Miles Pope, "Amy Sherald on Making Breonna Taylor's Portrait," *Vanity Fair,* August 24, 2020.

137 / Chadd Scott, "Amy Sherald's Portrait Of Breonna Taylor Going On Public View For First Time At Speed Art Museum In Louisville," *Forbes*, March 11, 2021.

138 / Laura Ross, *Promise, Witness, Remembrance*, *The Voice-Tribune*, May 5, 2021.

139 / Tyler Green, "No. 492: *Promise, Witness, Remembrance*, Magic Realism", The Modern Art Notes Podcast, April 8, 2021.

140 / Elizabeth Howard, "Short Fuse Podcast #42: Promise Witness Remembrance," *The Arts Fuse*, July 13, 2021.

141 / Speed Art Museum, Speed Contemporary Event, March 10, 2021.

142 / Artnet News, "The Art Angle Podcast: How Breonna Taylor's Life Inspired an Unforgettable Museum Exhibition," *The Art Angle*, May 14, 2021.

143 / Speed Art Museum, "Director's Cut with Amy Sherald,' YouTube video, May 21, 2021.

144 / Speed Art Museum, "Director's Cut with Amy Sherald,' YouTube video, May 21, 2021.

145 / Speed Art Museum, "Director's Cut with Amy Sherald,' YouTube video, May 21, 2021.

146 / Speed Art Museum, "Director's Cut with Amy Sherald,' YouTube video, May 21, 2021.

147 / Speed Art Museum, "Director's Cut with Amy Sherald,' YouTube video, May 21, 2021.

148 / Speed Art Museum, "Director's Cut with Amy Sherald,' YouTube video, May 21, 2021.

149 / Speed Art Museum, "Director's Cut with Amy Sherald,' YouTube video, May 21, 2021.

150 / Huey Copeland, "Taking Care: Huey Copeland and Allison Glenn on *Promise, Witness, Remembrance*," *Artforum*, Vol. 50, No. 8 (Summer 2021).

151 / Speed Art Museum, Speed Contemporary Event, March 10, 2021.

152 / Huey Copeland, "Taking Care: Huey Copeland and Allison Glenn on *Promise, Witness, Remembrance*," *Artforum*, Vol. 50, No. 8 (Summer 2021).

153 / Artnet News, "The Art Angle Podcast: How Breonna Taylor's Life Inspired an Unforgettable Museum Exhibition," *The Art Angle*, May 14, 2021.

154 / Gregory Volk, "Bearing Witness to Breonna Taylor's Life and Death," *Hyperallergic*, May 1, 2021.

155 / Holland Cotter, "A Museum Says Her Name," *New York Times*, April 12, 2021.

156 / Holland Cotter, "A Museum Says Her Name," *New York Times*, April 12, 2021.

157 / Siddhartha Mitter, "How a Museum Show Honoring Breonna Taylor Is Trying to 'Get It Right,'" *New York Times*, March 11, 2021.

158 / Speed Art Museum, All-Staff Meeting, January 22, 2021.

159 / Laura Ross, *Promise, Witness, Remembrance, The Voice-Tribune*, May 5, 2021.

160 / Jasmine Amussen, "In conversation with Toya Northington," *Burnaway*, May 11, 2021.

161 / Speed Art Museum, Speed Contemporary Event, March 10, 2021.

162 / Jasmine Amussen, "In conversation with Toya Northington," *Burnaway*, May 11, 2021.

163 / Speed Art Museum, "There Are Black People In The Future," YouTube video, May 22, 2021.